DRAWING AND PAINTING THE CLOTHED FIGURE

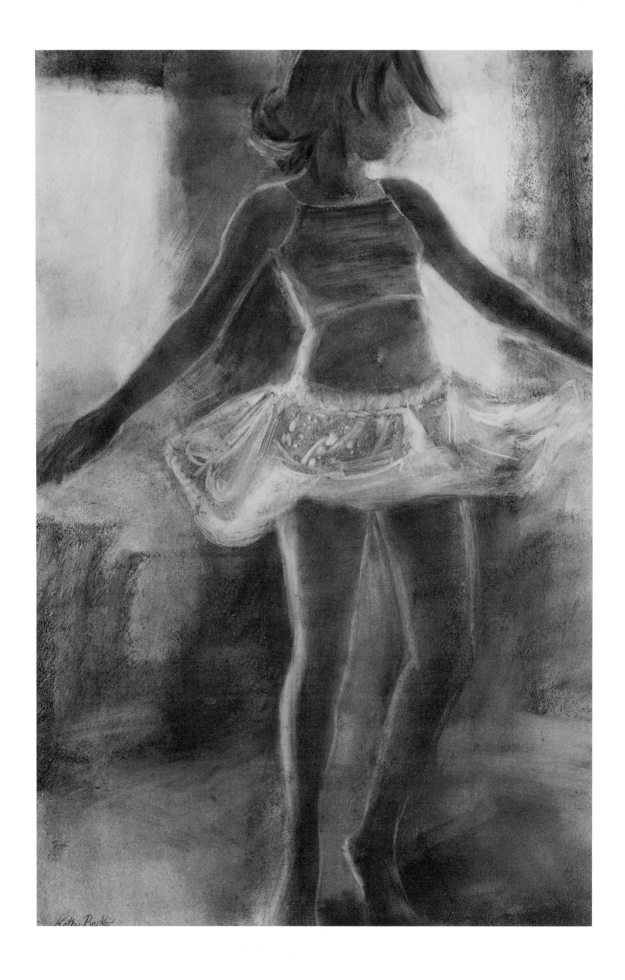

Kathy Parker

DRAWING AND PAINTING THE CLOTHED FIGURE

KATHY BARKER

THE CROWOOD PRESS

First published in 2005 by
The Crowood Press Ltd
Ramsbury, Marlborough
Wiltshire SN8 2HR

www.crowood.com

British Library Cataloguing-in-Publication Data
A catalogue record for this book is available from the British Library.

ISBN 1 86126 775 4

Acknowledgements
Thank you to West Dean College.

To all the people who modelled for me. In particular I would like to mention
Zena Machette, Clare Nichols and friends who helped and supported me in one
way or another: Dragana Kristic, Pippa Small and especially Rachel Taylor.

To all the artists who submitted work.

Last to my loving family. I dedicate this book to my mother and to
Pierre and Manon.

www.kathybarker.co.uk

Typefaces used: text, Stone Sans; headings, Frutiger; chapter headings,
Rotis Sans.

Typeset and designed by D & N Publishing
Hungerford, Berkshire.

Printed and bound in Malaysia by Times Offset (M) Sdn. Bhd.

CONTENTS

Preface 7

1	THE NAKED BODY	9
2	THE DRAPED FIGURE	33
3	DRAWING AND PAINTING CLOTHES	57
4	DRAWING AND PAINTING THE CLOTHED FIGURE	85
5	DIFFERENT POSITIONS AND COMPOSITIONS	103
6	ACCESSORIES AND PROPS	141
7	DEVELOPING SELF-EXPRESSION	167

Index 190

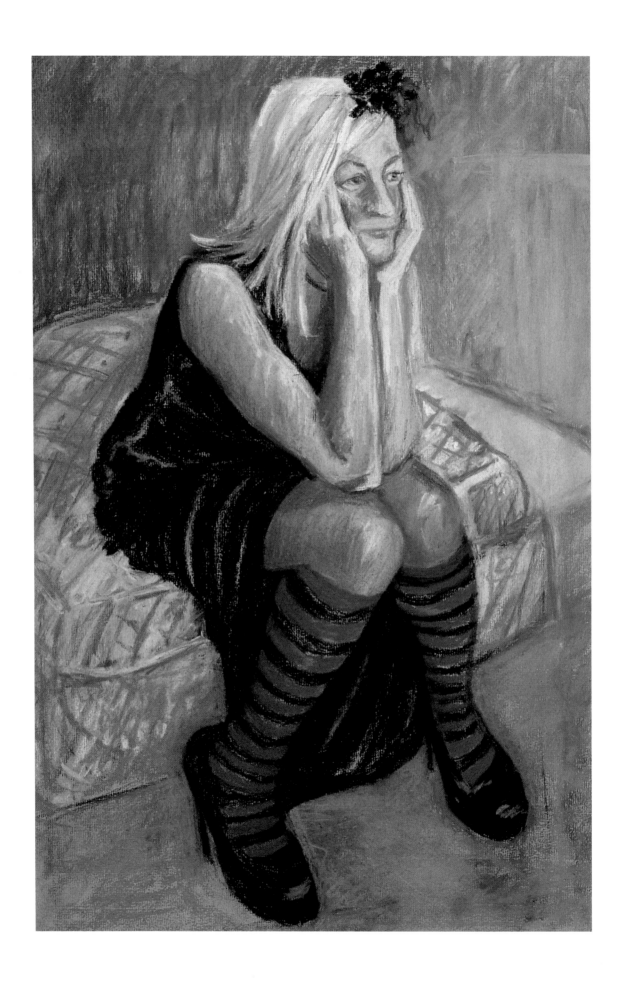

PREFACE

The figure has always been and probably always will be a subject of fascination that we can all relate to and identify with both physically and psychologically. When the figure is clothed there is scope to enhance or emphasize a posture or body movement to portray a particular character, the telling of a story, or perhaps just to enjoy the effect of a patterned or coloured design.

This book starts by addressing the naked figure. The practical exercises will help beginners to translate what they see on to a two-dimensional surface. The following chapter then examines the various ways of searching for form through the fold using a range of drawing techniques and media. Fabric, colour and pattern are looked at, both in terms of how to marry these with the figure and appropriate painting techniques.

This book is intended for the beginner as well as those with more experience. Whilst there is a strong practical emphasis, equal prominence is given to the importance of 'idea' and providing inspiration on this pleasurable and exciting journey of individuality and self-expression.

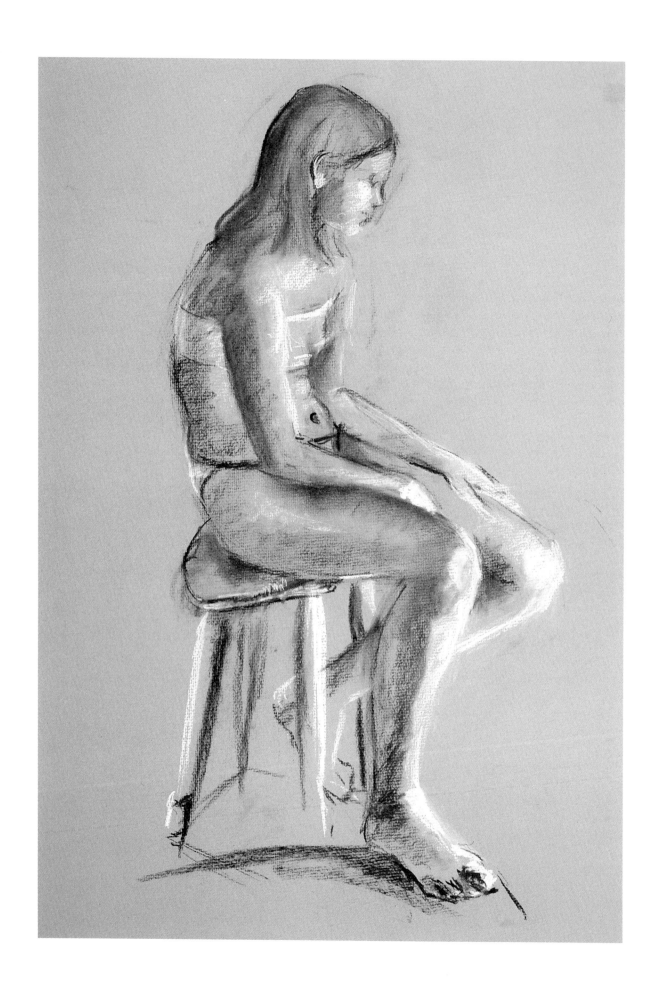

THE NAKED BODY

Having some understanding of the proportions, structure and posture of the human body will help you enormously when you come to draw and paint the clothed figure. Although there are innumerable different styles and cuts, everyday items of clothing such as trousers, shirts and jumpers all follow the line of the body. Knowing and recognizing where the thigh muscle is, for example, can make a pair of trousers look more realistic because what you are depicting when drawing the cloth is in fact the structure beneath – the human body.

However, sometimes when the body is clothed it is not so easy to see what is going on underneath and clothes such as jackets or coats can hide parts of the body's structure, making it more difficult to portray. You may already have experienced such a situation and found parts or extremities of the body ending up looking very disjointed or wrongly positioned in relation to the head.

Because we all have a body, it is natural to assume that we know everything about its form, but this can prove to be far from the case. Although we look at ourselves in the mirror and observe people all the time with many types of body shape, when we try to put what we think we know on to paper, things can go horribly wrong.

This can be disconcerting but try not to let it put you off – the actual 'doing' is part of the enjoyment, not just the end result. Fortunately, there are techniques that help you to draw accurately. However, it is only through study and practising in greater depth that you will learn to 'see' and notice what you see. To be able to draw what you see requires observation, observation, and yet more observation.

It is also useful to have some general information about the body's anatomy, its characteristics and how it bends. Take a look at the skeleton – bones such as the collarbone and shin bone are very near the surface and may be delineated just beneath the skin. Good points of reference when drawing the clothed figure are prominent parts like the knees and elbows. Then there are the muscles that pad the bones and shape the body. You can sometimes see these quite clearly underneath clothing.

Once you get an idea of body form you can visualize how the cloth might behave, though this depends on the material itself and what part of the body it clings to or is hinged upon. Think of a tablecloth on a table; now think of a skirt hanging from the waist. Compare a shirt hanging on the back of a chair to a coat hanging from the shoulders.

If you are a beginner, try not to worry about becoming overwhelmed by anatomy or feel that your inexperience will hold you back. The act of drawing is a practical experience, not an intellectual one. So use parts of this chapter as a guide or reference resource but remember that knowing the name of every bone will not help you to draw it better. Indeed, too much emphasis on getting it right and self-criticism can lead to the neglect of creativity and spontaneity. Always remember that drawing should be an enjoyable experience.

Materials

To complete the exercises in this chapter you will need the following equipment:

- Pencils – there is a whole range of pencils that are marked or graded H for hard (the top end will not go darker than a pale grey) and B for soft-leaded pencils. Try a 2B pencil, which can be used for both light and dark tones, and is soft enough not to dig into the paper.
- Willow charcoal – versatile in tone, good to draw freely with and for mark-making. Easy to wipe away marks and redraw on top.
- Charcoal pencil – slightly darker than willow charcoal, providing greater precision with emphasis on line. Less easy to erase.

OPPOSITE PAGE:
Girl on stool.

- ▪ Erasers – use a standard eraser for rubbing out and a putty or kneaded eraser that you can mould to delicately erase with precision.
- ▪ Paper – sketchbook or sheets of cartridge paper. Size A3 minimum or A2/A1 will allow you to experiment with drawing larger figure sizes.
- ▪ Drawing board – if you are not using a sketchbook you will need a drawing board and clips.

Position

The model should be positioned at least 14ft (4.5m) away from you. You must be able to see the entire pose and, if you are a beginner, you will want to avoid getting straight into foreshortening (the closer you sit to your model, the more disproportionately large the nearest body part will appear). Position yourself so that you can flick your eyes from model to drawing from the same standing or sitting position. You do not want your view blocked by your drawing board if it is on an easel, so face the model and angle the easel. Now you have your position, loosen up and relax – move your body, feel the whole of your arm and shoulder move, not just your wrist, as you draw. If you are sitting, make sure the board is tilted up or supported if you are not working from an easel. Avoid having to look down at your drawing and up at the model which results in you drawing much more from what you thought you saw than from actually looking and checking. Furthermore, if the drawing is lying flat, your visual perspective to the paper is different, so that the drawing looks all right as long as it remains flat but may be distorted when tilted up vertically.

Remember Your Model

Make sure that your model is comfortable and that there is sufficient heating. Standing or sitting in one position for a long time can be really tiring. If he or she needs a break, simply mark around the pose with charcoal, contouring the feet if standing or, if sitting, the buttocks and suchlike. You can use masking tape if you do not want to mark the furniture. Also, remember that no matter how experienced your model may be, the body tires of a pose and there are invariably little shifts that sometimes become perceptible. Do not let it worry you – modify your drawing if need be but do not necessarily erase the original. A history of underdrawing or faint traces of where the body forms were originally positioned can very much add movement and life to the finished drawing.

It is always a good idea to emulate the position of your model so you can experience and feel the pose yourself. This will help you to understand the direction of the limbs and also the tensions and muscles being used.

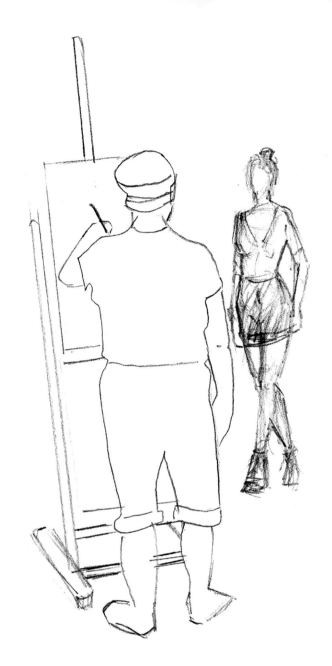

Make sure you can see the model.

Proportion and Measurement

Although bodies come in various shapes and sizes, there are guidelines to average body proportions that are helpful in determining whether or not you are on the right track. However, each time you draw the body you will find degrees of difference in height, head shape, the pose, your reality point of view and perspective. Later on you may also add artistic licence or interpretation to the list. You may deliberately wish to distort in order to convey what you want to say or to evoke an emotive response in the viewer. El Greco is a fine example of this – the figures in his paintings are very elongated.

Proportion is the mathematical relationship of one part in comparison to another part or parts and to the whole. Traditionally, the head is used as the unit of proportion the rest of the body is measured against. The average man and woman have a head to body ratio of 1:7, in other words, the number of times the head length (from the top of the head to the chin) fits into the length of the body. However, you will frequently find that this ratio can vary by a half measure either side.

Characteristically, children have much bigger heads in relation to their bodies. A toddler will have a ratio of approximately a 1:3.5 or 1:4. As children grow, their bodies catch up in relation to their heads with the most obvious growth being in the length of the arms and legs.

The Ancient Greeks devised idealized proportions in order to represent the gods through the perfection and beauty of the human body. The Renaissance artists perfected mathematical proportion and an idealized ratio is still 1:8.

Today we tend to represent the body a little more realistically. It is helpful to compare average body proportions with those of your model. As you gain more experience, you will find variation between individuals. Based on a 1:7 ratio, notice how one head length is the equivalent almost down to the nipple. The half-way point of the body (3½ heads) would be just above the genitals. Beginners often tend to draw the arms too short.

See how the elbows are generally level with the waist. The wrists tend to line up with the bottom of the genitals when the arms are hanging straight and the hands come down to mid-thigh. Hands are bigger than you think; see how your own hand almost covers your face. The foot is about the length of one head or the distance from the inside of the elbow to the wrist.

It is also interesting to note that the breadth from fingertip to fingertip with the arms outstretched at the sides is about the same as the height from the top of the crown to the toes with the legs straight and together.

EXERCISE: **MEASUREMENT**

— OBJECTIVE: To measure the figure

— MATERIALS**:** Pencil and eraser

— POSE/SET-UP: Any

— TIME: Not less than 30 minutes

Extend your arm and keep it straight, hold the pencil vertically, close one eye and align the tip of the pencil with the top of the model's head. Now place your thumb where the chin ends. This is the head length measurement. Maintaining a straight arm and

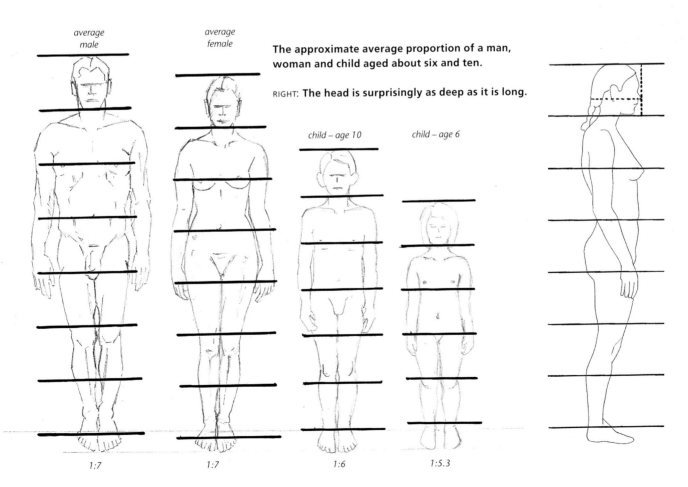

average male

average female

The approximate average proportion of a man, woman and child aged about six and ten.

RIGHT: **The head is surprisingly as deep as it is long.**

child – age 10

child – age 6

1:7 1:7 1:6 1:5.3

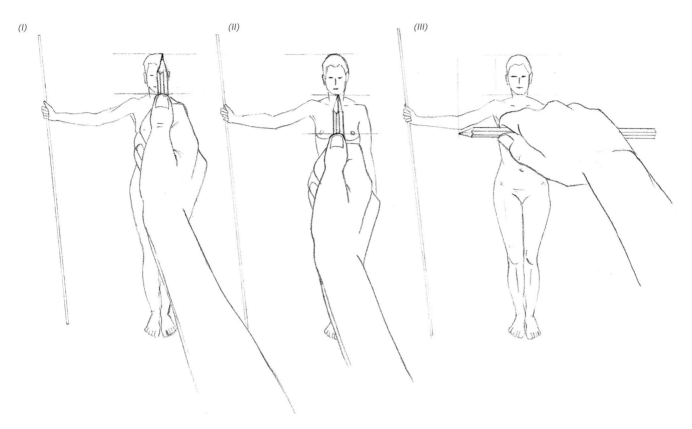

(I) (II) (III)

(I) **Align top of pencil with the crown and thumb with chin. The distance from the point of the pencil to the tip of your thumb will equal the height of the head;**

(II) **move the pencil down so that the top of the pencil aligns with the chin; the tip of your thumb will show where the head length aligns with the body;**

(III) **keeping arm straight, rotate pencil horizontally to ascertain body proportion equal to head unit of length.**

without moving your thumb, bring the pencil down until the tip aligns with the chin. See where and what your thumb aligns with now. Is it above, on, or below the nipple line?

To compare the head length to the distance between the shoulder and elbow, keep your arm steady, hold your pencil in a horizontal position, align your thumb with the shoulder and see where the tip ends. However big or small you draw the length of the head, make sure you maintain the same proportional measurements. So, if the head length is equal to down to the nipple, make sure this is how it appears in your drawing.

It is most important to remember to keep your arm straight so that the pencil is always at the same distance from your eye and that you remain standing or sitting at the same distance away from the model. Otherwise your measurements will be inconsistent. For the same reason, you must ensure that your pencil, whether held horizontally or vertically, does not tilt towards or away from you. Think of street mimes and pretend there is an invisible wall that your pencil cannot poke through. If your pencil does tilt it changes the measurements just like when you bend your elbow.

Sometimes, the head may not be sufficiently visible to use as the unit of measurement or even if it is, it may not be the easiest one to use. For example, the pose may be one where it is difficult to establish which measurement is longer – height or width. If this is the case, mark what you think the measurements are with crosses, dots or lines on the paper. Now, taking up your pencil, measure the height from the top of the head to the foot and compare it with the width from fingertip to fingertip. Whichever is the shorter of the two should be used as the measurement to establish the ratio of the other. In the example shown (*above right*) hand to hand is only fractionally longer than head to foot, therefore the format is practically square. To obtain the head ratio, measure from the chin down this time, and compare it with the width, the difference is equal to the measurement of the head.

As the artist you get to choose the initial unit of measurement. However, if you choose the head length unit and make it quite large in your drawing then the other measurements will be correspondingly large and the result will probably be that you cannot fit the whole pose on to the paper. On the other hand, if you literally transfer the tip of your pencil to thumb measurement to

(I) *(II)*

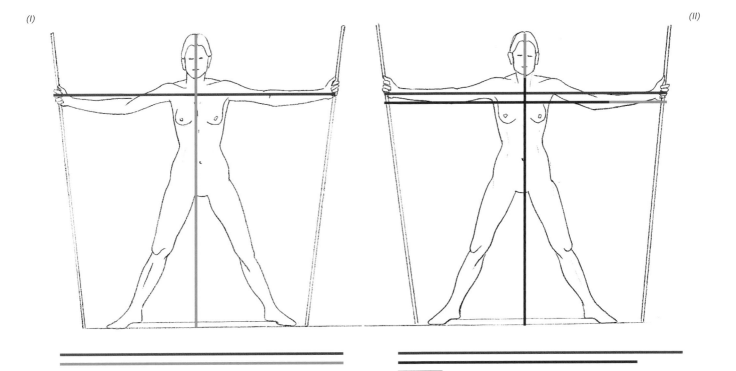

(I) The length from head to lowest points of feet is the same as breadth from one hand to the other. Observing this will make you realize how big you can go on your piece of drawing paper.

(II) Measuring from chin down to floor and subtracting it from the breadth will give you the head length.

paper your figure will end up very tiny and it will be tricky to see what you are doing. So, if unsure, establish the tallest and widest proportions on the paper first before getting into further comparative measurements.

The Skeleton

The skeleton serves as a good point of reference. If you have some understanding of anatomy, with experience you will be able to draw the body with or without a model. As you look at the skeleton, try to simplify its form to a series of shapes and lines, like a stickman. This will be very helpful when attempting to draw the balance and posture of a pose.

The skeleton has approximately 206 bones that form a structural framework of support and protection. Differences between the male and female skeleton are minimal but the female is generally smaller and lighter with a slightly wider pelvis for the purposes of childbirth.

The bones are connected by a variety of structural joints with differing fibrous tissues and are bound and composed with ligaments, synovial fluids, cartilages and so on. The manner in which the bone moves depends on what type of joint it is connected to. For example, there are fixed joints that look like seams joining the bones of the skull. The cavity and the skeletal face (cranium) form a kind of oval shape when seen from the front. The only part that moves is the lower jaw (mandible).

The head is connected to the neck by the bones of the upper part of the spine (cervical vertebrae). The first two bones (atlas and axis vertebrae) form a pivotal joint that is mostly responsible for the sideways movement of the head.

The bones of the spine (vertebrae) are mostly individual except for the five bones of the sacrum, which are fused together. Intervertebral disk joints and synovial joints act as buffers against shocks caused by running and similar activities. They also determine the small amount of movement between each bone. The thoracic vertebrae can move in two directions and the lumbar vertebrae in three. Only the neck has full movement. Notice the 'S' shape of the spine when seen from side view. If you can

sketch the meander or direction of the spine you can capture the nature of the pose.

Look at the shape and structure of the rib cage, think of deeply inhaling and expanding the chest. Twelve pairs of ribs attach to the thoracic vertebrae of the spine at the back and then curve around to the breastbone (sternum) at the front. Notice the configuration of the lower ribs, how they taper in with only the last two being joined at the spine. The shape of the rib cage is rather like an egg with a bit missing at the bottom.

The shoulders and the hips both have ball and socket joints, which rotate and move backwards, forwards and sideways. The shoulder girdle is composed of the shoulder blade (scapula), the collarbone (clavicle) and joint, which joins the upper arm (humerus). However, it does not connect to the vertebrae by joints or ligaments but by muscle. Although the collarbones articulate with the breastbone, the whole configuration allows

for great movement. Experience this by shrugging your shoulders up as far as possible.

The pelvis comprises the sacrum, the coccyx and the hip bone. The hip is formed from three fused bones and it is the iliac or ridge of this structure that is visible just below the surface of the skin. The pelvis articulates with the thigh bone (femur). It is important to be aware of the movement and directional line of the hips when drawing the figure. The shift of weight through the pelvis to one leg or another affects the way in which you would naturally carry or position your shoulders, spine and head.

The arms and legs both have joints that work like door hinges. The arms move forwards at the elbow whilst in the legs the movement is backwards at the knee. The upper arm articulates with the bones of the forearm (ulna and radius) at the elbow joint. This allows the radius to rotate around the ulna. Take a look for yourself. Extend your arms straight out at your sides.

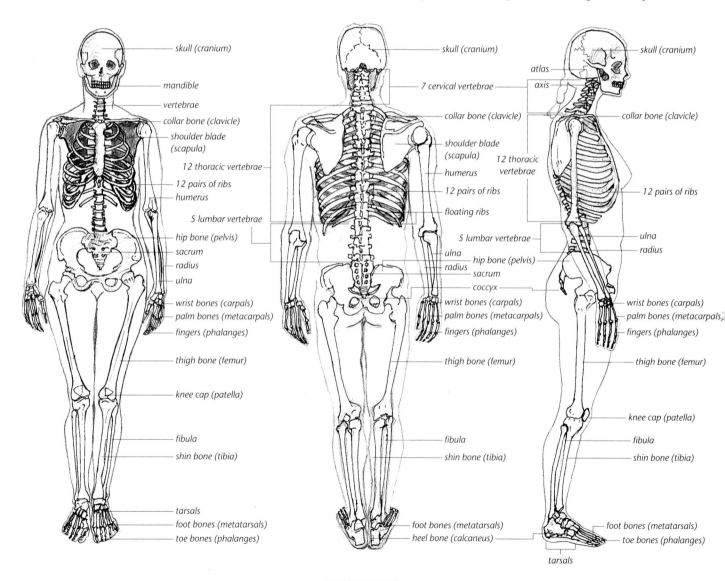

THE SKELETON
Front view, back view and side view.

Without moving your shoulders, turn your palms up to face the ceiling and then down to face the floor. The forearm articulates with the eight carpal bones of the wrist, which are arranged in two rows of four and allow for considerable flexibility. The carpal bones form articulations with the palm bones (metacarpals) that can be seen on the back of the hand. The palm bones join at the knuckles to the fingers and thumbs. The fingers each have three bones (phalanges) whilst the thumb has two. The thumb has a seller joint allowing swing and rotational movement to be able to hold a sledge-hammer or a needle.

The longest bones of the body are in the legs. The thigh bone accounts for more than a quarter of an adult's height. Observe how the head of the pelvic end of the thigh bone angles out to form the greater trochanter (this can also be seen under the skin at the top end of the thigh). The knees are the largest and most complicated joints of the body – take a detailed look at the kneecap (patella). The lower leg consists of a large shin bone (tibia) and the fibula, a comparatively thin bone. These meet with the ankle joint, which swings back and rotates, articulating with the seven tarsal bones of the foot to make the weight-bearing function possible. The tarsal form arches with the metatarsals in the foot, which are larger than those in the hand. The head of the shin bone on the inside ankle meets with the heel bone (calcaneus). It is more prominent and higher up than the fibula, which protrudes from the outside lower leg.

EXERCISE: LOOKING FOR LINES OF BALANCE AND POSTURE

— OBJECTIVE: To get the correct balance and look for skeletal structure beneath the flesh

— MATERIALS: Pencil

— POSE/SET-UP: Variety of standing poses

— TIME: 10 minutes for each pose

Lightly draw the pose using simple shapes such as an oval for the head and a larger one for the rib cage. See if you can detect the 'S' curve of the spine. Draw the position of the arms and legs with simple matchstick lines, indicating joints with dots or small circles. Make marks where you think the feet are. Hold the pencil vertically with your arm outstretched. Close one eye and align the tip of the pencil starting at the pit of the neck for the front, the ear for the side, or the nape of the neck for a back view of the model. Allow your arm to move down but do not alter your hold on the pencil. Draw a vertical line starting from the pit or nape of the neck or ear, straight down to the feet. Where did you draw the feet, arms and legs in relation to this vertical line? Keeping the arm outstretched, refer back to this vertical line as you adjust and modify your drawing.

Alternatively, you can use a ruler to see where this line or edge intersects with the floor in relation to the feet. This tells you where the weight is. Does the vertical line fall between the feet or does it align with one foot?

If you are unsure about the direction or angle of the arm or part of the arm such as the shoulder to the elbow, close one of your eyes and align your pencil with the part you want to check. Remember not to tilt the pencil towards or away from you. Think of it as being one of the blades on a windmill that has a 360-degree rotation but the blades do not bend forwards or backwards. You can find the angle with the elbow bent, for here you are not actually measuring the unit length. By holding the pencil closer to your eye, you will find it easier to transfer the correct angle to your drawing. Another way to check the angles of body parts is to compare the degree of slant with the vertical plumbline of the pencil held at arm's length. You can also gauge angles by holding the pencil horizontally.

It helps to draw the spatial lines between the positions of the feet. Are these at an angle in relation to each other? Check to see. Now, look again – does the heel align vertically with the ear? Does the line fall between the feet? Notice how when the weight

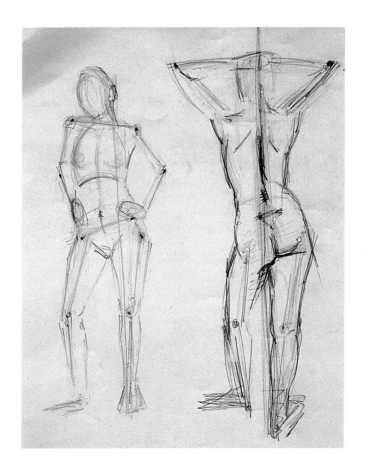

Matchstick men structures with simplified head and ribcage shapes. Plumblines are drawn in from the beginning. The flesh is padded out last.

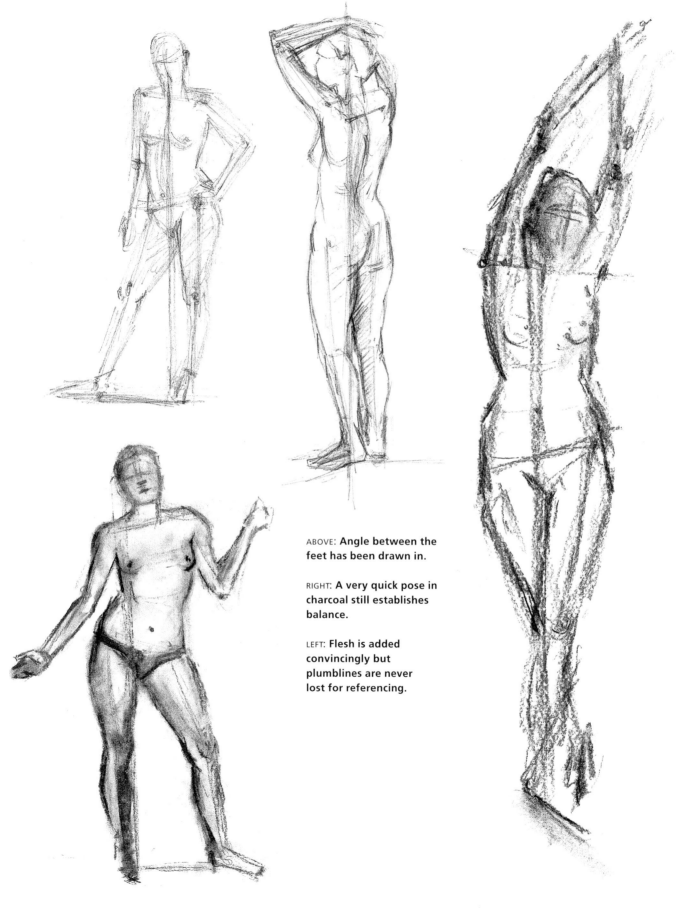

ABOVE: **Angle between the feet has been drawn in.**

RIGHT: **A very quick pose in charcoal still establishes balance.**

LEFT: **Flesh is added convincingly but plumblines are never lost for referencing.**

is on one foot, the pelvis tilts up on the same side and, as a counterbalance, the shoulder on that side tilts down towards the hip. Draw a line from shoulder to shoulder and a line to represent the pelvis. Is it straight or does it angle up on one side? What does the shoulder line do? To experience this counterbalance of the shoulder and hip, try standing with your weight on one foot. See what position your shoulders naturally adopt. Try keeping your shoulders dead straight whilst maintaining this position. It should feel really awkward.

Keep checking and looking. Try not to rub out what you have already drawn unless you have been very heavy-handed and have too many lines that are now confusing you. It is much better to make your modifications with a little extra pencil pressure. Try to get the tilt of the head and keep checking on the vertical line for reference. Notice how often some part of the foot will line up with the ear, the pit or the nape of the neck. You may wish to draw curves for the thighs, the bottom or anything else that enables you to capture the balance as you go along. However, be sure to establish the basic structure first.

The Muscles

There are over 600 muscles in the body falling into three categories: smooth muscles that move involuntarily such as the stomach muscles, the heart muscles, and skeletal muscles that move voluntarily and are concerned with movement, posture and balance.

A muscle is made of millions of interlocking fibres that contract when you use it. It is controlled by nerve endings that respond to signals from the brain. Because a muscle can only do the 'pull'

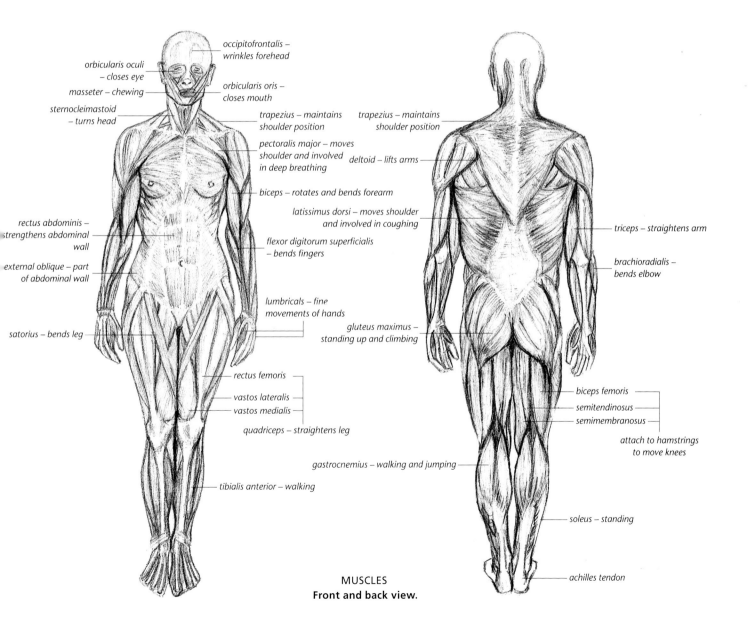

occipitofrontalis – wrinkles forehead

orbicularis oculi – closes eye

masseter – chewing

sternocleimastoid – turns head

orbicularis oris – closes mouth

trapezius – maintains shoulder position

pectoralis major – moves shoulder and involved in deep breathing

biceps – rotates and bends forearm

latissimus dorsi – moves shoulder and involved in coughing

flexor digitorum superficialis – bends fingers

rectus abdominis – strengthens abdominal wall

external oblique – part of abdominal wall

lumbricals – fine movements of hands

satorius – bends leg

rectus femoris

vastos lateralis

vastos medialis

quadriceps – straightens leg

gastrocnemius – walking and jumping

tibialis anterior – walking

trapezius – maintains shoulder position

deltoid – lifts arms

triceps – straightens arm

brachioradialis – bends elbow

gluteus maximus – standing up and climbing

biceps femoris

semitendinosus

semimembranosus

attach to hamstrings to move knees

soleus – standing

achilles tendon

MUSCLES
Front and back view.

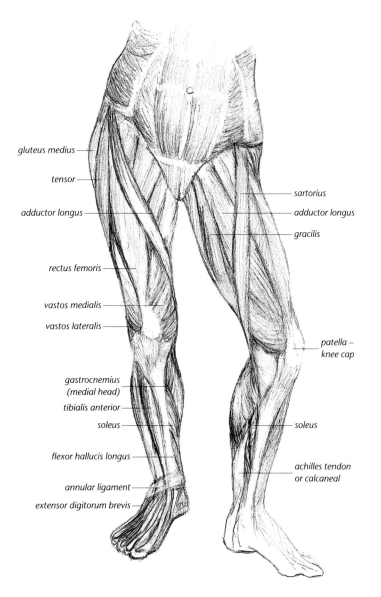

gluteus medius

tensor

adductor longus

rectus femoris

vastos medialis

vastos lateralis

gastrocnemius
(medial head)

tibialis anterior

soleus

flexor hallucis longus

annular ligament

extensor digitorum brevis

sartorius

adductor longus

gracilis

patella –
knee cap

soleus

achilles tendon
or calcaneal

action that moves the bone, most muscles work in pairs. For example, when you bend your arm, the biceps contract and the triceps relax. When you straighten your arm, the triceps contract and the biceps relax.

Muscles are joined to the bones by tendons except for a few in the face that are attached to the skin. The head and neck muscles are responsible for the posture of the head and the rich variety of facial expressions that convey our emotions.

We will now look at the superficial skeletal muscles that most clearly delineate the body from underneath clothing and others that you may see on the well-toned body of an athlete.

The trapezius muscles, which can be seen from front and back view, hold the shoulder position and the shape between the neck and shoulders formed by the deltoids that lift the arms.

The major pectoral muscles define the chest shape. The abdominal muscles (rectus abdominis) strengthen the abdominal wall. The back is shaped by the trapezius and the latissimus dorsi. The gluteus maximus forms the buttock and is the biggest muscle in the body.

The biceps are used to shape and flex the forearm. The triceps straighten and shape the back of the arm. From the elbow, tapering towards the wrist are the forearm extensors and flexors.

The rectus femoris, vastos lateralis and vastos medialis form the quadriceps and together with the adductors give a distinctive shape to the thighs. You can sometimes delineate the satorius muscle that bends the leg and, along with the quadriceps, shows a change of muscle direction. The other most obvious shape in the leg is the calf muscle (gastrocnemius).

To further your understanding, draw the outline of a pose and then draw the muscles where you think they should be, or make studies of selected areas of the body such as the thigh or arm. This will help you to become more aware of muscle direction through following the lines of the fibres.

ABOVE: **A study of
leg muscles.**

RIGHT: **Placing the
muscles helps your
awareness of form.**

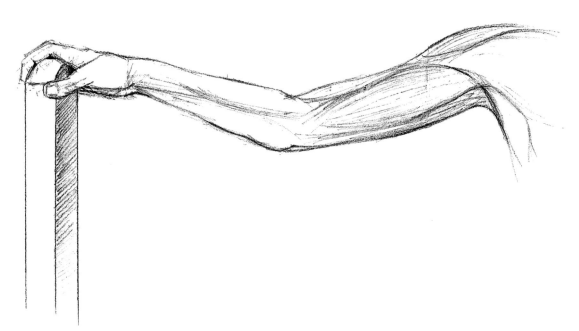

EXERCISE: **DRAWING IN STRAIGHT LINES**

— OBJECTIVE: To heighten awareness of the
 direction of the planes of the body

— MATERIALS: Pencil

— POSE/SET-UP: Standing or seated

— TIME: Not less than 40 minutes

Although the body is full of curves, limiting yourself to finding
them with nothing but straight lines makes you see the contours
of the body afresh and helps you to understand which direction
the planes are going in by focusing on the angle of the lines you
are drawing.

Lightly mark your measurements. To find the shape of the
head or the roundness of a breast, allow the lines to intersect,
criss-crossing one another as each line trave
directional path. The build-up of intersecting
enable you to find the shape and form.

EXERCISE: **INSIDE TO OUTSIDE**

— OBJECTIVE: To create an awareness of the
 direction of form with emphasis on the muscles

— MATERIALS: 2B pencil

— POSE/SET-UP: The torso should be slightly twisted

— TIME: Not less than 40 minutes

Lightly mark your approximate measurements. Use the vertical
line of balance and establish the skeletal framework. You can

Drawing in straight lines.

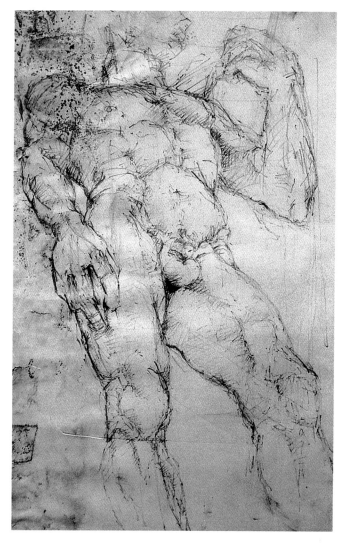

Statues and sculptures are a great resource for non-moving
models and depiction of well-toned muscles.

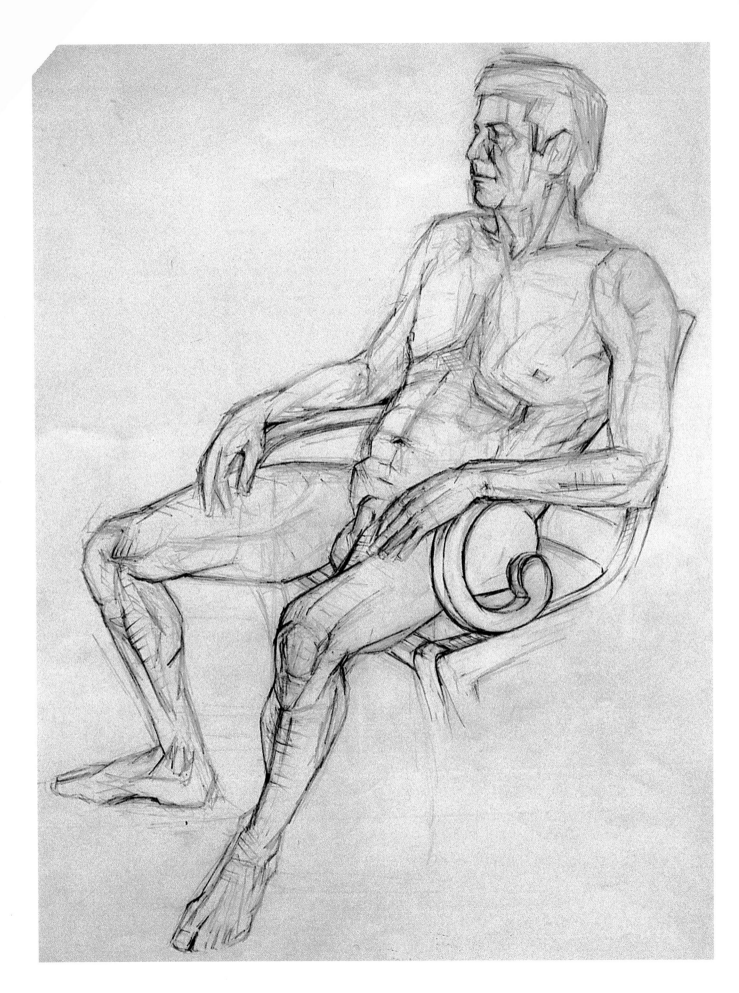

mark this with dots, crosses or a little edge line of form rather than stickmen.

Begin in the area that interests you most – perhaps the chest or maybe somewhere central such as the navel. Journey along with your pencil, searching for the angle or direction of a plane. Lines and curves may overlap both on the inside structure and the external outline of the body. Try to avoid using an eraser – allow the marks to become part of the drawing. Keep your marks light where you are still searching but where the structure is more clearly visible, express it with a stronger line. Add lines that curve or angle in the direction you think the plane of a particular muscle is going. Keep working from inside to outside to discover the outline of the body.

EXERCISE: **BODY MAP CONTOURS**

— OBJECTIVE: To think about the contours
 of the body in three dimensions

— MATERIALS: 2B pencil

— POSE/SET-UP: Seated

— TIME: 45 minutes–1 hour

Think of the body as a map with contours. Very lightly draw a simple skeletal framework and/or mark your approximate measurements. You may find it easier to measure as you go along, checking the next body part or proportion area against the one you have just done. Try to position the mid-point of the pose in the centre of the paper so there is enough room.

OPPOSITE PAGE: **Muscles have been emphasized and the figure sought working from inside to out.**

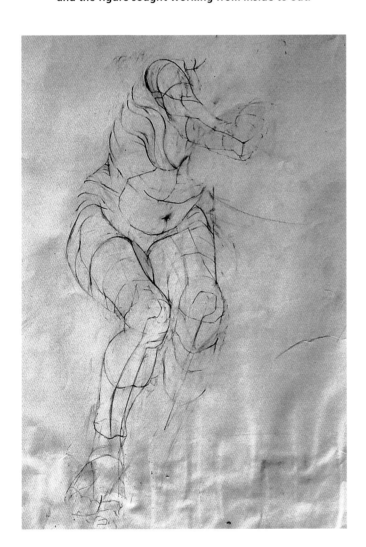

Experience the contours of the body.

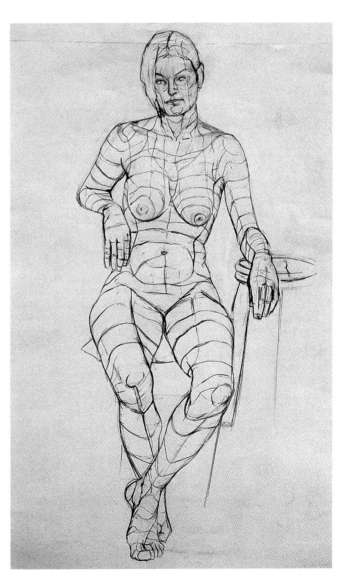

Contours describe the third dimension.

Whilst the correct proportions and alignments will obviously help, if you are a beginner and cannot get the pose to your satisfaction, have a go anyway. Select an outside edge of the body such as the arm and start from there.

Pretend your pencil is an ant that moves in a mainly horizontal direction across the body, coming up at a gradual angle or more steeply if that is the case, tracing along a flat or softly curved area and then finally going over the hill and down the other side either gradually or steeply. Keep the vision of a contour map in mind. Where there are mountain ridges let your ant travel vertically.

Simple Head Proportions

When drawing a likeness you have to measure the individual proportions of the face in relation to other parts and to the whole face shape. The position of your sitter's head and your own viewpoint will also affect where the features go. However, like the body proportions, there are guidelines you can use. These average proportions will also help you to avoid any of the usual prob-

lems experienced by beginners, such as placing the eyes too high up in the forehead.

The shape of the head is often similar to that of an egg, the narrower end representing the chin. Dividing the egg shape in half both horizontally and vertically gives you the centre line of the face from crown to chin and a rough indication of the line of the eyes.

The nose is about half-way between the eye line and chin, the mouth is half-way between the nose and chin. Between the eyes is a space of approximately the width of one eye. When drawing a portrait, study this relationship and also the width from either side of the eyes to the temples. The mouth line from front view is much wider than you might think, reaching more or less from the centre of one eye to the centre of the other. The top of the ear is usually level with the eyebrow and the bottom with the end of the nose. The neck begins directly below the ears but might be hidden in front view by a strong jaw line. The hairline starts just within the forehead egg shape and extends up and beyond both in height and width.

However, it is through observing details such as whether the eye line of an individual is slightly higher than the half-way mark and measuring the difference in length between the eye to the hairline in relation to that between the nose and mouth that enables you to capture a likeness of the sitter.

Get an Egg

See what happens when your viewpoint changes or the head tilts up or down. Draw the central lines and mark the eyes, nose and mouth lines on an egg. Hold the egg above and then below your eye line – tilt, rotate and observe where and how the line changes according to your viewpoint. Notice how the eye line remains parallel with the line of the nose and mouth if the egg is tilted.

A Sideways Head

Draw a square and a circular shape then position them as shown in the diagram (*see* page 24). Divide in halves as before then copy the simple lines to practise drawing the shape and position of the features. Remember that the head is as deep as it is long and in comparison the features take up relatively little space. You can also adopt this format for a front view of the head by placing the orb within a rectangle.

A tip to remember is that drawing the head in three-quarters profile will help you to achieve more depth and it is also more natural looking. If you have a skull or can get a good picture of one it is worth drawing as it will increase your awareness of the planes of the face. Depict these planes in simplified straight lines. Keep visualizing the skull. Touch your own face. Find the angles to describe the planes.

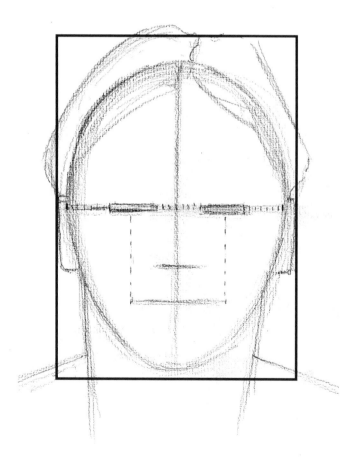

Simple upside-down egg shape.

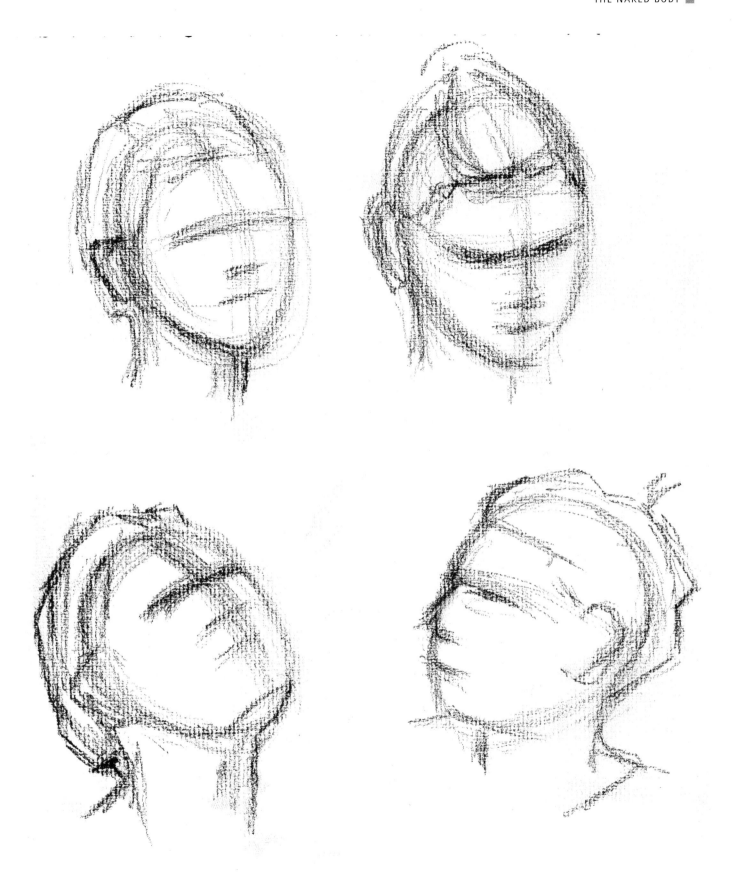

Head shapes viewed at different angles.

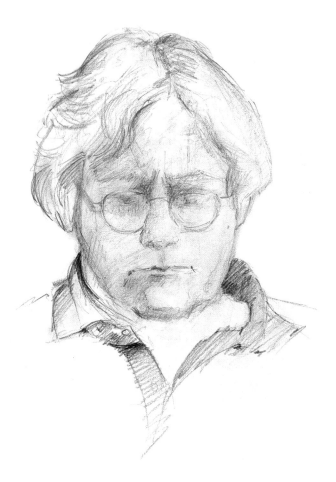

Study of head – Gavin.

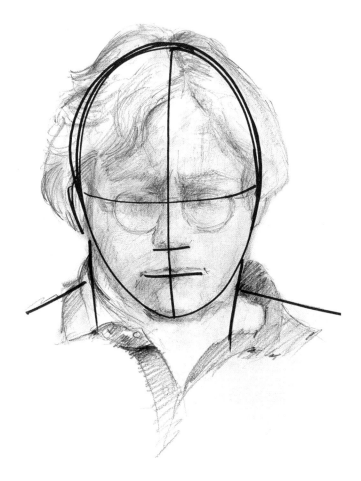

Head is a little below eye level.

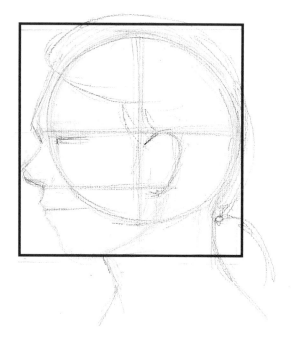

Head profile is as deep as it is long.

Perspective and Foreshortening

Perspective is a system of drawing that reproduces the three-dimensional space that you see in reality on to the flat plane that is your drawing paper. Objects as you see them appear bigger the nearer they are to you and smaller the further away they become. If your object is very near, such as a person with an arm and hand outstretched towards your face, the hand will seem large in relation to the arm, which will taper and appear to become smaller. The greatest proportional differences will be nearest to you, decreasing as the object recedes into the distance and towards the vanishing point. Since we know that a person does not suddenly grow a huge hand or instantly shrink, what we see is an optical illusion that when drawn in perspective is called foreshortening.

Your viewpoint is at eye level directly in front of you. This is your perspective. It is also your horizon line and remains constant regardless of your position or what your subject is. The only instance when a horizon line does not apply is if you are drawing an object by itself. Any object between you and your horizon will recede from you the viewer towards your horizon line.

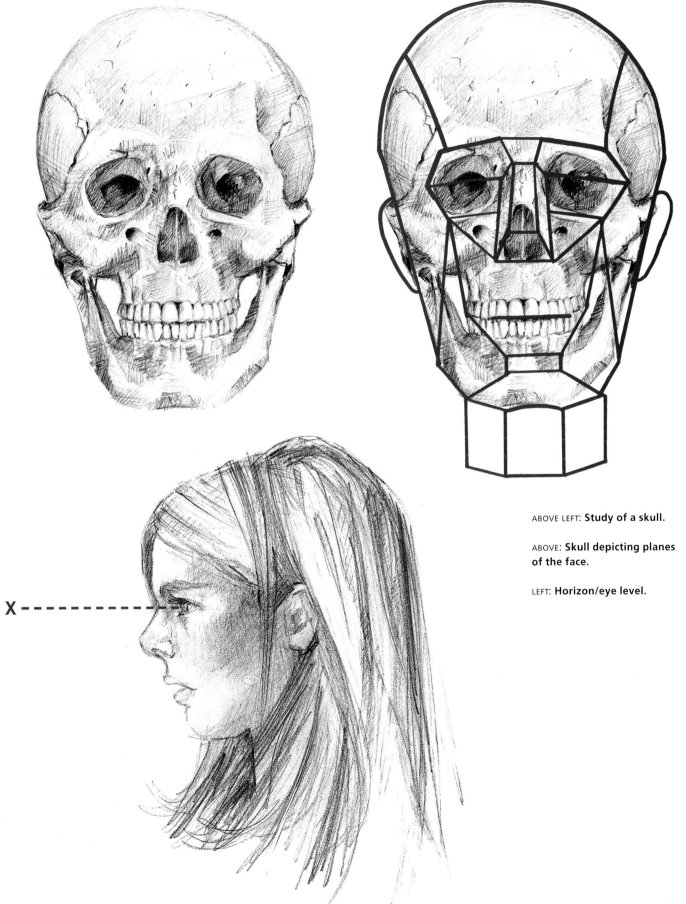

ABOVE LEFT: **Study of a skull.**

ABOVE: **Skull depicting planes of the face.**

LEFT: **Horizon/eye level.**

X

Parallel or One-Point Perspective

A one-point perspective has one vanishing point that coincides with the viewer's eye level or horizon line. When an object such as a cube is viewed straight on, whether it is above, below or on the horizon line, it will recede and converge at the vanishing point, that is at the horizon line.

BELOW: **One-point perspective.**

BELOW RIGHT: **Lines come up toward you when object is above eye level and down toward you below eye level.**

Angular or Two-Point Perspective

Two-point perspective has two vanishing points. If you move your viewpoint in relation to an object or person, you are no longer looking straight on but at an angle and you will therefore have another vanishing point. Although both of these vanishing points meet on the same horizon line, they do not converge.

Oblique or Three-Point Perspective

Three-point perspectives have three vanishing points. Two of them, like the two-point perspective, will vanish on the same horizon line. The third will vanish below it if you are in a high position looking down, or above if your viewpoint is looking up.

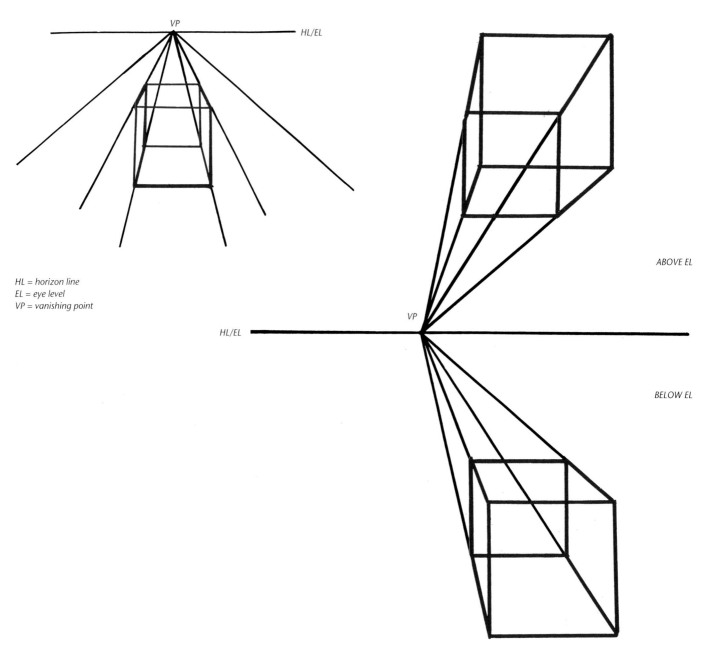

HL = horizon line
EL = eye level
VP = vanishing point

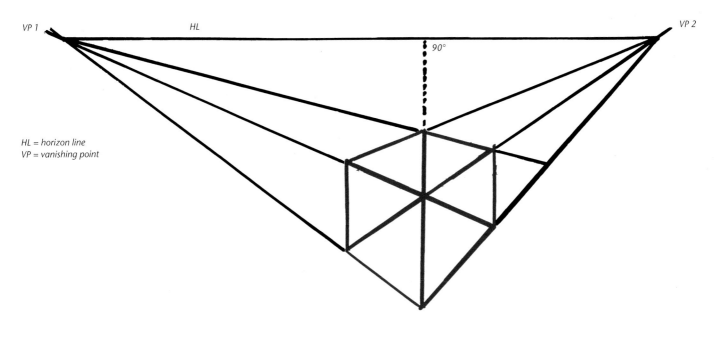

HL = horizon line
VP = vanishing point

Two-point perspective.

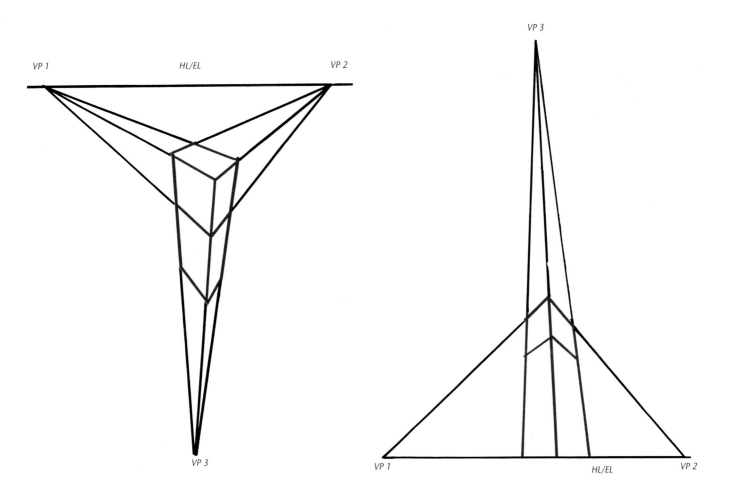

Three-point perspective/looking down.

Three-point perspective/looking up.

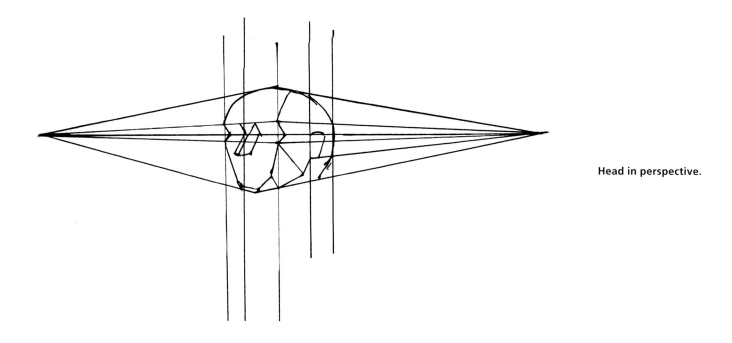

Head in perspective.

Drawing in Perspective

When you draw a three-quarter head portrait you are drawing in perspective. Note how the side of the face turned away from you is proportionately smaller, and the angle line of the eyes, nose and mouth.

Try the next exercises from the three different perspectives. Treat the body as an entirely new object that you have never seen before – really look and rely on what you see rather than on what you think the body should look like.

EXERCISE: **CROSS-CHECKING HORIZONTAL AND VERTICAL RELATIONSHIPS**

— OBJECTIVE: To draw in perspective

— MATERIALS: Pencil and eraser, or charcoal

— TIME: Not less than 40 minutes

POSE ONE
The model should be lying down with one knee bent and an arm stretched out at the side. Stand or sit at a distance of no less than 3ft (1m) from either the head or feet. You may find it useful to make a small cube sketch with a one-point perspective at the side of your drawing. Remember to keep your viewpoint constant, in other words do not move your perspective. Make a note of exactly where you are sitting or standing.

To decide which way round the paper should go and establish what size you can make the figure to allow you to get the entire pose on to the paper, measure the widest and tallest parts of the pose and use the shorter length as your unit of measurement.

Where the pose is symmetrical, in this case the nipples and shoulders, draw the horizontal line between them. Notice how they are parallel in perspective to you because your object is not angled away from you but converging either side towards the vanishing point.

Look at the horizontal line of the shoulders – where is the head in relation to it? Without tilting it, hold your pencil outstretched and horizontal to check. Is it half above and half below, totally above, totally below? Softly draw in other strategic horizontal lines such as the mid-thigh and note what it aligns with. You will probably make some interesting discoveries as you select other horizontals to check.

Remember to measure proportions – is the length from crotch to mid-thigh about half that from breast to shoulder? Is the length from nipple to shoulder the same as from crotch to nipple?

Check the vertical lines by holding the pencil outstretched towards the model. Do the body parts align? Draw vertical lines from the head to the toes or vice versa if your viewpoint is at the other end. Need to do some adjusting? You can lightly draw as many horizontal and vertical lines as you see fit, the important thing is to check, double-check and then check again!

POSE TWO
Place yourself alongside and at an angle to the model lying on the floor. Have the model pose symmetrically so you can easily draw the parallel lines between the elbows, wrists, thighs, ankles and so on. Find the angles as before, align the pencil and then

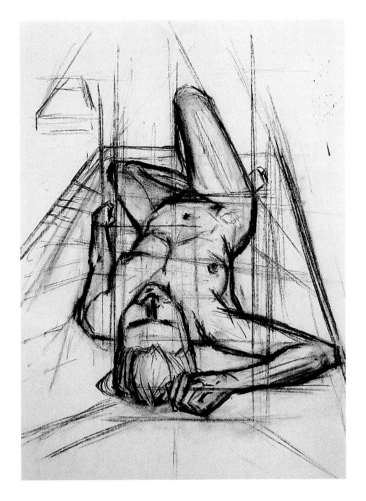

cross-check these with the verticals and horizontals. Once you gain more confidence try an asymmetrical pose.

POSE THREE
Have the model stand on a table and place yourself quite close, either on the floor or a low seat. Alternatively, the model can sit on the floor with you standing nearby. You will be surprised by what lines up with what!

Keeping It Simple

When you draw a clothed figure you might notice a fold highlighting a muscle or body part beneath but before going into such detail it is important to establish the basic shape and structure. The next two exercises will help you to establish methods that will suit your own way of working, which can often be a combination of several approaches.

LEFT: **Close viewpoint emphasizes foreshortening.**

BELOW: **Angular perspective.**

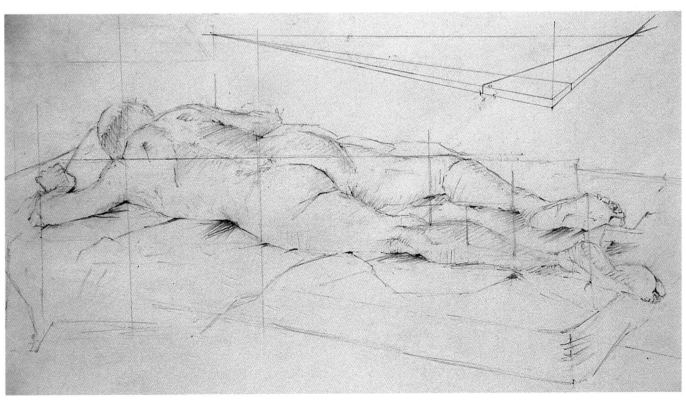

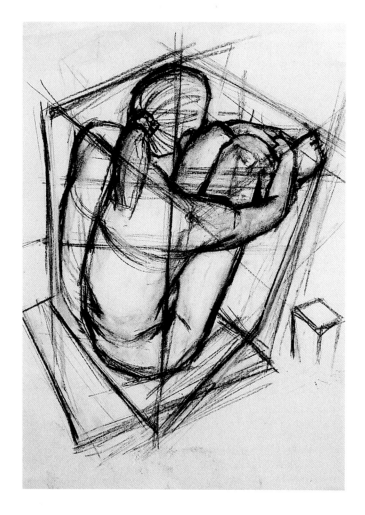

ABOVE: **Looking down.**

RIGHT: **Looking up.**

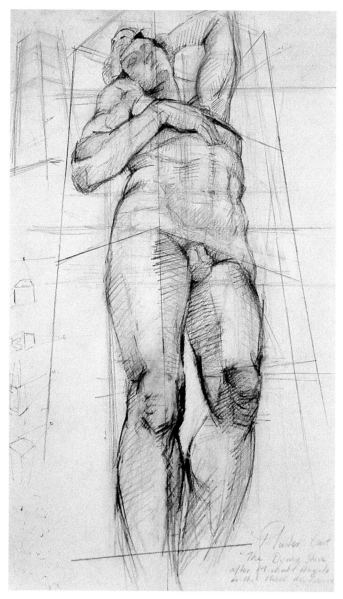

EXERCISE: **SHAPES AND STRATEGIC POINTS**

— OBJECTIVE: To place the figure on the paper

— MATERIALS: Charcoal or pencil

— POSE/SET-UP: Dynamic

— TIME: 5–10 minutes

You need to know what kind of space the figure will occupy on the paper. It is so disheartening if you have spent a long time drawing detail only to realize that the figure has been badly placed and you cannot fit everything in.

First, mark the extremities of the pose – the furthest points right or left whether vertical or horizontal. With your arm outstretched,

use your pencil to check measurements and angle alignment. For example, the head to extreme toe may be at an angle. So sketch in the angle and check the measurement in relation to another key extreme point to point. Use the charcoal flat on its side to make these linear marks.

Think of simple geometric shapes such as the square, rectangle, triangle or cylinder. What shape would best describe the torso dressed in a jumper? You would probably divide it into one shape for the upper half and another for the lower half. Could a skirt be simplified to a triangle? These shapes do not have to be perfect; it is simply to help you position the body in the right place.

Allow your pencil to free flow, to go over a shape again in order to qualify the form. Do not get into detail; always try to find an appropriate shape instead.

You can use line to deal with the arms and legs. Look for the direction of the limbs and mark the joints where the limbs bend to change the angle. Check the elbow and knee joints as pairs and then in relation to each other. Draw a line between the pairs and see whether they are on the same horizon level or angled away in perspective. Are they symmetrical or asymmetrical? You can draw the angle between them to help you. To verify that you have positioned the body correctly, use the horizontal and vertical alignment method.

EXERCISE: **A TUBULAR APPROACH**

— OBJECTIVE: To develop flow and rhythm by simplifying the form into rounded shapes

— MATERIALS: Pencil or charcoal

— POSE/SET-UP: Sitting, standing or lying down

— TIME: 5 minutes for each pose

Visualize the human form as a series of tubular and rounded shapes. This will help you to address the angles and movements of a pose with rhythm and flow. Keep your pencil moving on the paper, circling, qualifying the shapes that you see, allowing overlaps and building your way up to the committed pose. Use smaller rounded shapes for the joints, rather like those on the wooden human maquette made for artists.

Over this basic form you can then add more straight-edged geometrical shapes for the clothing. Allow the underdrawing to remain visible at this stage. You will often find that the clothing will contour the structure beneath.

Conclusion

So far we have been dealing with underlying structures of the body, the use of perspective and simple geometric shapes to form the basis for further drawing. In the next chapter we will be looking at the draped figure, whilst continuing to look for the body structure underneath, and at some of the drawing techniques that define form through line and tone.

ABOVE: **Note how the extremities of pose have been marked and placement on paper thereby established.**

RIGHT: **Rounded shapes make easy work of a pose.**

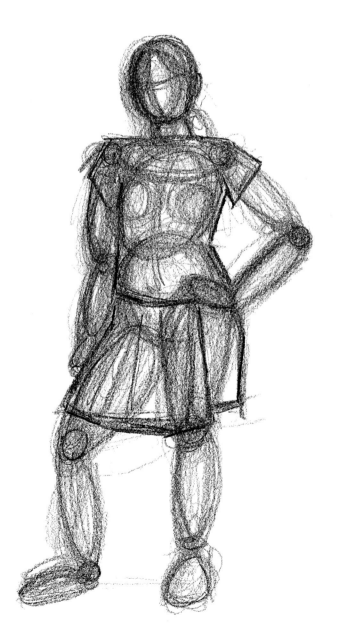

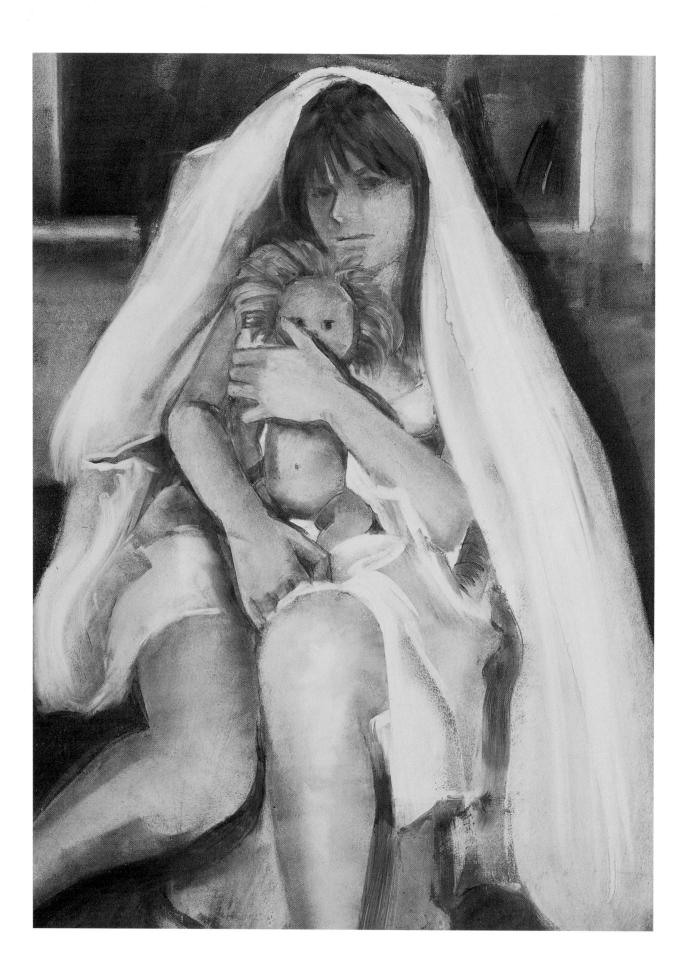

THE DRAPED FIGURE

We have already used line to measure and place structures on paper before proceeding to draw a figure. However, line is very versatile and in addition to describing the form or shape of an object or figure, it may also be used to describe volume, rhythm, movement, weight, tone, direction, texture, expression or mood.

Tone, sometimes referred to as a value or a shade, ranges from the lightest light or white through all the shades of grey to the darkest dark or black. Tone also refers to the lightness or darkness of a colour – a navy blue, for example, has a tonally dark value compared to a yellow. Tone therefore describes the lightness or darkness of an object along with the actual play of light as it falls upon the object and the resulting shadow cast. As tone describes these things, it reveals the shape and form of the object itself.

The first two exercises of this chapter approach line and tone independently of each other in order to help you differentiate between the two. We will then explore the various techniques and approaches in the context of drawing the draped figure and the search for the body structure beneath. But first we will look at the general characteristics of the fold.

Materials

To complete the exercises in this chapter you will need the following equipment:

- Pencils, charcoal
- Erasers – one hard eraser and a soft putty eraser
- Black and white chalk, soft pastels or conté crayons (optional)
- Lamp black gouache (a little warmer than the ink) or watercolour paint.

- Watercolour brushes
- Quill or bamboo pen – these make bold fluid lines. You can make your own bamboo pen by getting a reed and sharpening one end of it to a point with a Stanley knife or craft knife.
- Dip pen – this comes with different nibs for a variety of applications.
- Ink – avoid waterproof inks as they do not flow so well and become clogged in the nib. Use Indian ink, which is fairly permanent anyway when dry.
- Paper – there is a wide variety of paper available in different weights, colours and textures. These elements can exert a significant influence on the drawing. Standard drawing paper or cartridge paper are suitable for most drawing. However, a slightly toothed (textured) paper produces a very attractive, textured quality of line. Canson or Ingres paper is best for pastels as it catches particles of pigment. Watercolour paper comes in three finishes: hot-pressed, which is smooth; cold-pressed, which has more of a texture; and rough, which is highly textured. The heavier the paper, the less likelihood of buckling when using washes. The smoother the paper, the easier it will be to draw on with pen and ink.
- Fixative – this comes in an aerosol that you can buy at any art shop. Use it to prevent smudging in drawings done in charcoal, pastel, chalk or soft pencil. Make sure you spray in a well-ventilated room or take the drawing outside.
- Candlestick (white) for wax resist.
- Gum strip to stretch the paper.
- Torchon (a stump made of tightly rolled paper that can be used for blending or shading in charcoal, pastel or graphite drawings).
- Several drapes

OPPOSITE PAGE:
CONTRARY MARY.

Structure of a fold.

Analysing Folds

The draped figure is rather enchanting to look at – the cloth moulds itself over the human form and produces a rhythm and movement of line through its shaping folds. By definition, drapery is not fitted to the body in the same way as clothing. This semi-concealment can often appear far more alluring and sensual than the completely naked form. From a casually placed drape to a meticulous arrangement, the image of the adorned figure is always one of beauty and grace.

Drapery or cloth has no innate structure but whether hanging from a fixture or crumpled upon the floor in a heap, a basic form to the fold can be seen. Of course, no two folds will be exactly the same, but the way the drape may pleat or fold at certain fix-tures or anchoring points on the body, or the manner in which it falls from different suspension points can be studied and noted. Drapery behaves according to the laws of gravity and will trav-el downwards in a vertical journey towards the ground. This is true whether the figure is seated or lying down, the only difference being that the nature of the posture will determine how often its path may be interrupted by projecting body parts such as the knees, breasts and buttocks.

The manner in which the drape attaches to the body will affect the form of the fold. It may be tied at the waist with a cord, knotted or simply draped from the neck and shoulders. It may even be gathered up in the hand or pulled taut. Whatever the arrangement, the drape will always continue downwards until it reaches the floor. At this point it will ruck and buckle in on itself to finally rest.

The form or character of the fold will depend on the type of fabric the drape is made of. Thin material will often produce masses of fluid and fine folds whilst there will be fewer, more angular folds where a thicker fabric is used.

The structure of the fold itself is usually composed of three ele-ments: an ascending plane; a top-edged plane that can be either flat or curved; and a descending plane. This basic structure will vary from folds that overlap each other to gentle, undulating folds depending upon how the cloth is being draped, held, gathered or attached to the body.

George B Bridgman first categorized different types of fold in 1942, and the seven characteristic folds are shown here.

The Diaper Fold

The diaper fold occurs when excess material sags between two points of suspension such as a pair of open knees. The more material gathered at these points, the more radiating folds there will be. If the suspension points from which the fabric falls are on the same level, the festoon-like fold will appear centrally; if the suspension points are at different levels, asymmetrical dips will occur nearer to the lower point.

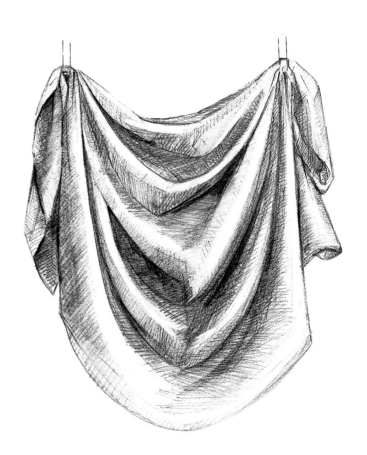

The diaper fold.

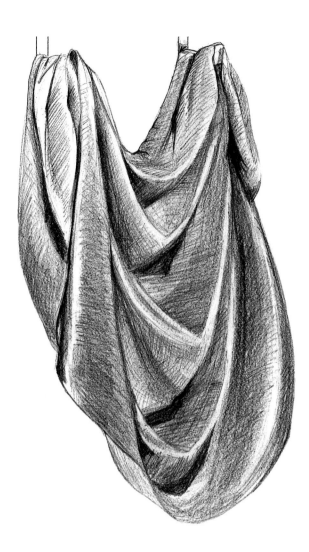

**Planes of a diaper fold seen from
an angle, with planes going in and out.**

The Drop Fold

This is where the material falls freely from one support or suspension point creating a series of conical shapes. The most obvious single drop fold can often be seen where the drape hangs from a bent knee. The edge or hem, if above ground level, will also imitate the ellipse of the cone-like shape.

The Pipe Fold

Here, the material forms one or more tube-like shapes resulting from folds systematically created by pleats, or through bunching the material at one end and then allowing it to drop. Pipe folds are also made when one end of the drape is fixed and the other end is pulled or stretched taut.

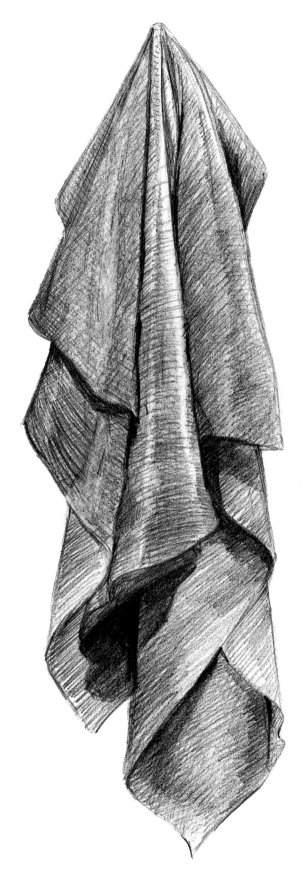

The drop fold.

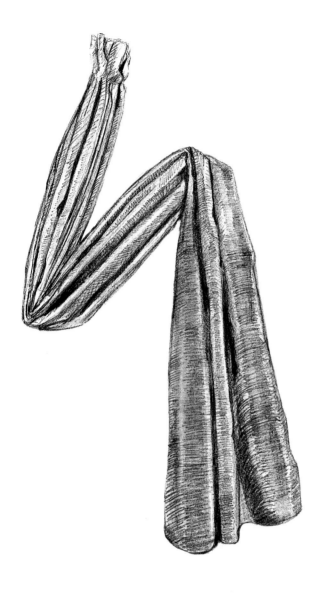

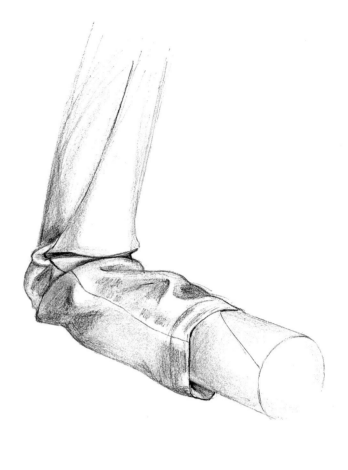

LEFT: **The pipe fold.**

ABOVE: **The lock fold.**

BELOW LEFT: **The spiral fold.**

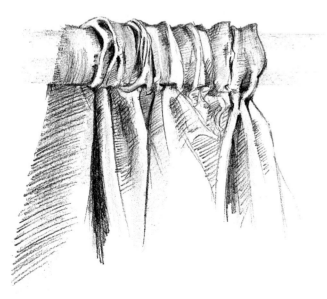

The Lock Fold

Where the material is attached to a cylindrically formed part of the body such as the leg or arm, or to a flatter but larger cylindrical area such as the abdomen, the material is forced to make an abrupt change in direction in the same way as it would at the sharp angle made by a bent elbow or knee. This results in the material forming a flap either side of the fold where the opposing cylinders meet.

The Spiral Fold

This fold occurs where the material is bunched around cylindrical shapes such as the arms or legs. Often, the spirals do not crease all the way around and if the arm is bent the creases are more likely

to stretch diagonally from shoulder to elbow whilst continuing in a more circular fashion from elbow to wrist. The main distinction between the creases of the upper arm and the forearm is that they twist in different directions when the arm is bent.

The Zigzag Fold

The zigzag fold is found in stiffer materials where a tubular shape has been bent and the material is twisted in different directions.

The Inert Fold

When the cloth is not draped upon anything, the arbitrary arrangements of folds made when it is dropped or placed upon a flat surface are known as inert folds.

Drawing Techniques and Approaches – Introducing Elements of Colour

For the following exercises try different arrangements of drapery in a variety of positions from standing and sitting to the reclining pose. Use fabrics of different weights – a cotton sheet, muslin or something finer like chiffon. Have extra drapes around to compose with or attach several to the figure. These can be knotted, belted,

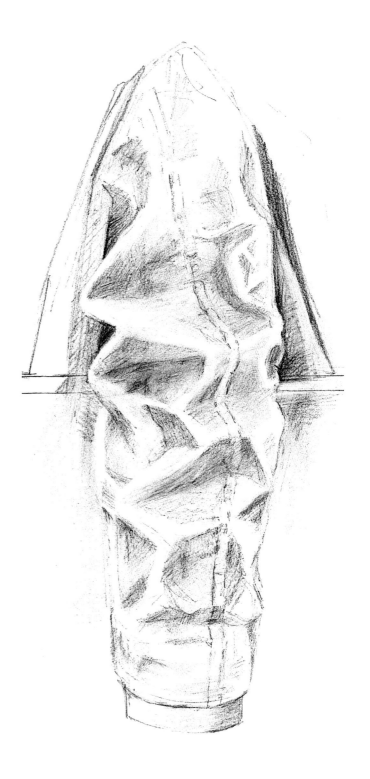

The zigzag fold.

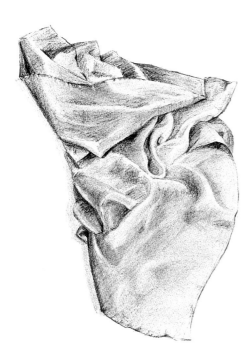

Fluid fabric of the inert fold.

tied or maybe pinned. You will notice that heavy materials will tend to sag; stiffer materials will produce rather angular folds whilst those in soft fabrics will be more fluid and flowing.

EXERCISE: **USING LINE TO OUTLINE AND FIND FORM**

— OBJECTIVE: To describe shape and form with line and develop an awareness of rhythm and movement

— MATERIALS: Pencil or pen, several drapes (a 100 per cent butter muslin drape, approximately 23ft (7m) long, was used here. Wound and tucked, it creates a Greek look very well)

— POSE/SET-UP: A classic stance draped in the sheet, perhaps standing with a slight twist to the body and one foot on a low chair, footstool or step

— TIME: 30 minutes (the model will tire, so try to complete the drawing within this time so as to keep the drapery the same)

The idea of this exercise is to describe the outline or outside shape of the figure as well as the form of the internal body structure without referring to or building up tonal values of light and dark. Use line only to follow the drapery folds and body muscle. Once you have some basic elements placed, try to keep your pencil moving fluidly. Where you do not want to draw, just lift the pencil but continue the flowing action of the hand.

Start with easy circling but try not to press too hard so that you can cover mistakes or make adjustments by overdrawing rather

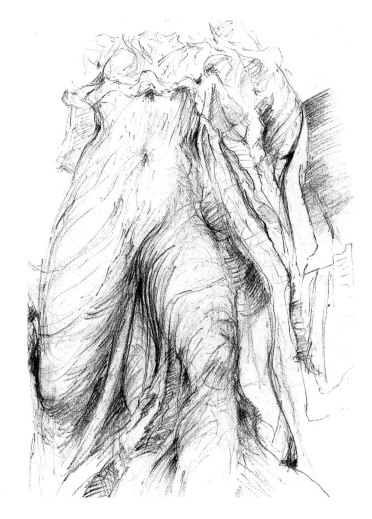

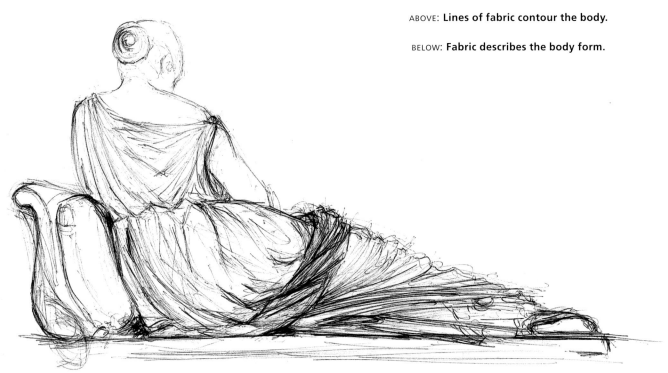

ABOVE: **Lines of fabric contour the body.**

BELOW: **Fabric describes the body form.**

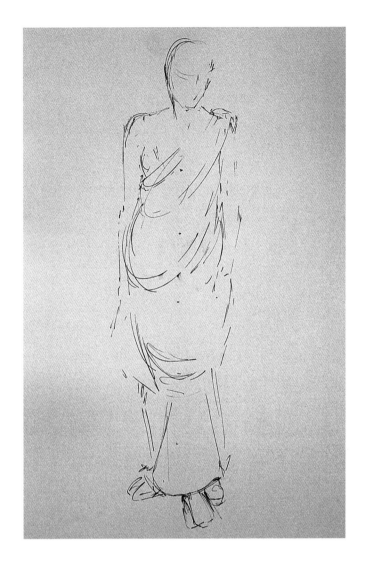

Initial marks.

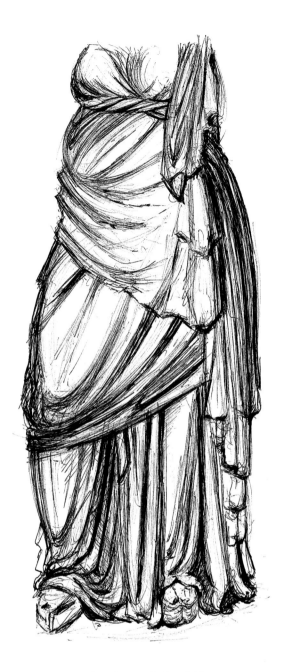

An abundance of pipe folds.

they are and use the vertical line method to see where the head aligns in relation to the floor and what parts of the body are either side of the line. Look for the round forms of the breasts, bottom or hips to help you with position in order to avoid ending up with a figure about to topple over. Whilst you will not want to draw them, still check the angles made between pairs of landmarks; really look to see if they are on the same level or whether one is lower or higher than the other. Remember you can cross-check by holding your pencil horizontally to see what other parts of the body align on the same level, just as we did in Chapter One.

As you gain more experience in drawing, you will be able to draw the figure without having to make any preparatory measurements. However, at this stage, don't worry if your measurements turn out to be less than perfect. Everyone has to start somewhere to be able to have something to work with!

than using an eraser. Next, stop and check – are the simple shapes going in the right direction and are their proportions going to be correct in relation to the whole? Rather than drawing in straight lines, which may grate against the curving lines of fabric, measure and mark little dashes or dots to determine where landmark parts of the body are before you commit to drawing those sweeping lines that you see in the fabric.

Note the shoulders, knees, elbows and, if you can see them, mark the feet. If the feet are hidden, then mark where you think

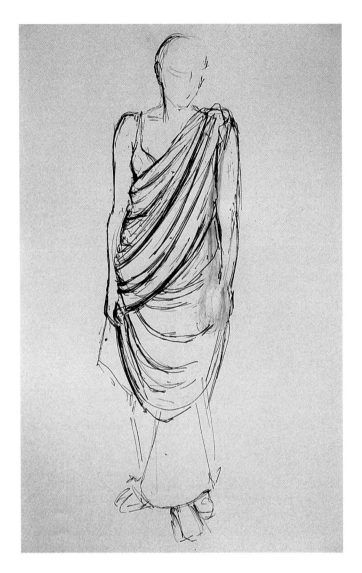

You can use white gouache to
correct a really hindering mistake.

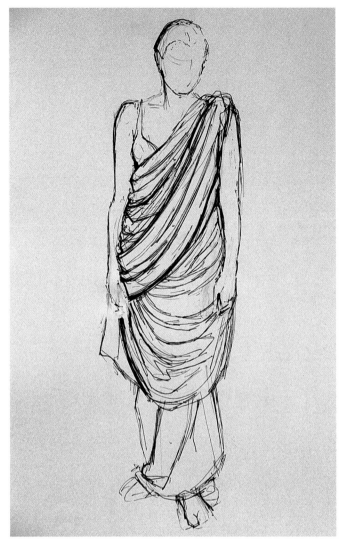

Lines are strengthened.

The individual nature of the cloth will influence the way you approach this exercise, but these general guidelines should help you. Use the cloth to seek the structure, pretending that your pencil or pen is a mountain hiker following only the paths depicted by the folds or pleats. Journey across the body always following these paths, curving up and flowing over ridges. You can meander off to explore where the cloth pleats or folds in another direction and if it comes to a dead end, stop and search for another path.

Maintain a lightness of touch until you are sure of the direction of the fold and notice how one fold can appear thicker or darker than the next. Sometimes this is because there is an area of bunched-up material; maybe the folds overlap or the valley of the fold is deep.

Be sensitive in the lines you draw, they do not all have to be of the same quality and can vary from wispy, unsure, searching and delicate to strong, determined and definite. This varied use of line mark can describe thin or thick folds of material, as a heavy dark line can read as bulk or volume and weight because the shadow cast is deep.

Strengthen sweeping lines following the rhythm and movement of the posture. Notice whether there are pleats or folds travelling in a similar direction and find the longest one as this will express the posture in one fluid, continuous line. Perhaps you can see a crease that starts at the shoulder or breast and continues on an unbroken path to sweep right down to the floor. Look for any areas of tight little folds or creases that may signify a twist

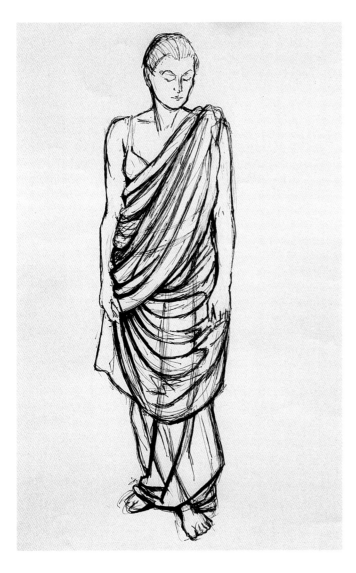

The folds are given similar strengths
compared to the earlier examples.

and change of the body's direction. All these fold lines are clues as they follow the contours of the form beneath and in doing so reveal the body structure.

With the naked body, allow the outlines to overlap by following the delineation of a muscle, such as where the edge of an arm overlaps back into the inside form. Be sure that the face has the same linear quality as the rest of the body and drapery otherwise the finished drawing will not hang together. You can follow hair direction in the same way as you did with the pleats of cloth but there is no need to try to draw every single strand you see! A few directional stands will be enough to suggest the form of the mass and will look much more convincing in describing the volume.

Only use an eraser if there is a really disruptive and very dark line that has been drawn in the wrong place and is actually hindering your ability to re-establish the form correctly. If this has happened and you have been using a pen then try painting it out with a little white gouache but note that this does make the surface more difficult to draw on.

EXERCISE: **TONES TO FIND FORM**

— OBJECTIVE: To draw the form by means of tone alone

— MATERIALS: Charcoal, putty eraser, cartridge paper, a torchon for more precise blending and fixative spray

— POSE/SET-UP: Seated comfortably and draped from the head. Strong sidelighting

— TIME: 1 hour

There is nothing wrong in using a combination of line and tone and indeed most artists do in one way or another. However, for the purpose of this exercise, avoid working with your charcoal in the linear fashion except for initial structural placement and measurement.

Use your eraser rather like a pencil to suggest the form and to help differentiate light and dark shades. Apply the flat side of the charcoal to cover an entire sheet of cartridge paper. With your fingers, rub it all into the paper but do not cover it too heavily or else you will have a lot of rubbing back to do. You can always build more layers of charcoal later.

Once you have the charcoal covering, draw the basic structure with a minimal use of line to help you start off. Next, using your fingers to smudge (you will find the charcoal comes off easily) and an eraser, rub back to depict the lighter areas of the figure. Think of how you can often discern images in the clouds, so find your figure in the grey charcoal dust. You can use a hard eraser to begin with and you can also rub back with your fingers to establish the vague shapes of the lighter sides of the body and drapery down to the floor.

Add more charcoal to the darker areas that you observe but avoid going too dark for the moment. By squinting you will be able to see tonal differences much more clearly and this will help you to simplify the tones into dark, mid and light. Draw with the charcoal held more on its side, which will help you to block in bigger areas and cut out detail. If you hold the charcoal like a pencil then you will be drawing in line again. If this happens, you can easily rub back and the line is gone in a flash. For example, instead of drawing a dark line because that is what you see, try arriving at that line through the process of rubbing back either side of a patch of charcoal until the lighter areas almost meet in the middle.

Look to see if you can find certain shapes of form in the drapery. Observe the space between the pleats or creases of material. What

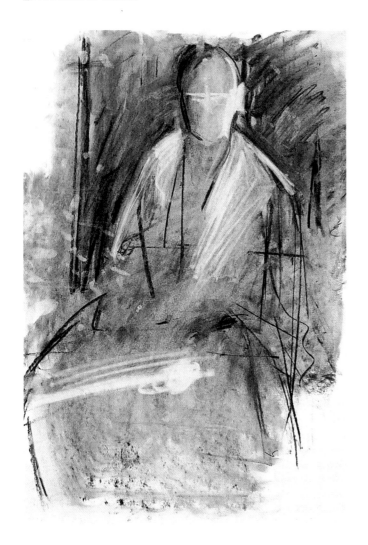

Linear work will rub back easily
once you have basic form.

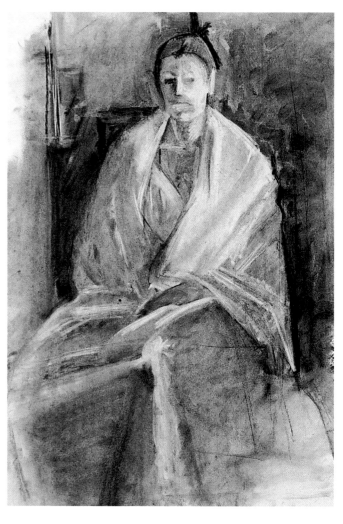

Dark, mid and light areas of tone are
established. NOTE: **drawing with the eraser.**

is the volume like in contrast? Can you discern any cone-like shapes or perhaps pipe and tube shapes of various sizes? When you have found a shape, look to see which side is darker. Leave the darker side with the charcoal and then find the lightest part, which will depend on the fall of light. Is it in the middle or on the other side of the shape? Grade the tones between dark, mid and light by smudging and smoothing with your fingers. This makes the shape appear rounded or three-dimensional and will add to the illusion of depth. Pay attention to the outside bottom edges or hems of the drapery and make sure these ellipses, whether convex or converse, echo the roundness of the shape that you have seen in the cloth.

This approach to tonal drawing also makes you address the issue of the space surrounding the figure because you will have to observe how dark or light the space, window or backdrop is

compared to the edge of the cloth or skin. You should reassess the tonal relationships between the blocks of background tone and the figure then decide whether you need to rub back or apply more charcoal. Not all the background will be of the same value, so keep it simple by dividing the space into easy geometric shapes. Perhaps the tonal contrast is simply between the floor and the wall but in both there will be subtle grades of tone, the direction and intensity of which will depend on the fall of light in the room.

Once you have established your basic values, find the area that you think has the darkest tone, perhaps a corner of the room that is cast in shadow or maybe an indent in the crease of the draped material, so long as it is somewhere that you can rightly make your charcoal as black as possible. Look at this tone and compare it to the cleanest and lightest tone that you have made by rubbing back to the white of the paper. Now be conscious of all the possible

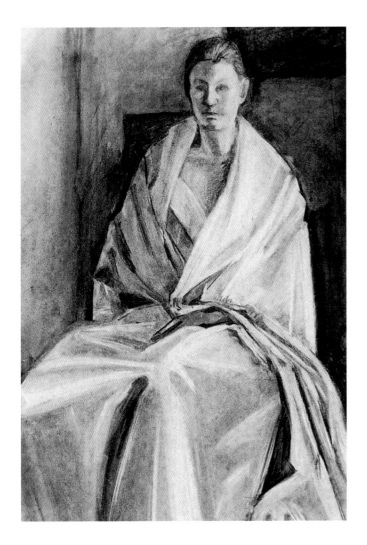

Subtle tones are worked up to the final result. Crisp ironed cotton bed sheet fabric produces more angular folds.

White is used for the light tone and some of the initial drawing.

tones or greys you can see when looking at your subject and the basic three tones that you can now expand in your drawing.

This is a very tactile exercise, so have fun getting stuck in with your fingers to blend back or soften up hard edges. You can use the eraser to rub back in larger areas, or on its side to rub and smooth back more subtly. You can also make linear or impressionistic fleck-like marks to depict light, so do experiment with the eraser's versatility. Surprisingly, you can be quite precise with a putty eraser, moulding it to a point in order to depict the light falling across the bridge of a nose or cheekbone or to describe the wispy lights of the hair. Spray your drawing with fixative when you are finished.

EXERCISE: **THREE-TONE DRAWING**

— OBJECTIVE: To explore and determine tonal variations using dark, mid- and light tones

— MATERIALS: Charcoal, white and black chalk or soft pastels or conté crayons, Ingres or Canson mid-grey toned paper, eraser, fixative

— POSE/SET-UP: Seated and draped. Use sidelighting

— TIME: 1 hour

For the lightest tone use white chalk or pastel, the toned grey paper will represent the mid-tone and the darkest tone will be the black chalk or pastel. As mentioned before, tone not only refers to shades of grey but also to how light or dark a colour is. So if you want to work with a different colour of paper then make sure it is the same colour as the dark pastel but of a much lighter shade. For example, if you decide on a light buff paper for your mid-tone then select a darker sanguine colour for your dark tone. The white remains the same.

On the corner of your paper, test what tonal range you can expect to achieve. Clearly, the lightest tone will be the area where you have applied the white very densely. However, drawing lightly or using less pressure allows the tone of the paper to show through, thus creating a slightly darker tone or half-tone in relation to the white. This also works the other way – if you apply the black with full pressure and then lessen it gradually, you will be left with the mid-tone of the paper.

Start by drawing in the lighter parts of the draped figure and general set-up of the pose. Look for any cone, pipe or triangle forms in the drapery to help you. Where the cloth drapes on a flat surface the material will also become flatter. Its folds can start to be seen in terms of line direction and their placement seen in perspective, receding into the horizon. Draw the darker, shadowed areas in black, again refraining from using much pressure. Once you have the basic forms of the figure and drapery you can start to emphasize where you see the darkest and lightest tones.

TOP LEFT: **Some darker values are laid softly.**

TOP RIGHT: **Note the dark to light values that are being used for reference at top right hand corner.**

ABOVE: **Head is finalized.**

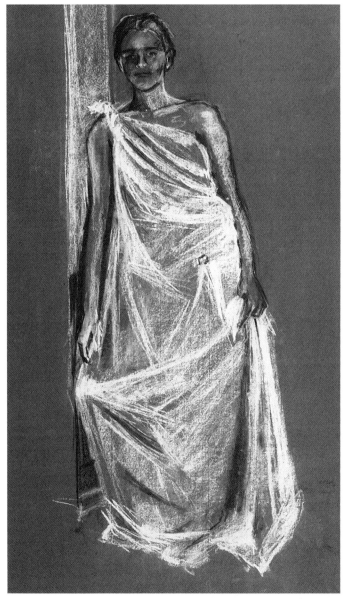

RIGHT: **Using brown paper and a darker brown pastel (minimally used) with softly applied white for mid light tones and densely applied white for highlights.**

**A dark rose pink and a lemon yellow
work effectively on a tan paper.**

You can try using the chalk on its side rather than simply holding it like a pencil. This will enable you to fill in broader areas of tone and find the form through values of light and dark rather than just through line. See how you can produce a three-dimensional form quite effectively. With minimal use of dark charcoal and white chalk, the image will read very well even though it may be largely made up of the mid-tone of the paper. If you overdo the drawing, lightly smudge back or use your eraser.

To bring in simple but exciting elements of colour, experiment with a variety of combinations on different coloured papers but keep to the light, mid- and dark tone principle.

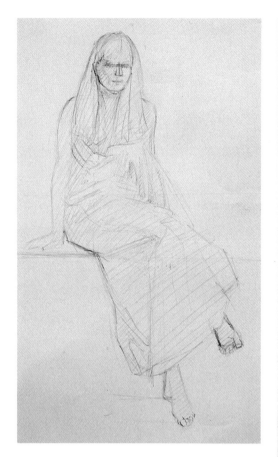

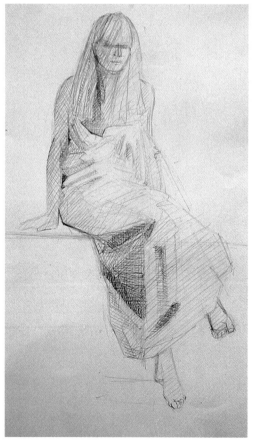

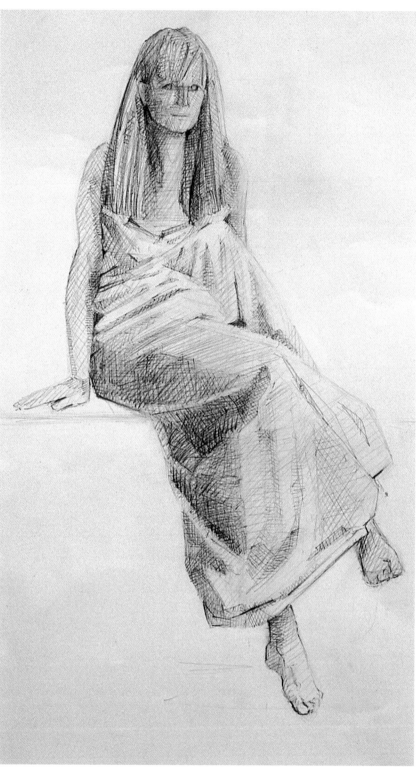

TOP LEFT: **Outline and areas to be toned are established.**

BOTTOM LEFT: **Values are made darker by crosshatching.**

ABOVE: **The finished result.**

EXERCISE: **BUILDING TONE WITH LINE**

— OBJECTIVE: To create tone through
 the use of hatching and crosshatching

— MATERIALS: 2B pencil

— POSE/SET-UP: Lying down. Use sidelighting

— TIME: 1 hour

Whilst you can quickly scribble a few lines with a pencil or use the side of it for broader lines, smudging and blending with the fingers and eraser to produce a variety of tones, you can also create tone by using line alone. This more methodical and traditional approach will increase your awareness of directional light and help you to analyse more precisely where it falls upon the figure. Amongst other things, building tone through line can be helpful when using a drawing tool such as a pen that does not smudge.

Hatching means creating tone or shade by drawing a series of parallel lines. Crosshatching is drawing more parallel lines that cross over those underneath. The more you crosshatch, the darker the tone will become. Hatching is usually drawn on the diagonal; crosshatching can be done in any direction you choose. You can crosshatch in straight or curved lines in order to sympathetically follow the direction of the form whilst maintaining the parallels.

Hatching and crosshatching tones will vary according to the grade of the pencil or combination of pencils you use and how much pressure you apply as you draw – the more pressure, the darker and thicker the line. Also, the tone will appear to darken the closer together the hatching lines are drawn.

With experience, you will find your own way of working that will reflect the drawing medium used and your individual style. However, you should begin by trying to keep the parallel lines straight and use just one drawing pencil in order to simplify the exercise.

To the side of your drawing sketch five small square boxes. Keep the first one blank and then hatch all the others on the diagonal. Leave the second box with just the parallel diagonal hatch, crosshatch the third and fourth boxes in different directions, and box five should end up crosshatched on both the diagonals, vertical and horizontal. You can now use these squares as a guide to compare with the tones you see on the draped figure.

Draw a soft pale outline of the figure. Squint both eyes to see the light and dark areas in a simplified format, doing away with any distracting details. Lightly trace areas that are to remain white and then sweep across the rest of the figure with diagonal and parallel lines. Now you have identified the area of lightest tone and this is to remain untouched.

Build the darker shades by crosshatching. Each time you crosshatch the lines should be getting shorter because as you work towards the darkest tone the lighter tone before it will have been crosshatched less. Keep squinting to distinguish the tonal areas

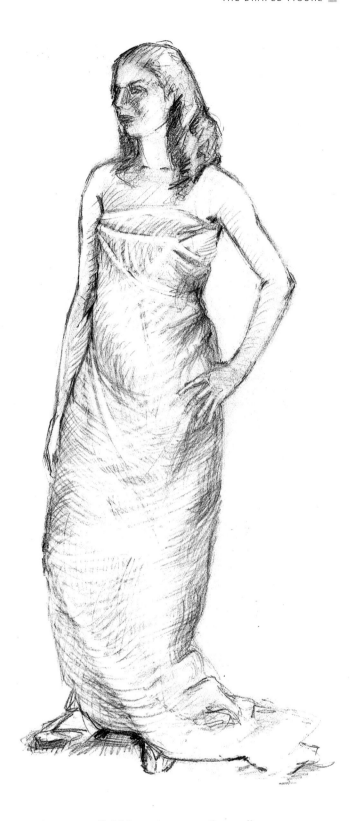

**Hatching using a pencil as well
as an eraser to soften hard
edges and lighten smudges.**

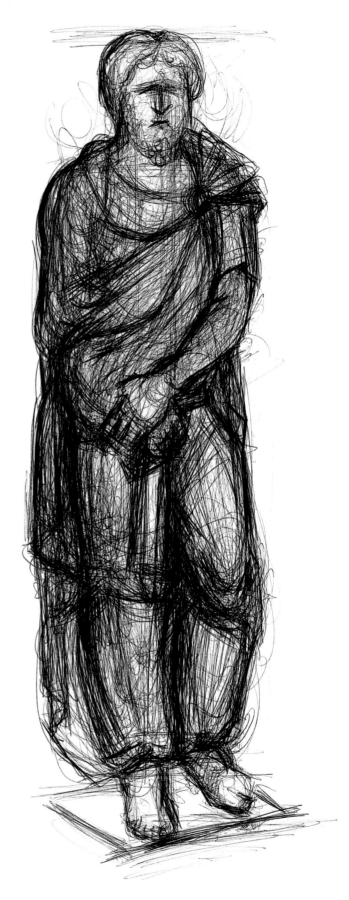

ABOVE: **Scribble hatching.**

RIGHT: **Scribble hatching until the scribbles describe the form rather than values.**

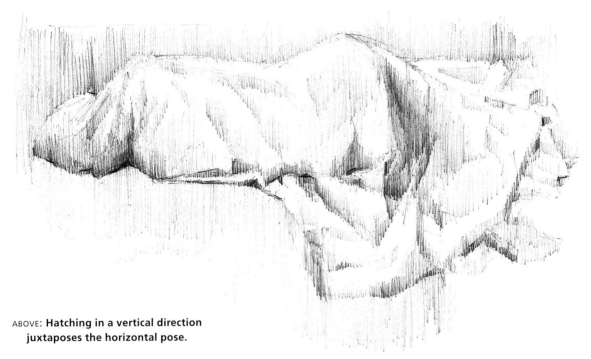

ABOVE: **Hatching in a vertical direction juxtaposes the horizontal pose.**

RIGHT: **A mixture of tone and line on grey paper describe the flowing folds of this standing figure.**

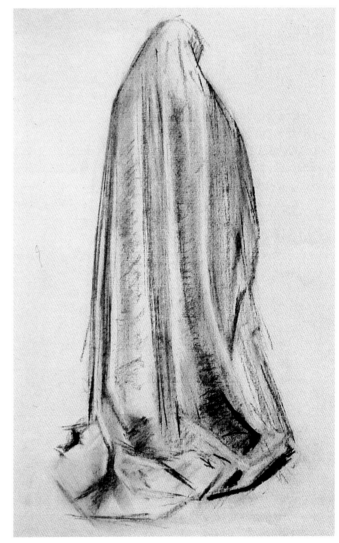

when necessary. A darker drape will require an overall tone value but just treat it in the same manner and build to darker shades. However, if you squint in this case, the tone just becomes one dark area so you need your eyes open to see any differences of value here!

You can find the form through tonal line alone without having to outline the folds of cloth, rather arriving at this borderline or crease in the cloth through the meeting of distinct tonal values.

Try building tonal line by scribbling, curling hatches, and hatching in one direction.

EXERCISE: **LINE AND TONE WASH USING PEN AND INK**

— OBJECTIVE: To bring tonal layers of wash and linear drawing together

— MATERIALS: Dip pen (or bamboo or quill pen), Indian ink, lamp black gouache, hot-pressed watercolour paper, watercolour brushes

— POSE/SET-UP: Use two or three different tones of fabric to drape the figure

— TIME: 1 hour

Mix gradations of tones with water and the lamp black gouache in a dip palette. You only need a tiny amount of black. Make an

Watered-down lamp black is used to draw with a paintbrush.

extremely pale wash to paint in some of the outlines of your figure. Be sure to keep it simple – the idea of this exercise is for detail to be arrived at through the accumulation of tonal layers of wash and linear drawing.

Keep the paint mixture that you use for the wash pale so that any mistakes or repositioning of your outlines will not distract from the end result but rather become part of the drawing process. If you do make a real blunder or use too much black, mop it up with cotton wool or kitchen towel. Then, using either a clean brush or cotton wool, put a little more water on the paper to dilute the area you want to get rid of. Mop up using more cotton wool or kitchen towel. In this way you can knock a stain right back and even make it virtually disappear.

Because gouache is water based you can correct or remove a tonal area even when the wash has dried. Use the same method as described above, but overdo the clean up and you will start lifting away some of the pulp of the paper too!

Try to avoid having to do this, because you will want to retain clean white areas of the paper that will read as the lightest of tones. Always apply the wash sparingly. You can mix a really dark tone and paint it on but generally it is better to build up to the darker tone through layers of pale washes, allowing each layer to dry before adding the next. This method enables you to see watermark stains and transparent layering effects that are aesthetically quite seductive.

Because you will be using fairly watery materials throughout this exercise, work with the drawing board placed in a more horizontal position or even flat on a table in order to prevent drips from running down. It will also be easier for the ink to flow from your pen. Do lean over your work so that you have a proper viewpoint or perspective otherwise you will end up with distorted proportions in your figure drawing.

When the first pale painted outline drawing is dry, start drawing in with your pen and Indian ink. However, before you do so, practise on a piece of scrap paper to see how your pen flows against the texture of the paper and play around with the different qualities of line you are able to produce. Observe the direction of falling hair, the pull of folds at the knee, the position of a hand. If you notice that the under wash drawing is not quite right, there is no need to worry as the ink drawing will be far stronger and bolder. Do keep looking at your subject; avoid simply drawing over the painted marks you have made. Remember you can make little dots and thin marks to delineate areas such as the corner of an elbow. Then just take the plunge and go for it! Be daring and bold. Look for pleats or creases in the drape that have dark lines, crisper lines, thick lines or more thread-like lines. Really study your subject matter.

There is no need to do all of the ink drawing at once. Alternate, if you prefer, between washes and line. Remember to allow time for the ink lines to dry. It is easy to forget and you will find that it is very dense and powerful and difficult to lift off.

You will need to practise this technique but your efforts will be worthwhile as it is possible to produce some lovely effects.

Pen and ink build-up
the image.

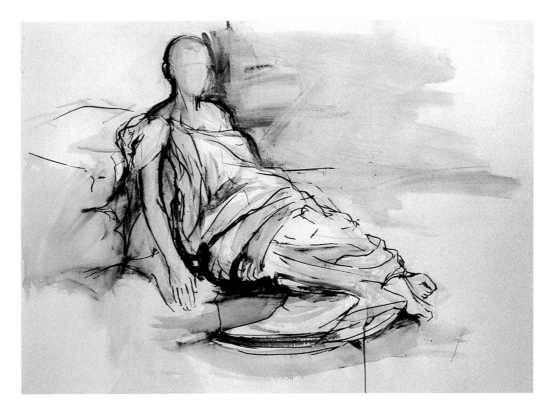

BELOW: **Some washes were
laid over dry layers whilst
others were a little wet to
create a more 'painterly'
effect. Satin lining for
fabric produces softly
arranged folds.**

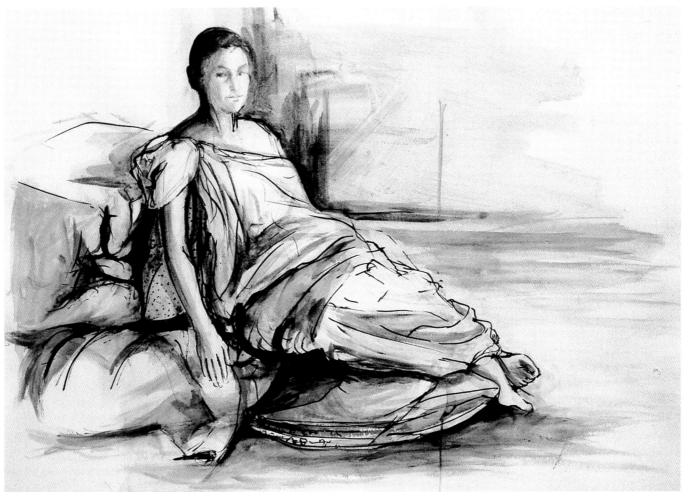

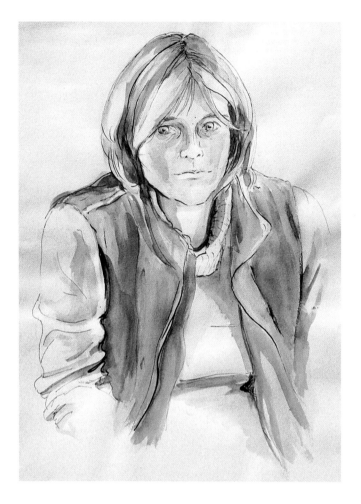

Each layer of ink or wash was completely
dry before the next application of ink or wash.
This produces a more illustrative feel.

HOW TO STRETCH PAPER

You will need a drawing board, paper, gum strip,
scissors, a sponge and water.

Sponge down the paper until quite damp. If dripping
with water, mop up with a sponge.

Place the paper on the board with the textured side
up if using cold-pressed or rough watercolour paper.

Cut four pieces of gum strip that are at least a couple
of inches longer than the sides of the paper.

Dampen a piece of gum strip on the sticky side with
the sponge and stick the paper to the board (try to
place half of the tape on the board and half on the
paper). Dampen and stick the remaining pieces of
gum strip around the board. Don't worry if the paper
is cockled because as it dries it will shrink and become
flat.

Smooth over with your fingers, making sure all the
gum strip is flat and firm. If the paper is quite thick
you should make sure the gum strip does not move
by using a staple gun.

EXERCISE: **AFTER HENRY MOORE – SEEKING THE FORM WITH MIXED MEDIA**

— OBJECTIVE: To find the form with contour, line, tone and
wax resist

— MATERIALS: Indian ink, wax, black gouache, willow char-
coal, smooth watercolour paper and brushes, gum strip if
stretching paper beforehand, and any choice of ink pen

— POSE/SET-UP: Seated comfortably and draped

— TIME: Not less than 1 hour

This exercise, which has its roots in contour drawing, will really
heighten your sense of the three-dimensional as you travel like
a sculptor around the figure.

The materials used produce a pleasing effect but you will need
to practise using them. Begin with a very dilute black gouache,

and with the tip of a small round brush establish your figure. If you
make a mistake, lift off with some kitchen towel. This drawing does
not have to be perfect or detailed – just enough to give you some-
thing to work with and one that you can correct to a certain
extent. Take your ink-dipped pen and work in a horizontal linear
fashion to contour the hills and valleys of the cloth, keeping it light
and minimal. You are not so much following the creases of the
cloth but the direction of its undulations, for example where the
cloth sweeps from knee to knee or closely follows the form of the
arm, which is hidden underneath. Reflect the undulation of the
material whilst maintaining the horizontal linear description of
form. Keep these contouring lines fairly light so that you can apply
the wax to some areas without worrying about too much heavy
underdrawing. Remember to wait until any wash or ink has dried.

The wax resist will repel the toned washes to represent high-
lighted undulations, which also represent different planes of the
body. Wax the area firmly with the candle and also try a bit of

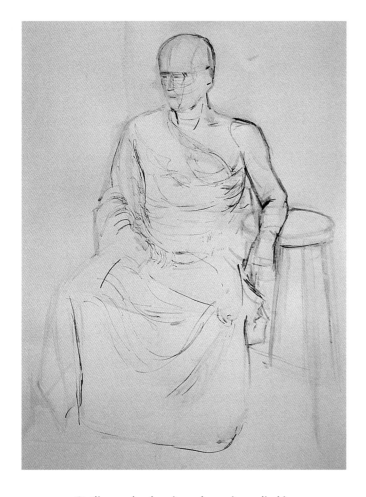

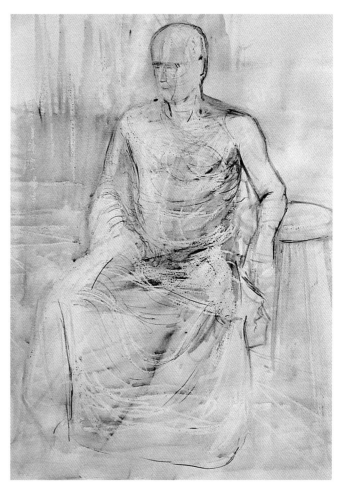

ABOVE: **Outline and pale mix and wax is applied in areas.**

ABOVE RIGHT: **A pale wash applied over the figure and areas of background. Once dry, more wax can be added to desired areas.**

RIGHT: **Note the broad areas of wax to describe planes. Washed calico suits the linear elements describing the form of the figure as the cloth undulates fluidly over the body.**

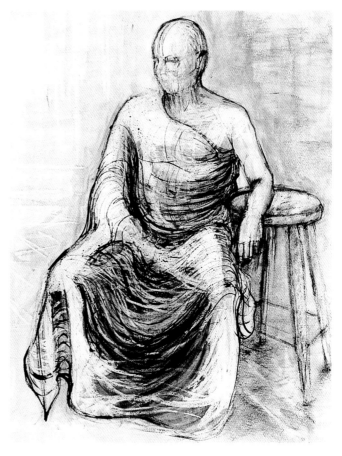

guesswork to softly integrate these areas by wax drawing some more undulations of drapery. Be selective – you don't want highlights everywhere!

Mix a thin wash of fairly diluted black gouache and cover the drawing. You will be able to see at once precisely where the wax has been placed. Once the wash has dried, strengthen the figure with alternate ink drawing and washes, working back into the figure, establishing and qualifying structural form. You can add wax to gradate more pale tones.

Finish off with some charcoal to create more tone. If you do make a mistake, use a scalpel knife to scrape back to the paper. This is time consuming and only appropriate for a small area. You can wet the paper to lift off some of the gouache wash, or as a last resort use white chalk to bring back some highlight. Note that these corrections will show up on the finished drawing.

EXERCISE: **PENCIL AND WATERCOLOUR WASH**

— OBJECTIVE: To bring tonal line and colour wash together

— MATERIALS: Watercolours or gouache paint, HB pencil, watercolour paper, watercolour brushes, gum strip if stretching paper beforehand

— POSE/SET-UP: Preferably seated, perhaps on monochromatic patterned cushions or other coloured fabric

— TIME: Not less than 1½ hours (and allow time for washes to dry)

The degree to which the draped cloth will cling to the form it follows depends on the fabric. However, in a reclining position,

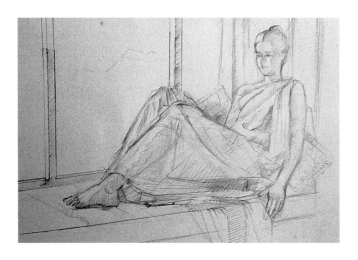

ABOVE: **Drawing and areas of tone are established first.**

RIGHT: **Pale washes are applied over the drawing but the white of the paper is left to represent the lightest of tones.**

look to see if there are areas where it may just mould over half the breast before sweeping over the torso and coming to rest upon the flat surface. Look at the directional folds of creases on the floor or bed, which literally depict spatial perspective.

Take a pencil and measure to place your figure on the paper. Spend time on your drawing because it forms the basic structure over which the washes will be applied. Really search for the structure of the body from underneath the folds. Strengthen lines that imply shadow in the flowing folds of cloth.

Draw in some of the tones using hatching and crosshatching. It is much easier to identify dark and light areas before applying washes of colour but do not be too heavy-handed. Trace the simple pattern of the cloth or cushions so that you can see where to keep the tones lightest.

Now that you have established the tonal areas, mix a very pale wash similar to the colour of the drape and apply all over with a broad brush. This will be your lightest tone. While this is drying, use a pale wash of something like Naples yellow for the face, hands and legs. Although you want a diluted mixture of more water than colour, do avoid colours bleeding into each other. In the example shown (see opposite), it would not matter so much because the girl is wearing a yellow sheet, but if it were blue, you would start making unwanted greens. If this does happen, blot back with kitchen towel, cotton wool or a sea sponge. You can also wet the paper with clean water again and carry on blotting to lift off the paint.

As the washes dry, tone will build up through the layering effect. Remember the white of the paper will be the lightest tone of your drawing or painting. To paint a brighter colour, you can

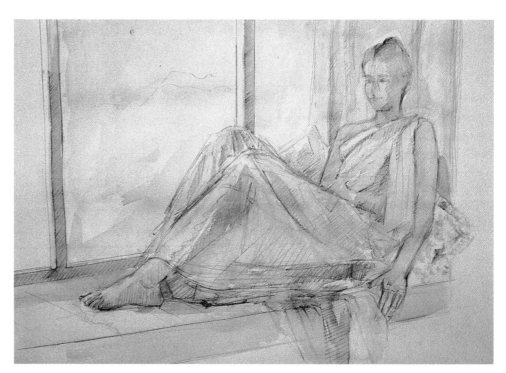

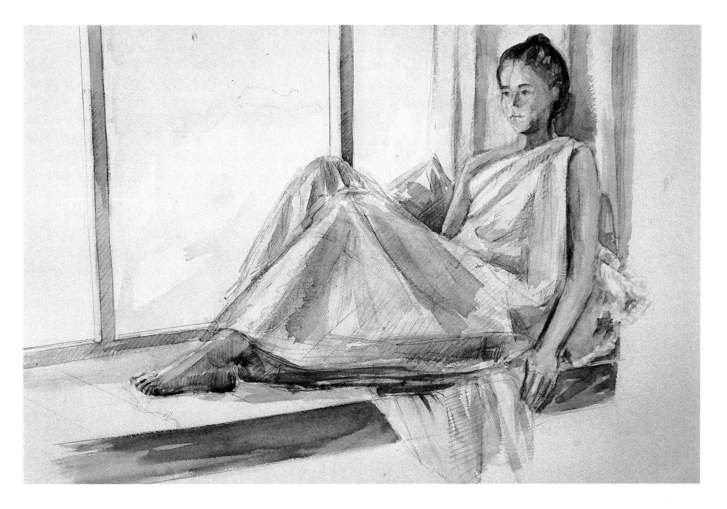

Washes built up to create some tone in colour.

reduce the amount of water in the wash, so the hue appears more intense. When you are painting the shadowed areas increase the ratio of black in the mixture.

In the example, the lightest tones of the drape have been left as they are, and the more intense areas built up by denser washes of Naples yellow. Yellow ochre and a tinge of cobalt blue with black were used for the greyer, darker or shadow areas. Indian red was used for the shadow colour of the legs showing through the yellow cotton bed sheet. The skin was initially established in Naples yellow and then a burnt sienna was washed on for warm skin tones whilst a hue made from alizarin red and cobalt blue was used for shadow skin areas.

If you are a beginner and cannot get the precise colour you want, just keep the colours pale, remember to rinse your brush well each time you change colour and to replenish the rinsing cup as often as necessary.

The key to a watercolour wash is exactly the same as that for an ink and wash one – less is better than more. It is so much

easier to add a little than it is to take away. Build up the tones through layers, allowing each layer to dry thoroughly before applying the next. If you find that you have overdone the washes and lack any of the highlights, you can use opaque paint to give it some body colour; so add some white gouache to a colour mix or just use white on its own to regain some of your highlights.

Conclusion

Throughout this chapter we have been analysing line and tone and the ways in which both can be applied to define form, volume and light. We have also examined the manner in which drapery behaves, and observing how different fabrics hang and contour the body structure. Simple elements of colour have also been introduced.

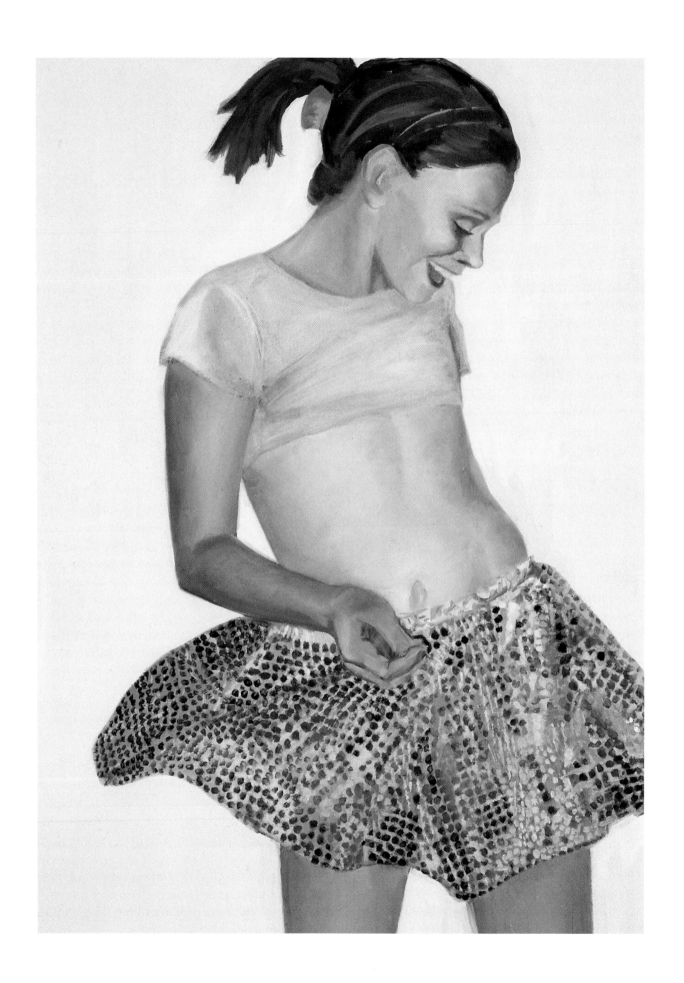

DRAWING AND PAINTING CLOTHES

This chapter begins by looking at the different types of mark that may be used to describe the texture and quality of the cloth that you want to draw. In order to help you to depict the world in colour, the rudiments of colour theory are then explained, including the properties of colour, mixing colours and complementary colours. However, it must be stressed that these principles are only guidelines and it is your own practical experience that will ultimately teach you the most.

Materials

To complete the exercises in this chapter you will need the following equipment:

- Pencils and erasers
- Soft pastels or conté crayons, coloured pencils
- Acrylic paints, oil paints
- Paintbrushes – flats, rounds, filberts of varying sizes, both synthetic and hog hair
- Cartridge paper, Canson or Ingres pastel paper, acrylic primed paper, oil sketch paper, primed board
- Rags
- White spirit
- Turpentine – used to dilute oil paints and as a solvent for glaze mediums. However, if you are still learning, white spirit is very effective and much more affordable.
- Cardboard
- Palette

OPPOSITE PAGE:
SKIRT FEVER.

Textures and Basic Mark-Making

A rich variety of fabrics are used in clothing, ranging from thin shiny materials like satin to less reflective ones such as leather. Then there are fabrics that are woven and textured, some are coarse, others soft and fluffy. All these elements, together with its weight and bulk, influence the way cloth may hang.

To describe texture, look at a selection of fabrics as if for the first time. Be sure not to miss any details of the texture, which can happen if you are familiar with a fabric. To convey the various characteristics and textures through your drawing, you need to select different types of mark to render their individual properties. For example, you would need to select separate marks to indicate the individual properties of a ball of cotton wool (soft), an egg (smooth) and the blade of a knife (sharp). Therefore the quality of line you would give to the outer edge of the egg would be different to the crisp line you would draw to describe a blade. You may choose not to use any form of line to represent the cotton wool.

It is only by experimenting that you can discover and make full use of the wide range of mark-making possibilities and whilst you may not always wish to portray all qualities and details all of the time, you may still wish to give an impression.

EXERCISE: **USING A PENCIL**

— OBJECTIVE: To analyse marks

— MATERIALS: 2B pencil, eraser, size A1 or A2 paper

— POSE/SET-UP: None

— TIME: Not less than 15–30 minutes

Before setting up a still life it is a good idea to take the time to explore the range of marks your pencil can make and to discover ways in which to use them – you may be surprised by the rich variety of marks you achieve. This process aims to make you more inventive and will help to make you aware of the marks that best describe what you are trying to draw.

Make as many different types of marks as you can think of. Be aware of your body movements as you do. Is your wrist stiff or relaxed? Are you moving all of your arm or just your fingers? See if restricting freedom of movement alters your mark-making in any way.

Begin with lines: light lines, dark lines, long lines, short lines, long and short hatched lines, long and short curved crosshatched lines, and curved lines. What about mixing straight and curved lines, either randomly or systematically built up in layers or in a linear progression? Notice how hatches that are close together appear to have a darker tone than those that are more widely spaced. The more space, the lighter the tone.

Next, try mark-making with dots and see if the same rules of spacing apply. Add another ingredient of dashes and then try mixing some of these variations of marks and their degrees of lightness or heaviness with all those crosshatching experiments from before. As you can see, the permutations are endless!

Hold your pencil at an angle so that you are drawing with the broad side. The resulting marks will be softer or fuzzier than usual. Build up rich mixtures of texture by fuzzy underlay upon which

Some mark-making variations.

you then draw crisper lines and marks that the pencil will make when held normally again. Expand to other marks such as dashes, zigzags, circles, scribbles – anything you can think of. Sharpen your pencil to make even more variations; you can also make a chisel end by sharpening it with a craft knife – the flat side will make thicker lines and the tips will make finer ones. Do not forget you can smudge pencil marks with your fingertips or use an eraser.

EXERCISE: **DRAWING MATERIALS OF DIFFERENT TEXTURES**

— OBJECTIVE: To analyse and select marks to best describe a variety of fabrics

— MATERIALS: 4H, 2H, B, 2B, 6B pencils, eraser, viewfinder or grid guide

— POSE/SET-UP: Still life of a variety of plain fabrics (shiny, matt, thin, thick, fluffy, woolly, ribbed)

— TIME: 1–2 hours

Make the set-up as interesting as you can. It will help if you have a backdrop such as a wall, board or screen on to which you can pin a selection of materials. You will also then be able to create a variety of folds such as diapers, pleats or drops. Avoid using very dark fabrics as it would be difficult to see textures properly unless it is something like net or lace on a pale background.

Seat yourself near the set-up. You can either use an easel or lean your sketchpad or drawing board on the back of a straight chair or table edge so that your support is comfortably tilted. Next, using a B pencil to draw, find the main lines of folds and shapes within the fabrics and look for geometric forms such as cones, orbs and squares. This will help you to see the basic structure of what at first may appear complicated and daunting. Once you have some initial placement then start working from the inside to out until you have a slightly more detailed outline of the whole. Do not draw the outline straight away or in isolation to what is making its shape. Look at the structure within; otherwise you will become frustrated when elements do not correspond.

You will find that a viewfinder or a grid guide will be useful here but remember that your pencil also makes an excellent alignment tool.

Test your pencils; a 2H will not go much darker than a mid-grey. This quality may be useful for suggesting transparency in shading of delicacy and fragility. By holding the pencil at an angle to shade you get a tone that is of a different quality to a 2B for example. You do not have to depict every single detail or crinkle to give an overall impression and remember you can put marks on top. Some of your textures will be lost as you build up the darker areas of tones to give form.

Really think about all the mark-making techniques from the previous exercise and find the way that best describes the difference between the fabrics before you. Pay attention to the folds – what differences can you see between thick and thin folds of fabric? If a fabric is very thick there will fewer folds with darker shadows cast in between. Thinner fabrics will be more fluid with less angular folds.

HOW TO MAKE A GRID GUIDE

A grid guide helps you focus on elements of what you're observing; lightly sketch a grid on your paper and you can focus on one square at a time, holding the guide up in front of you. The suggested measurements are not set in stone; but it's easiest to use a grid size that's easy to convert; so multiples of 10 are convenient.

Using a permanent marker, draw a grid of 40mm squares onto a transparent sheet, leaving a small border (approximately 25mm) around the outside. Use this border to attach the grid to a frame of stiff cardboard using masking tape. The frame should be about 40mm thick; big and light enough to hold up comfortably.

Remember that it is no more than a guide. The reference lines shift depending on which eye is closed and you would have to keep yourself and the guide absolutely still in order for the system to work perfectly.

HOW TO MAKE A VIEWFINDER

Cut two 'L' shapes 1–2in (2.5–5cm) deep from a rectangular piece of cardboard or white cartridge paper (250gsm). Arrange them like a window frame and you will see when looking through this window towards your subject that you can change what is in the frame by bringing it nearer to or further away from your eye. Alternatively, you can pull the 'L's away from each other to see more of the whole set-up or bring them closer together to zoom in on a section of the subject matter. Once you have chosen the area you wish to focus on, paperclip the 'L's. The inside edges of the frame correlate with the outside edges of the paper or cropped drawing. You can, if you wish, make evenly spaced marks on the inside edges of the viewfinder to denote a grid.

Basic shapes are lightly drawn in.

Study of a Leather Jacket

The outline was sketched using a 2B pencil, initially with a simple off-square shape. Measurements were observed and noted.

Line and hatching were used to mark areas of darker tone.

2B and 5B pencils were used for the very dark areas, and a 3H, which is fairly pale, to colour over some of the darker areas and

smooth the appearance of the tones. Pencils were held mostly at a flat angle to the paper, using the side of the lead to colour.

Textural or pattern description was added either simultaneously or on top of the toned areas.

An eraser was used for some highlights as well as for smoothing areas by smudging. The sheen look was created by noting that dark areas tended to contrast with the lightest.

Pen and Ink Study of Texture

The outline was lightly drawn in Indian ink.

Diluted washes of Indian black, burnt sienna and viridian green gave background colour to the fabric. The colours were also modified by mixing tiny amounts into each other.

Different squiggly patterns were then built up in sienna and black, paying attention to thick and thin qualities of line.

Washes were added when the patterns were dry to describe shadow.

Moving Into Colour

Although there is a great deal to learn about the theory of colour, its practical application is ultimately a matter of personal preference or choice. Contrast an old master such as Van Eyke with the Impressionist painter Monet. Both produced masterpieces that

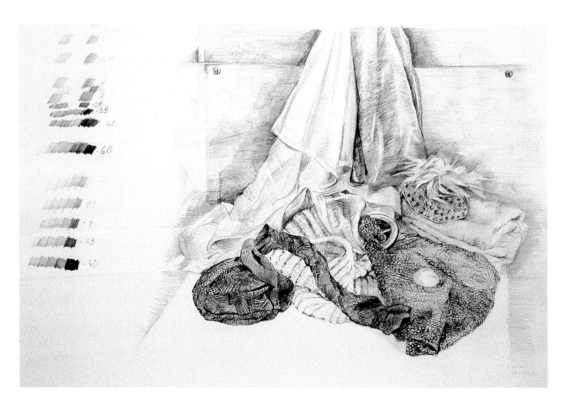

THIS PAGE:
**Pencils used:
4H/HB/B/2B/6B
plus an eraser.**

OPPOSITE PAGE:
TOP LEFT: **Hatching
notates the darkest
areas of value.**

TOP RIGHT: **Contrast of
light and dark describe
the sheen.**

BOTTOM LEFT: **Outline and
wash applied first.**

BOTTOM RIGHT: **Pattern
built up with varied
marks.**

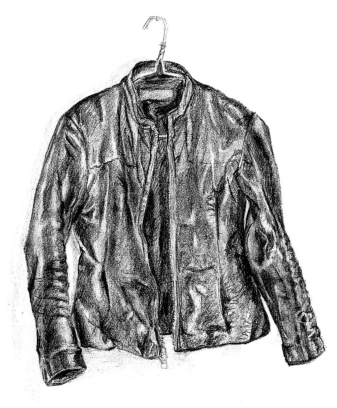

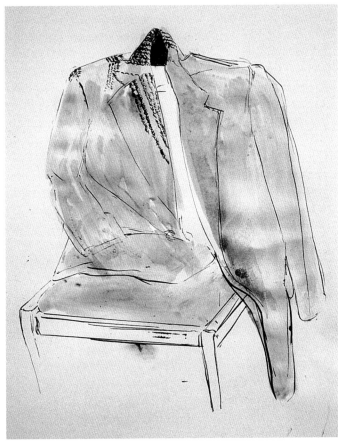

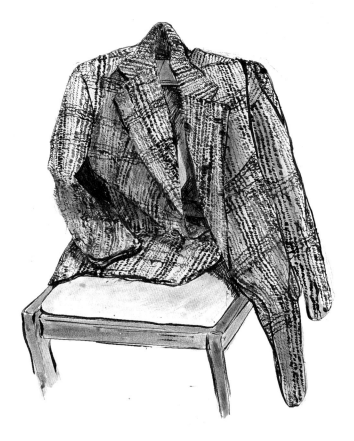

reflected their interest in the rendition of light and colour to describe what they saw. Whereas Van Eyke depicts every tiny detail in his painting *The Arnolfini Marriage*, rendering the transition from light through to shade by building up layers of glazes, Monet's approach appears instant and spontaneous as he seeks to capture the fleeting light. In all his paintings, the eye becomes involved in the colour mixing process. From close up you can clearly see brush marks of colour, sometimes used directly from the tube, painted patches or broken up interwoven patterns of colour. However, if you stand back, the colours blend to make sense of the pictorial scene before you.

How we each see colour is affected by several elements and the most important of these is light. Without light you cannot see colour, just look around you at night. Changes in daylight according to the season or time of day and different types of artificial light alter the appearance of colours. Each colour is also affected by its proportional relationship to another. For instance, a small area of a colour will appear darker than a large area of exactly the same colour. Colours will also appear to fade the further away from you they are. You can see this for yourself if you have the chance to look at a landscape or cityscape. The mountains, trees, roads and apartment blocks will fade the further away they are from your viewpoint, taking on a bluish-grey tinge. This accords with the colour theory that blue is a hue that recedes.

How you see colour is very personal – a tired eye may perceive less intense hues; the type of light and even your mood can also have an effect. As the artist, you are free to do whatever you like. Enjoy discovering new and unexpected ways in which to make colour work. However, it does help to become acquainted with the essence of colour theory and the terminology that is used to express it.

Colour Theory

White light contains all the colours we see in a rainbow. When these colours are separated they are seen as red, orange, yellow, green, blue, indigo and violet. When light falls upon a coloured object, the surface of that object absorbs all the rays of colour except the ones reflected back. These reflected hues are the colours that we see. A tomato, for example, has absorbed all coloured light except the red hues. White objects reflect and black objects absorb all coloured light.

The sequence of the colour wheel follows this prismatic spectral range and makes it easier to remember certain principles of colour and colour mixing. Black and white, which are considered achromatic (non-coloured, without hue) but are seen as properties of light and dark, are excluded.

Properties of Colour

Hue refers to the colour itself, such as blue or green, and it also describes a colour in terms of its position on the colour wheel. For example, orange-red compared to purple-red.

Value, also known as *tone*, refers to the darkness or lightness of a colour.

Saturation, also known as *chroma*, refers to the hue's intensity and the vividness or brightness of a colour. Saturation is not to be confused with value. You can have a pale dull colour or a dark bright hue. It is possible to make a red-grey to the same value as pure red.

Colour Mixing

There are three primary colours: red, blue and yellow. You cannot produce these by mixing any other colours. Red, blue and yellow are therefore essential – hence the name.

Secondary colours are the result of mixing two primary colours in equal proportions to make completely new colours. For example, a mixture of blue and yellow will produce a green; yellow and red will give you an orange; and red and blue will make a purple.

Tertiary colours are produced from mixing a secondary colour with a primary colour, for example adding green to a blue hue thereby making a turquoise and also producing a tonal range.

Choosing colours is not always straightforward when related to buying artist's materials because primary colours come in many different hues of red, blue and yellow and may be called different names depending upon the brand. Different qualities of paint can also alter the hues.

It matters, therefore, which yellow you use when making a specific green. For example, the green achieved by mixing ultramarine blue and cadmium yellow is of a different hue to the green made by mixing cerulean blue and the same yellow. This is true for any coloured medium you use – pencils, pastels, watercolours, gouache, acrylics and oils.

The palette used in the next exercise comprises two types of blue, two reds and two yellows and for a more direct working method, the exercise has been executed in a painting medium. If you are a beginner, the following colour mixing procedure will help you to familiarize yourself a little more with the process. If you have more understanding of colour mixing it is nevertheless a useful reminder of what one colour will do to another. It is an absorbing pastime and it can be a rather therapeutic one at that!

The reproduction of the colours in the following examples are not true; they are solely to show you what is meant and not to be followed as colour guides.

EXERCISE: **THE COLOUR WHEEL**

— OBJECTIVE: Colour mixing

— MATERIALS: Oil paints – student quality Windsor and Newton, Winton in lemon yellow, cadmium yellow, scarlet, permanent rose, cerulean blue and French ultramarine blue. Oil sketch paper, a palette, rags and white spirit

— POSE/SET-UP: A flat table to work on

— TIME: Not less than 30 minutes

Use a compass to draw a circle, divide it into quarters, and then divide each quarter into three equal segments. Number each segment from one to twelve on the outside circumference. To one side of the paper keep a record for your own future reference.

Mix the lemon and cadmium yellows to give you an average yellow, the two blues will give you a medium blue and the two reds to give you an average red. Make a fair amount so that you do not have to keep mixing more 'average' primaries.

Paint the first segment in yellow, segment five in red, and segment nine in blue. Now, between these primaries make the secondary and tertiary colours. It should run as follows:

RIGHT: **Lemon yellow (like a lemon) and cadmium yellow (an orange-yellow) make more of an in-between yellow. Scarlet (orange-red) and permanent rose (bluer red) make an in-between red. Cerulean blue (a greener blue) and French ultramarine (purple-like blue) make an in-between blue.**

BELOW: **Three primaries are placed – red, yellow and blue – and a secondary orange has been made between the red and the yellow.**

yellow, yellow-orange, orange, orange-red, red, red-violet, violet, blue-violet, blue, blue-green, green and finally yellow-green.

As the secondary colour is produced by mixing approximately equal proportions of two primaries, once you have produced orange for example, you can add more red to it in order to make it orange-red (but remember to paint your orange segment before you do so)! Relate each segment to the others and be prepared to change the ratio of colour in your mixture to get it right. A tip to remember is to add a tiny bit of the darker colour to the lighter coloured mixture you want to darken. For example, if you want a yellow-green, then add a tiny bit of blue to the yellow paint and keep adding gradually until you get it right. Adding the lighter colour such as the yellow to a mound of blue will have you going through a lot of yellow paint!

Colours have been mixed from yellow through to red.

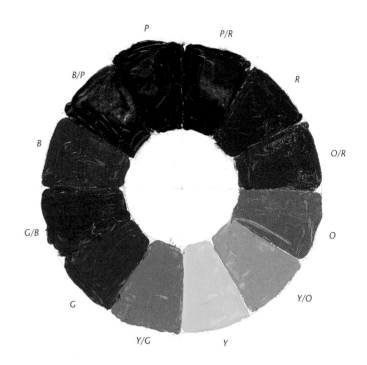

The colour wheel.

P = Purple	Y = Yellow
P/R = Purple/Red	Y/G = Yellow/Green
R = Red	G = Green
O/R = Orange/Red	G/B = Green/Blue
O = Orange	B = Blue
Y/O = Yellow/Orange	B/P = Blue/Purple

Complementary Colours

Complementary colours are opposites and appear as such on the colour wheel. A primary colour faces its opposite colour that has been made up by the other two primaries. For example, primary yellow faces secondary purple, which has been made by the primaries red and blue.

Side by side, complementary colours will make each other appear more vibrant, intense or bright. A red will somehow appear more intense, redder if you like, when seen adjacent to a complementary green rather than some other colour. This is known as simultaneous colour relationship.

When your eye perceives the complementary colour when it is not there, it is known as a successive colour relationship. Stare at a red colour for a few seconds and then look at a blank sheet of white paper – you should see the complementary colour afterglow. This is because the eye wants the satisfaction of balance.

Mixing Complementary Colours

If you mix two complementary colours together they will dull, mute or 'grey' each other down. Blues and yellows can make either brighter or duller hues depending on where they fall on the colour wheel – the warm or the cool side. For instance, a lemon yellow (cool) with a cerulean blue (cool) will produce a brighter green because both are close to green on the colour wheel. However, cadmium yellow (warm) has traces of red and is a more orange-yellow, which when mixed with the cerulean blue (a more green-blue) dulls the result because the red and green traces in these colours are complementary and so grey each other down.

Colour Combinations

Investigate for yourself to see what hues you get if you mix primary colours. Just use them as they are and try with the other colours in various combinations. Notice what happens when you mix scarlet red with cerulean blue. Not a very nice purple? That is because the blue used is nearer green, which therefore dulls the orange kind of red because you have two sets of complementary colours, orange/blue and red/green, which is why the result is so uninviting. Test these combinations out on your working sheet and with a pencil make a note of the hues you use as you go along.

Although complementary colour mixing may dull or mute down, it can produce some really rich and beautiful colours. For example, cerulean blue and orange produces a lovely copper

Neutral grey.

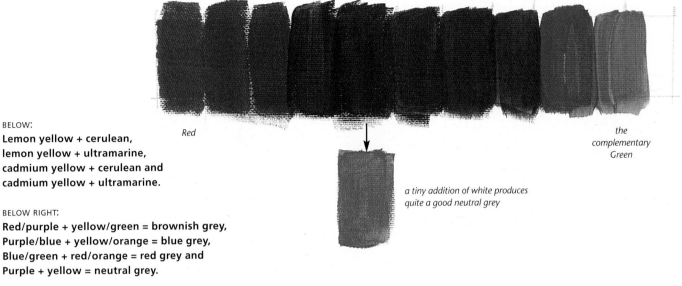

Red

the complementary Green

BELOW:
**Lemon yellow + cerulean,
lemon yellow + ultramarine,
cadmium yellow + cerulean and
cadmium yellow + ultramarine.**

*a tiny addition of white produces
quite a good neutral grey*

BELOW RIGHT:
**Red/purple + yellow/green = brownish grey,
Purple/blue + yellow/orange = blue grey,
Blue/green + red/orange = red grey and
Purple + yellow = neutral grey.**

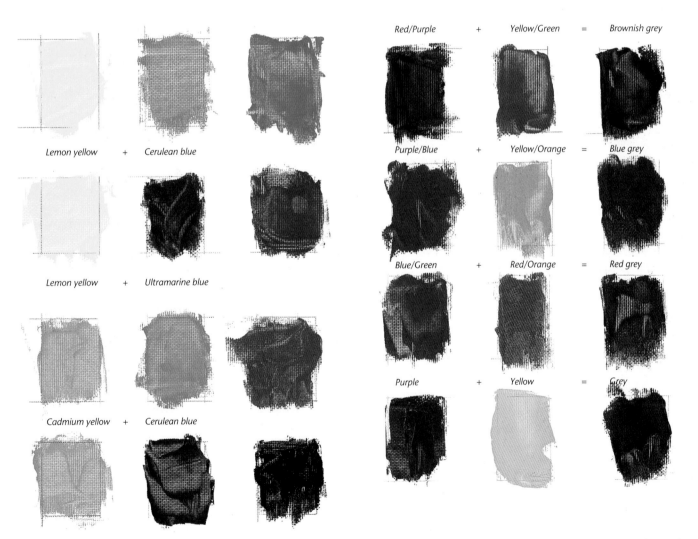

Lemon yellow + *Cerulean blue*	*Red/Purple* + *Yellow/Green* = *Brownish grey*	
Lemon yellow + *Ultramarine blue*	*Purple/Blue* + *Yellow/Orange* = *Blue grey*	
Cadmium yellow + *Cerulean blue*	*Blue/Green* + *Red/Orange* = *Red grey*	
Cadmium yellow + *Ultramarine blue*	*Purple* + *Yellow* = *Grey*	

NOTE: **these last two complementary colours were precise and mixed in exact proportion in order to make the neutral grey.**

65

colour and you will find that by altering the ratios, you can produce a whole range of browns and other muted colours.

EXERCISE: **DRAWING IN COLOUR**

— OBJECTIVE: Colour mixing in drawing

— MATERIALS: Coloured pencils in Prussian blue, spectrum blue, lemon cadmium, cadmium yellow, deep vermilion and crimson lake. A3 size cartridge or sketch paper

— POSE/SET-UP: Clothes draped upon or hanging from something like a chair. Items to be in primary and secondary colours

— TIME: 1 hour

The idea of this exercise is to relate what you have learnt from the colour wheel while still working without the use of white pigment. Colours do have tonal values but these values can be modified through the use of pencil pressure. The lighter the use of coloured pencil, the lighter the tone as the white paper shows through.

Draw a sequence of five boxes on a test piece of paper. In the first box, hatch with space between the lines; in the second, hatch with no space between the strokes. In the third box, crosshatch two ways; in the fourth, crosshatch three ways; and finally, in the last box, crosshatch four ways.

Try to produce the closest approximation of the colours you see with this limited set of pencils. Ask yourself whether the colours are warm or cool. This process will also heighten your awareness of local colour (the hue of the object itself isolated from any other influencing factor) and atmospheric colour (the colour of the object when seen in context).

Remember individual objects such as an orange in a fruit bowl or a blade of grass in a field are affected by light, shadow, reflection, etc. from their surroundings, as well as having their own hue.

Unlike painting, the only way to mix different coloured pencils is actually on the paper itself. This can be done through the crosshatch method or solid colouring in – both methods superimpose one colour over another. Where two colours overlay, a new hue will be formed; however, the eye will also blend colours so that a loosely hatched blue over a yellow can still easily be read as green. Where the two colours layer, you will get a new hue or variant. You can also apply one colour solidly over another but the results will vary depending on how much pressure you apply to the pencil.

Notice subtle differences of hue made by changing the order in which the colours are applied. Choose two primary colours and apply one over the other in equal crosshatching amounts and then reverse the sequence – do you notice any difference? Try altering the amount of colour or colours that you are blending by crosshatching one more than another. In this way you can build quite a variety of colour and tonal ranges.

As you look at the clothing you are to portray, remember that you can still use linear elements to depict qualities of fold, whether they are soft or quite angular, and to generally describe the nature of the fabric itself. However, because this exercise is primarily focusing on colour, form will be realized through hue rather than through outline.

In the illustration (*opposite*) there is a red nightgown on a chair with a bright yellow-green bag. Start by making a soft drawing in pencil; if you press too hard, rub it back a little. Now look at your subject matter and try to choose the most apt colour from your

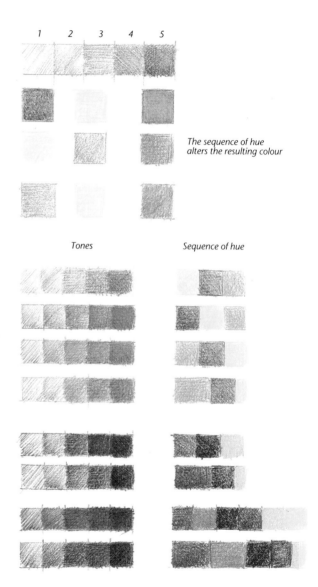

The sequence of hue alters the resulting colour

Tones Sequence of hue

Hatch just one way with spacing to produce the lightest tone in the first box (1), closer hatches to darken the tone in the next box (2), crosshatching two ways for the third box (3), crosshatching three ways for the fourth box (4) and finally, crosshatching four ways for the last box (5). See hues made from four-way crosshatching of one colour over another and note the differences obtained not only by amounts of colour but also the order they are applied.

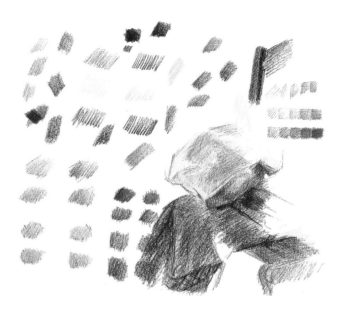

LEFT: **Drawing outlined in pencil.**

ABOVE: **Working test sheet.**

BELOW: **Nightgown executed using two yellows, two blues and two reds.**

range of pencils. You only have two reds, so think of the options: hard or soft colouring, building hatches of either red or the two layered together. We know the local colour of the cloth is red but the shadow areas of the folds appear much darker, even blue looking. Experiment by darkening a crimson lake with Prussian blue and test it on your work sheet. Ask yourself whether you want a warm or a cool colour. Although hot colours are thought of as the yellows, oranges and reds, and the cool colours are blues, purples and greens, this can be broken down further. For example, should there be more spectrum red (warm, i.e. more orange) than crimson lake (cool, i.e. more blue)? Or perhaps just one or the other? Could the hue then be modified with another warm or cool primary? When you have decided whether the hue is to be light or dark, lightly hatch just one way then crosshatch in every direction.

There is an area on the side of the green bag where red has been reflected back on to it from the nightdress. The local colour of the bag is a yellow-green; the reflections, shadows and such are the atmospheric colour, the colours of the objects seen in context. Don't worry about getting exact matches for the clothes, just select the nearest and be alert for different shades of hue. Do not be alarmed if you see browns or greys, even blacks. For the warmer brown colours try spectrum blue, lemon yellow and deep vermilion; for the cooler colours of the shaded areas use crimson, Prussian blue and cadmium yellow. You can also use all six hues to make different colour ranges simply by altering the sequence and amounts. The example (*right*) shows what you can expect to achieve.

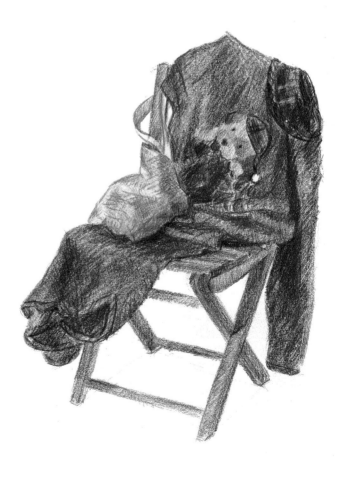

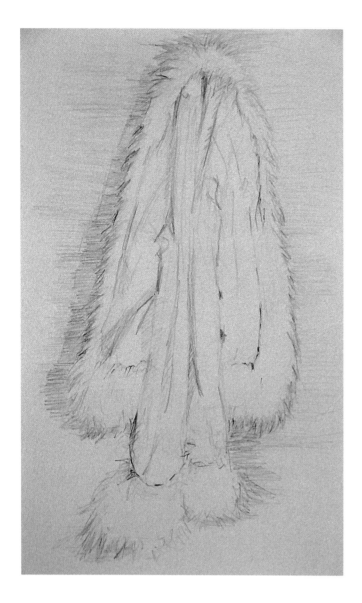

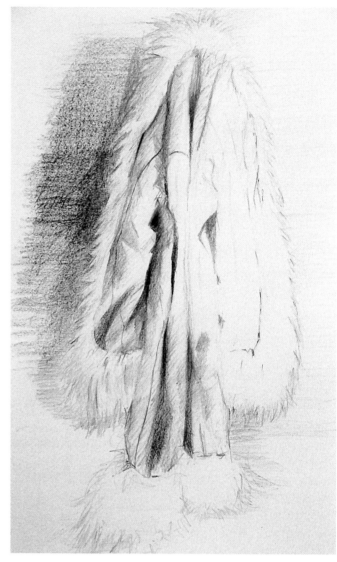

EXERCISE: **DRAWING PATTERN IN COLOUR**

— OBJECTIVE: To draw patterns and extend the use
 of the colour palette

— MATERIALS: Soft pastels and Ingres pastel paper,
 or conté crayons and Canson paper

— POSE/SET-UP: Any patterned item of clothing

— TIME: 1 hour

Any pattern that has a horizontal or vertical stripe will facilitate the
delineation of form. Stripes help you to contour the underlying
structure whether it is a figure, a table or simply the fall of the cloth.
You can follow the pattern of a line like a railway track, over the hill
of a fold and disappearing to the other side. You cannot see for a
little while but you will be able to pick the trail up again soon
enough. The position of each stripe will show you whether the line

ABOVE LEFT: **This pale blue jacket, executed with two yellows, two
reds and two blues, was initially sketched in with the dark blue.**

ABOVE: **Cerulean blue was used to describe the jacket's colour.
Light was described by keeping the colouring pressure light.
Subtle areas of shadow were brought about by analysing the hue.
The background is strengthened carefully to offset the jacket.**

OPPOSITE PAGE: **Hints of colour are given to these shag-like trims
but again keeping the hues restrained to allude to its cream colour.
Remember the complementary rules. The blue of the jacket makes
the eye push the trim towards a complementary colour.**

has moved up or down or indeed forwards or backwards in space,
which informs you of any change in plane and direction. This is
not as daunting as it appears although it can be time consuming.

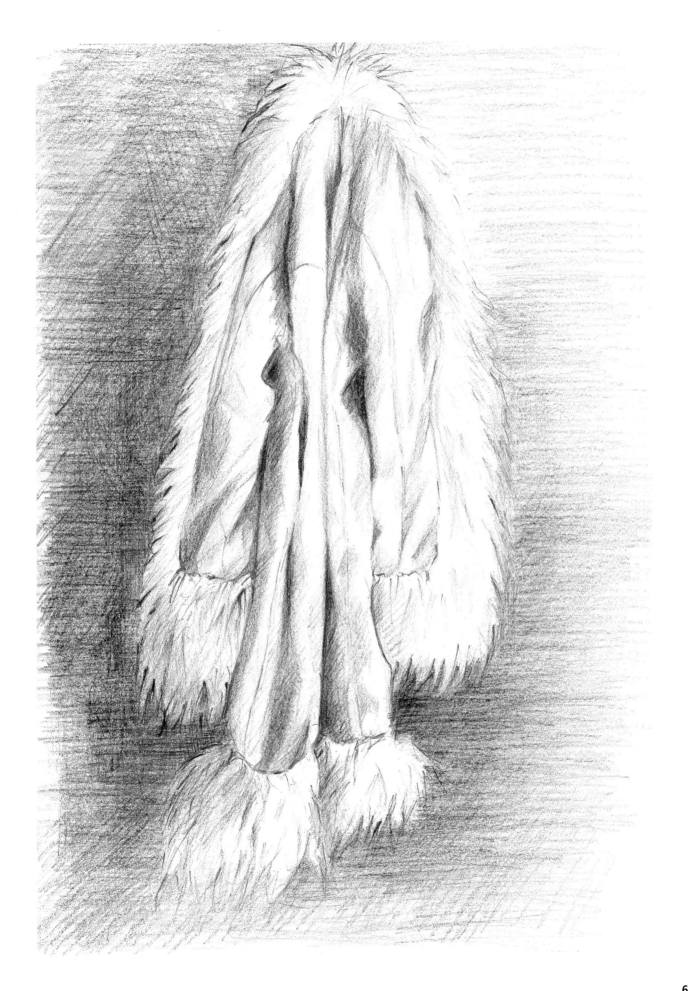

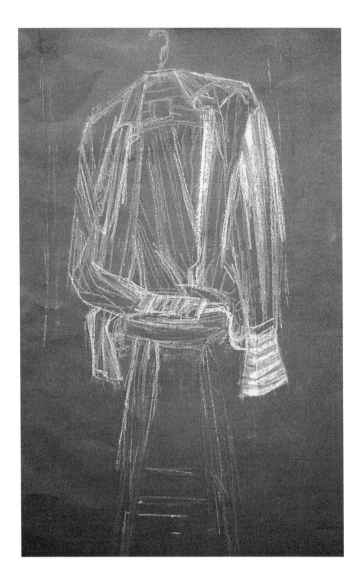

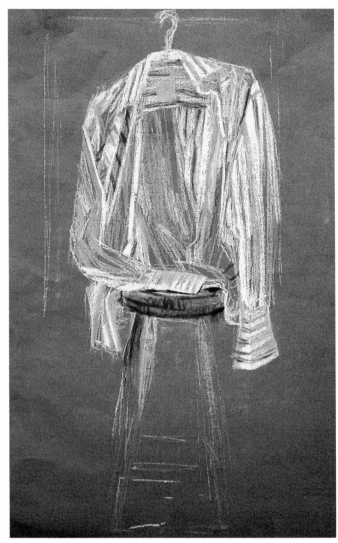

A checked pattern is more challenging. Rather than drawing square by square, it is easier to think of it as bands of lines across and down. Once you have the basics drawn you can begin to closely examine squares that have been cropped in telling folds or creases and where the material is either slack or pulled taut and stretched towards or away from another point of tension. If you put in the work, the results are rewarding.

Spots or polka dots can add to the three-dimensional illusion. When the spots are of a fair size, you can see half-moons or arc edges between folds, and the distortion of ellipses as the spot pattern dips in, out and over the form. However, this is not the case when the spots are very tiny as they tend to disappear between folds and creases. In this case it is probably best to aim for an impression although the dot pattern will still follow the horizontal and vertical lines. It may help if you visualize one of the faces of a die repeated on the material; perhaps the fourth face aligned vertically, or the fifth face aligned diagonally. If you are working in black and white or on white paper, the task of carefully encircling

tiny areas of paper that are to remain white can be really effective, although time consuming. Also, look for areas where the dots are nearer to each other or stretched further apart. All these qualities of pattern convey to the viewer the structure or lack of it beneath.

If you crosshatch using conté crayons and soft pastels, you can blend and build layers of colour and merge them by smudging the area with your fingertips. You can also apply pastel by holding it like a pencil to draw or on its side to sweep in broad areas of colour. Pastels contain whiting that lend them opacity and you also add the element of white itself. Keep it simple to begin with.

If you use willow charcoal to make your initial drawing, remember to wipe the excess off with a tissue so as not to dirty the hues to be laid. Alternatively, you can work in a neutral colour appropriate to the subject. Dust particles from the colours and your fingers can accumulate and smudge an area of work or dull the hues. Work on a tilted support so that the particles of pigment fall downwards. If leaning on the drawing, place a piece of paper between your resting hand and the drawing to stop unwanted smudging.

OPPOSITE PAGE:
LEFT: **The white striped shirt was sketched in white and pale pink was used to start putting in the stripes.**

RIGHT: **Some of the shadow stripes are beginning to be emphasized as well as darker areas of shadow in the whites depicted in grey.**

THIS PAGE:
Note different values of the stripes.

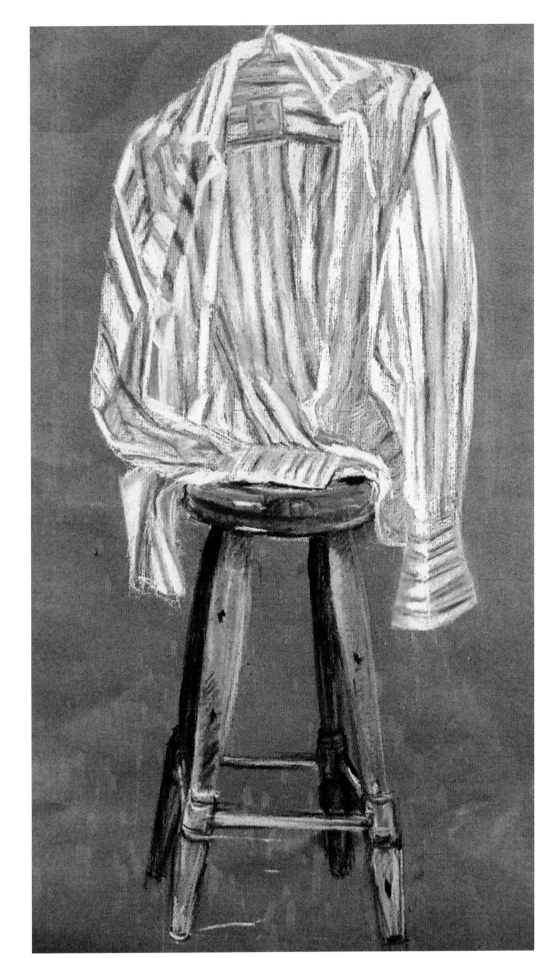

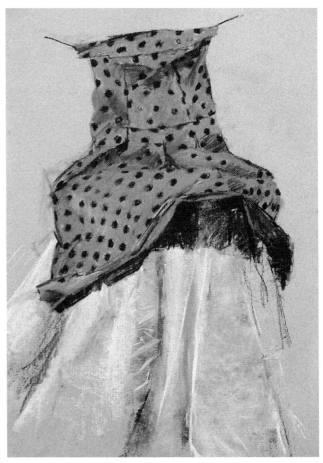
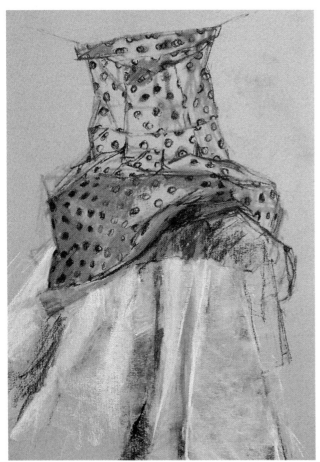
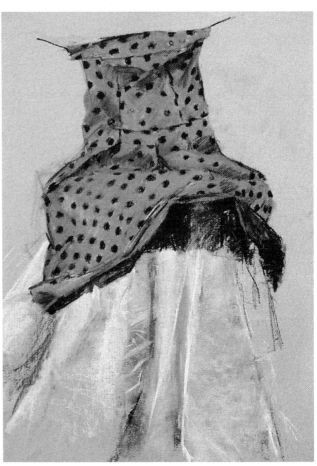

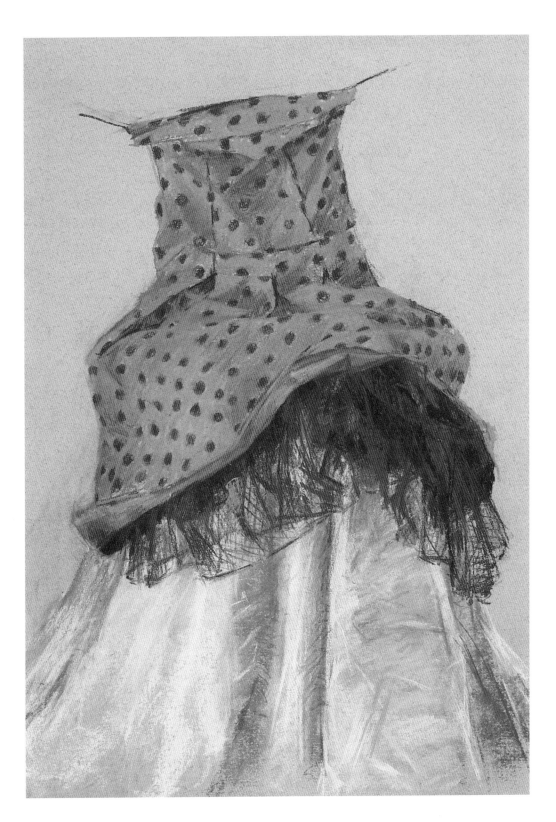

OPPOSITE PAGE:

TOP LEFT: **Choose the colour that matches your article of clothing most closely: pink is shown here.**

TOP RIGHT: **The red dots have been placed working in diagonal lines.**

BOTTOM LEFT: **Follow what you see; there are no hard rules and if you think you see a purple, be it in a pink or even a yellow item then follow your eye. Here the lilac serves as a slightly darker value to the pink making a shade through smudging as well as crosshatching.**

BOTTOM RIGHT: **Some red spots have been darkened in a few shadow areas with a deeper red/pink by using an alizarin and attention has been paid to their size and form because this can reinforce the form of the folds in the fabric.**

THIS PAGE:
Finally the petticoat has been added. When items go over other items think in layers of what is underneath or behind what you see. The drape of the sheet was resolved before the overlapping net fabric was drawn in.

Painting Clothes in Colour

In theory, you can make all colours from just the three primaries plus black and white. However, most painters extend their palette to include yellow ochre, burnt sienna, Indian red, raw umber, viridian green and terre-verte. Some artists also include cobalt blue in their selection. This clearly saves some time trying to obtain a hue that you might never quite achieve. Of course, you will develop your own palette based on personal preference. However, before you jump in painting it is best to have a quick look at lightening and darkening colours.

Lightening Colours

You can often darken or lighten a colour by adding the colour adjacent to it on the colour wheel. Mixing any colour with white gives you a tint. However to add white alone can radically alter the original hue, making very nice pastel hues but often reducing the brilliance and temperature so much that a third colour is needed to compensate.

Whilst it is easy to see that substituting white for a yellow would lighten a brilliant yellow-green (being nearest to it on the colour wheel), lightening an alizarin red might prove more challenging. You will need to use white, but on its own this will cool and change the nature of the original hue so a warmer red-orange is needed to compensate.

Darkening Colours

Mixing black into a colour to darken it gives you a shade. Whilst black is rich and can be a shortcut to other colours it can also be tricky because it can change the original hue. For instance, it will turn a yellow into a green. Until you gain some familiarity with colour it may be a good idea to avoid using black. In any event, you can always mix it from your primaries of red, blue and yellow.

It is often better to darken a hue with a darker colour that is close to it on the colour wheel. So a touch of ochre may be the best choice to darken a yellow without radically changing its character. Similarly, a red may be darkened by mixing it with a darker red or some of the earth colours such as the browns. If you want a cooler modification then a raw umber may produce the best result whilst a burnt umber will be warmer; a burnt sienna will darken the red much less but all the brilliance will be retained. Remember that mixing complementary colours may also produce the darker hue that you require, such as a selection of golden browns mixed from yellow/purple ratios.

To Intensify or Grey-Down Colour

Colours are supposed to be at their most intense or most saturated when used straight from the tube. However, some colours need a little white but, as you already know, if you add too much the colour will pale and the nature of its hue may change. For example, add a little alizarin to intensify cadmium red, or a touch of viridian green to intensify ultramarine blue.

The best way to grey-down a colour, to make it duller, is to add its complementary colour. Whilst mixtures of exact opposite colours on the colour wheel produce, when proportionately mixed, the achromatic (non-colour) grey, there are many other greys to be made – pink-grey, blue-grey, green-grey and so forth. These are not achromatic because they are in fact colours.

The best way to understand this is to start practising, beginning with painting some clothes.

EXERCISE: **PAINTING DRAPED CLOTHING**

— OBJECTIVE: To analyse tones

— MATERIALS: Oil paints, primed board or fairly thick cartridge paper, pre-stretched and sized ('sizing' paper means priming it with a thin coat of glue). Hog hair, synthetic or acrylic paintbrushes (which are good for smooth effects) in rounds, flats and filberts, rags, turpentine

— POSE/SET-UP: Any coloured items of clothing, non-patterned and non-shiny

— TIME: 1 hour or more depending on the complexity of the garment and drapery folds

It is suggested for this exercise that you work in oil. Once you have gone through this process you can then work using the medium of your choice to paint. The main reason for starting out in oil is so you can mix and blend hues at leisure without worrying about the paint mixtures drying up upon you.

Top outlined in a diluted colour with a small round-head brush.

TOP RIGHT: **Four tones: a light,
a middle, a middle/dark and a dark.**

BOTTOM RIGHT: **The tones are blended.**

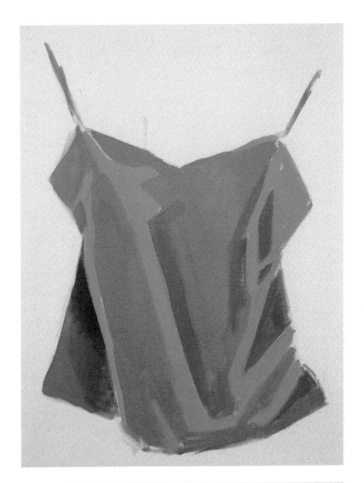

Draw your draped cloth in simple brush line, keeping the paint diluted or thinned with turpentine in the nearest hue to the colour of the cloth you are depicting. Opt for the dark side of the colour, as this will be more transparent, and refrain from using white or opaque colours at this point. You could roughly mark or code areas of value in order to make it easier for you to analyse. Drapery can be depicted in four to five tones but start with the basic light, mid- and dark tones. If you make a mistake either in delineating the item or marking areas, simply wipe back with a rag. If the paint is difficult to remove, wet the rag with turpentine. This corrective method of wiping back is one that is often used in the painting process so remember it for the future.

Next, mix the light, mid- and dark tones. The mid-tone should be as near as possible to the colour of the cloth you are painting. If you want to check how close the colour is, dab a bit on some scrap paper and compare it directly. Alternatively, load your brush with the mixture and hold it up in the line of vision of your drape. When you have the colour of the item being painted, mix a related light and dark tone. Check to see if the actual hue is different in the darkest area. Darker areas are best kept fairly transparent in painting to give the illusion of depth.

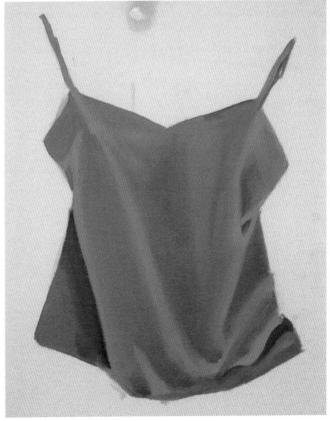

In this example, pure cerulean blue was used for the mid-tone and a mixture of Phthalate blue with a touch of raw umber for the dark tone because the area appeared slightly greener. The light tone was modified by adding Windsor green to a mixture of cerulean blue and white in order to keep the brightness or intensity of hue. Windsor green is much more intense than viridian green; see for yourself and make a tint with each.

Now that you have three basic tones, look for half tones in between. This would be the value between the dark and mid-tone and between the mid-and light tone. Four or five values should give you enough tones to depict your cloth. The clearest difference of tone here is a mid-light and a mid-dark (the pure cerulean hue). Begin by painting on the darks and work your way up to the lights. Keep a brush for each mixture of colour. Remember your rags; you can thicken the consistency of the paint by wiping excess turpentine from your brushes if necessary.

You can now start to model. Look to see if the material moves from dark to light in a gradual way or if values change quickly. These observations describe the fall of light as well as the nature of the fabric with its corresponding angular or soft folds.

Get an unused filbert and drag down the hard-edged meeting of two tones, softening and blending the values. You can also try using a finger to blend instead. Does it work for you?

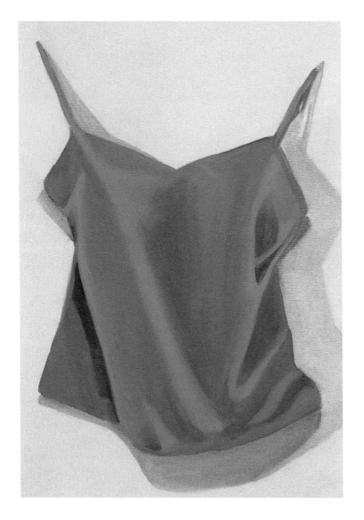

Final blends smoothed and background painted white complete with shadow.

Painting is not just about brushes. A note of caution: try not to overdo it as you still want to maintain separate values, so do remember to use different brushes for different hues, keep the brushes clean, and use that rag well.

EXERCISE: **UNDERPAINTING, GLAZING, OVERPAINTING AND SGRAFFITO**

— OBJECTIVE: To practise a range of painting techniques

— MATERIALS: Acrylic and oil paints, acrylic primed paper or board, turpentine, oil paint medium, stand oil or linseed oil

— POSE/SET-UP: A blue cloth with some pattern (a blue item is chosen because black and white underpainting supports a blue glaze well)

In an ideal world you would execute the various stages of this project entirely in oils or another medium such as acrylics. However, if you paint in oils over acrylic (never the other way around), you can glaze on the same day as you finish the underpainting. Acrylics dry fast, whereas if you were to use oils to underpaint, you would have to wait a minimum of a few days for the layer to dry. Oils have been chosen for the glaze because this will allow you to modify at will. Acrylic glazes, on the other hand, dry almost before you can blink, allowing no time for further modification.

The other point worth mentioning is the surface. In this example, primed acrylic paper has been used for the acrylic paint, which acts as a primer for oil. The paper has a smooth surface, which is more appropriate for glazing than a rough, less sanded, toothed canvas. Ready-primed boards are fine.

Begin by sketching out the material and folds. This can be done in pencil as the acrylic paint will easily cover it. Next, paint the drapery in black and white using the acrylic paints. Mix three basic tones using black and white to achieve dark, mid- and light

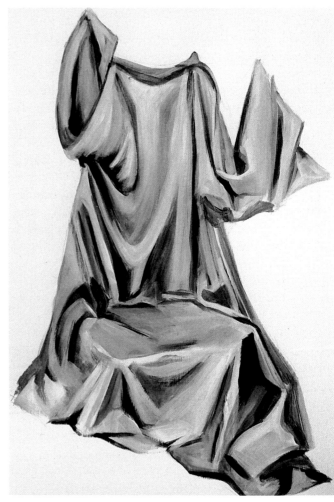

Black and white tonal underpainting in acrylic.

it. Dark hues tend to be transparent or semi-transparent when applied thinly. In order to thin the glaze further (make it more transparent with less blue pigment) add a glazing medium such as stand oil. You can then make it even more fluid with turpentine. In this way you can build up glaze after glaze as long as you allow adequate drying time in between.

However, because only one glaze is required for this example, it has been manipulated a little bit more. French ultramarine and Phthalo blue were used with glazing medium. Less pigment was used in lighter areas, more in darker areas. In some areas an additional shade was made with ivory black whilst still maintaining a degree of transparency.

If you find that these dark areas do not allude to 'space' anymore, it is either because of the thickness of paint just applied or because the underpainting was too dark in the first instance. Glaze a thinned blue over the entire underpainting and then decide what you want to change – you can easily wipe back to begin again or simply to soften slightly. To work with some precision, dip a rag in turpentine and wrap it round your index finger. Synthetic brushes will give even smoother, almost invisible brushwork. No opaque paint or what is sometimes referred to as 'body colour' has been used in this glazing stage.

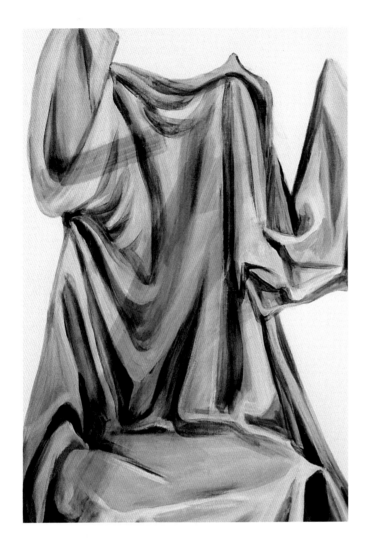

Glaze applied in oil.

Sgraffito used to create elements of the pattern.

values. It is best not to go really dark because you will be glazing later, which will darken values further.

Find your in-between tones and be aware of reflecting light. For instance, an area that is in shadow may have light reflecting back on to it from another surface such as a wall (especially a white wall) or even from the material itself. Reserve your highlights for pure white, which should however be unnecessary unless you are painting shiny fabric. Note sudden changes from light to dark describing angularity, or soft changes of value describing fluid folds.

As you will see, acrylic dries quite fast. You can repaint to your heart's content but avoid a build-up of thick paint as this can make the glazing process more difficult. Once your black and white, fully modulated tonal painting is dry the next stage will be to give it an oil glaze. A glaze is a transparent or semi-transparent colour put over an area that has already been painted in order to modify

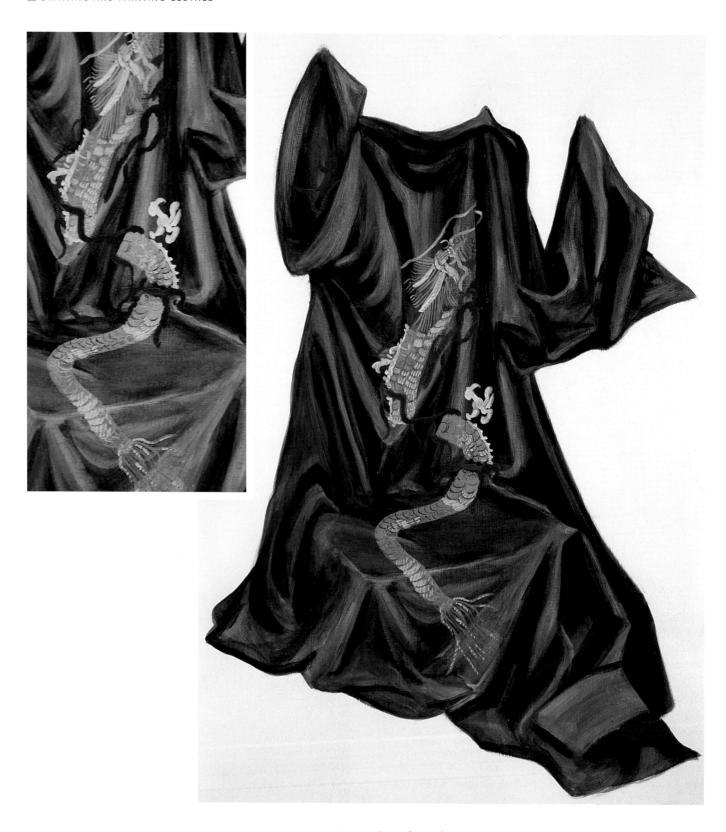

ABOVE LEFT: **Once dry, red areas were painted again and some pale ochre hatches were painted over certain areas to convey texture and light.**

ABOVE: **The finished result.**

You will now have to wait for your work to dry. This can take a few days or longer depending on the amounts of oil and glazing medium used. The more diluted with turpentine, the quicker the drying time. There should be no tackiness at all when you come to paint the pattern.

In this example the pattern has been painted straight on top of the glaze. However if you wanted to make the colours more luminous you would initially paint the pattern in white and allow it to dry completely before painting the hue on top. A small brush (size 1) was used for the fine work but you could use an ever finer one (size 0). A thicker application of yellow ochre was applied with a flat brush and the mixture was kept dry, without turpentine. Rather than painting a tiny ochre coloured shape each time, areas were blocked in and the edge of a palette knife was then used to sgraffito or scratch back into the dry layer beneath. Remember to wipe off excess paint on your rag from the palette knife each time. This method works well when you have a light value of opaque paint over a dark value ground.

Painting Red Material with a Glaze using a Supporting Ground

The main characteristic of any shiny material is the fairly strong contrast between light and dark values. You will also notice reflected light, as the material reflects between folds. If working over a period of time, you will see how natural daylight can really affect your values, especially the highlights. You could consider either working with electrical light or at a set time of day. If you prefer natural light, a north-facing workspace is best.

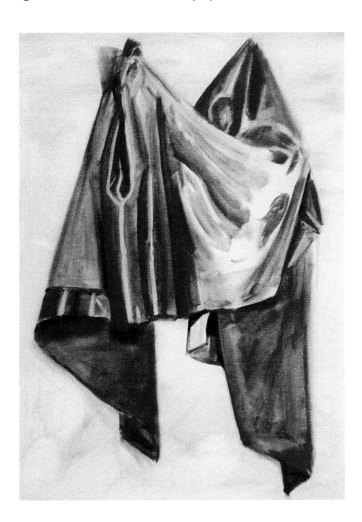

Give the surface a wash of yellow ochre acrylic paint diluted with water. This imprimatura supports and enriches the colours to follow. Once the ground is dry, paint the drapery in the following hues that will support the future glaze: mid-tones in light red, which can be more thinly applied to describe lighter values; mid-dark tones in Indian red; and for shadow darks add a little black.

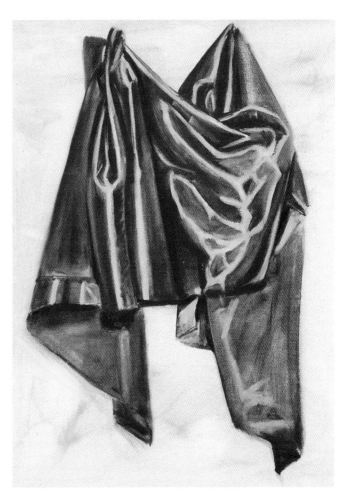

If you accidentally paint over a highlight, then use your turpentine and rag to pull the background back. Strengthen highlights with a thin dry mixture of yellow ochre, a touch of light red and flake white. Avoid getting your light and middle tints mixed up. Note that no glazing medium has been used and all colours were kept fairly thin.

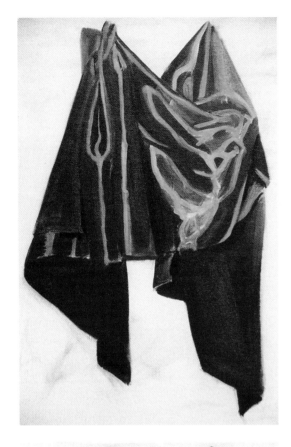

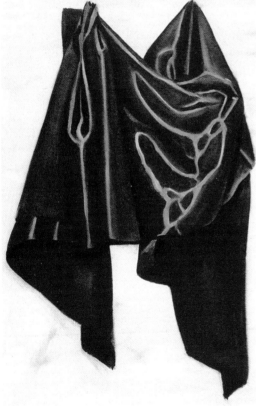

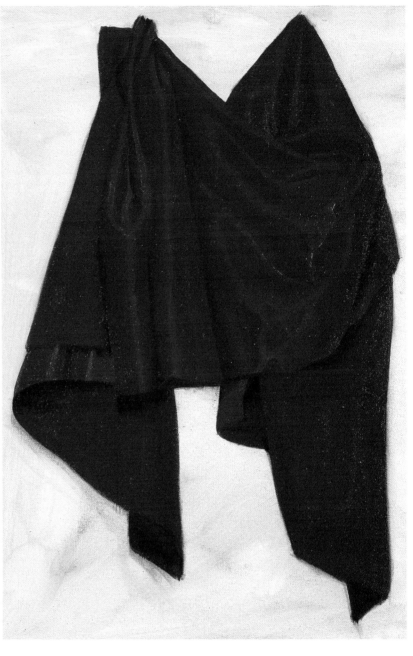

TOP LEFT: **Once this layer has dried (a few days) you can paint on your next layer: white for the highlights, vermilion (to save confusion, orange/red, as some brands have quite different hues for this very same name) and a little Indian red for the mid tones. For the shadow add a tiny bit of black into the mixture.**

BOTTOM LEFT: **Again avoid losing your distinct areas of highlight; do re-establish if necessary. Once you have got all the paint down, blend with a dry brush.**

ABOVE: **The entire fabric was given a final thin glaze of vermilion.**

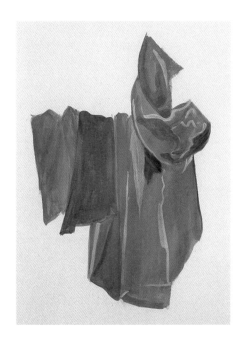
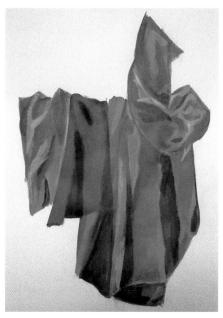
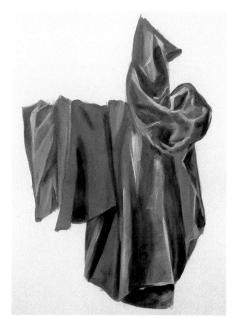

ABOVE LEFT: **Shirt drawn and blocked in.**

ABOVE MIDDLE: **Lights are blended and shadows are painted.**

ABOVE RIGHT: **Highlights are re-emphasized.**

RIGHT: **Two or three warm transparent green glazes have been applied.**

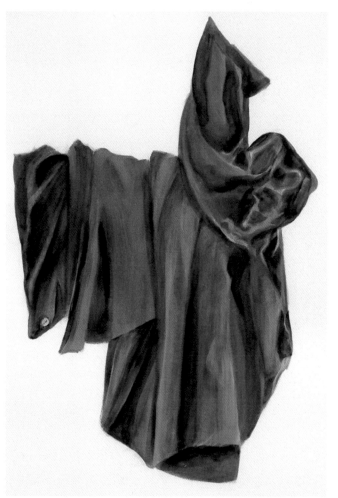

[NOTE: Flake white falls in between titanium (cream off-white, strong tinting power), and zinc white (cold white, which has a little transparency to it).] For more information on supporting colour grounds and glazing, try John Cawse (1840) *The Art of Painting Portraits, Landscapes, Animals, Draperies, Satin & c. in Oils Practically Explained by Coloured Palettes* (R. Ackerman; held at the Victoria and Albert Museum).

Glazing and Painting a Shiny Material in Acrylic

Choose an item of clothing and draw it. Acrylic primed paper has been used here but any fairly thick piece of paper is also suitable.

One colour mix has been loosely brushed in for the non-sheen lining of the blouse and another colour mixed for the rest. White has been added to this second mix in order to highlight the light tones that have been knocked back by blending. You can use acrylic retarder gel to slow down the drying time, allowing you extra time to mix and blend. You could use a stay-wet palette or just spray your palette with water intermittently.

Use an acrylic glazing medium. The best thing about acrylic is that you can repaint relatively quickly. Sharp edges are created by using flats – load and place the edge of the brush on the surface then drag it away from the line you wish to create.

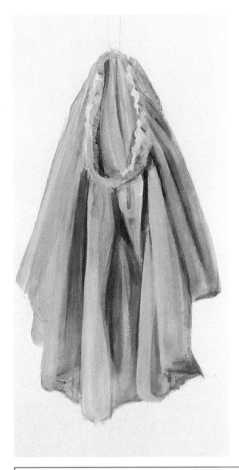 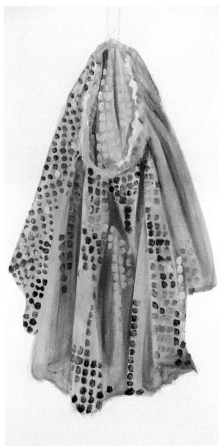

INSTANT AND APPROXIMATE GLAZING EFFECTS

An easy and instant way to see the effects of a glaze that will also help you to understand the process is to use transparent coloured sheets. Overlay the coloured sheet on to an already coloured ground to get an idea of how it will look.

Furthermore, by placing these sheets on a white piece of paper you can see what happens when one colour is superimposed on another and notice the difference when you reverse or change the order. For example, a blue sheet followed by a red sheet will produce a slightly different hue of purple to a red sheet overlaid with a blue one. As the layers build up, the transparent effect diminishes and the colour will become grey or even black.

ABOVE LEFT: **Sequinned skirt initially drawn out and relative underlying hues have been washed in.**

ABOVE MIDDLE: **Sequins painted in lemon yellow, yellow ochre and Venetian red. Shades made by adding ultramarine/raw umber or more directly with black.**

ABOVE RIGHT: **Glazes of lemon yellow applied. Note the scumbling on the inside lining hanging from the hook. This is where opaque or semi-opaque paint is scrubbed or dragged over the painting so that the layer beneath can still be seen in parts.**

OPPOSITE PAGE:
Several glazes and strong contrasts of light and dark help to give a sparkle effect.

Conclusion

In this chapter we have looked at different textures of fabric and some of the ways in which to convey these qualities in drawing and painting. We have also focused on colour and its principles, working through different techniques and methods. In the next chapter we will be focusing on drawing and painting the figure and clothing together, working in pastels and oil paints.

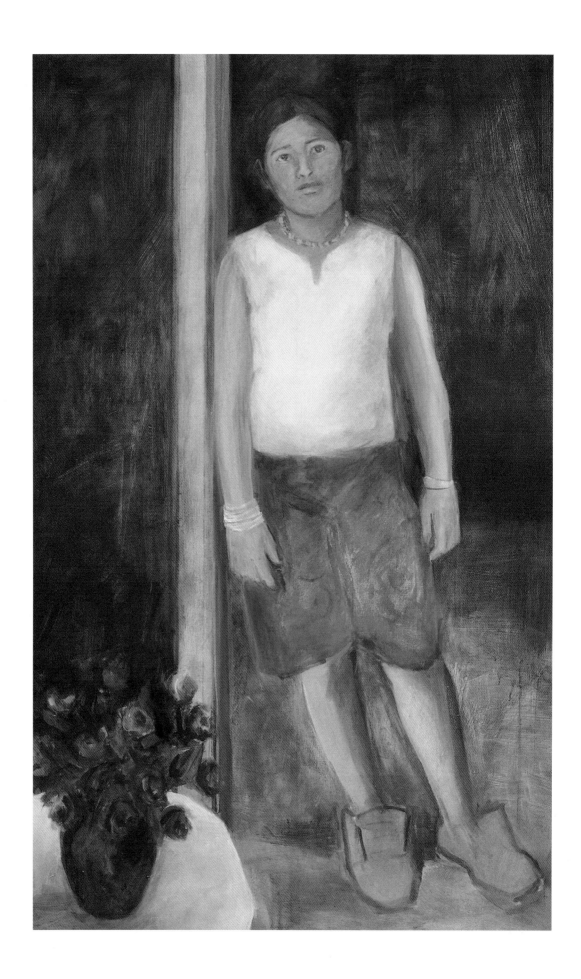

DRAWING AND PAINTING THE CLOTHED FIGURE

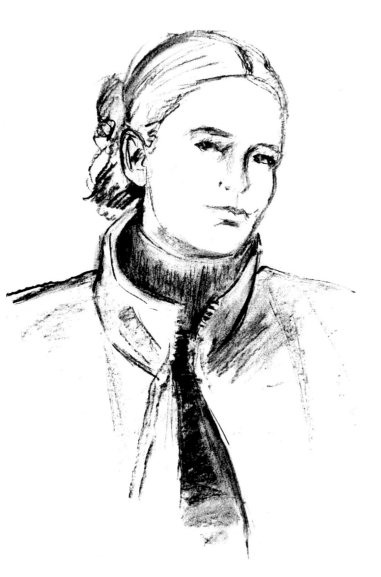

OPPOSITE PAGE:
FLICK.

THIS PAGE:
Collars are rounded as they follow the round tube shape of the neck.

The great thing about drawing and painting the clothed figure is that your family and friends may now be more willing to sit for you, so remember to ask!

In this chapter we will begin by looking at drawing with pastels and painting in oils, explaining the various techniques where appropriate. We will also examine skin tones and colour relationships. As we work through the exercises we will study methods of drawing and painting the body and clothes together.

An important point to remember is that most clothes are cut to follow the structure of the body and, as we saw with drapery, the material will follow the form too. This may seem very obvious but it is important to remember that garments do not just lie flat but curve around to follow the body. Cuff edges, for example, reflect the shape of the wrists by circling around the cylinder-like shapes. The same is true of collar lines as they go around the neck. These ellipses will vary in degrees of roundness, depending upon the cut and style of the garment as well as the viewpoint or perspective of the artist, but they will never be dead straight. The same is true of hemlines and their edges. For example, when you look at someone wearing a skirt, irrespective of whether it is gathered, pleated or plain, the hemline is longer at the front and gets a little shorter as it goes around the sides to disappear to the back of the body. Although a skirt is often rounded at the hem, it is not usually cut much shorter at the back. The viewer is simply seeing the skirt in perspective.

Several types of fold are created as the fabric follows the body form (*see* pages 34–7), which help to describe the structure of the figure beneath. We have seen when drawing the draped figure how folds or creases behave depending upon the type of fabric being used to drape, noting that a stiff material makes more angular folds more than a thin flowing fabric. Now we are going to pay attention to the bulk of a fabric in relation to the figure when describing the clothing. For instance, the cuffs and collar of a thick woolly sweater will come out in relief to the body as seen at the wrist and neck, whilst a leotard or swimsuit will be more like a second skin. As we study the clothed figure, we should aim to keep it simple by looking for the folds that describe or capture the bare essentials of the pose, from folds

that describe roundness to those that fall straight down indicating, weight, movement and gravity.

Materials

To complete the exercises in this chapter you will need the following equipment:

■ Willow charcoal
■ Pastels – you can buy these in a box, which will give you a good selection to begin with, but you can also

ABOVE LEFT: **Edges of sleeves still maintain a degree of ellipse, never dead straight.**

ABOVE: **Hemline tapers as it goes back around the figure.**

RIGHT: **T-shirt fabric follows body form closely.**

BELOW RIGHT: **Thickness of collar is indicated by its extra protrusion from the body. Note how the outside edge of the fur-trimmed collar still retains a degree of roundness.**

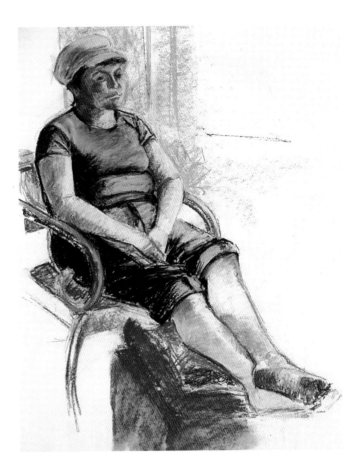

buy individual colours. Do ask at your art shop if they can give you a photocopy of the colour chart in their catalogue that gives you the names of the hues.

- Oil paints
- Brushes – a brush is made up of a wooden handle, a ferrule (the metal piece that holds all the hairs together) and the bristles at the end that deposit the paint. Hog hair brushes are ideal for painting in oils as they are strong enough for loading paint and working against the texture of the canvas. Sable brushes are the best choice when you want a soft brush for detailed work or to apply a thinned layer of paint. Synthetic brushes are a less expensive alternative but they will not last for so long. For the exercises in this chapter you will need a selection of the following types of brushes: rounds – suitable for a range of uses, the smaller size is fine for drawing; flats – useful for blocking in and creating sharp edges; and filberts – good for drawing and blending.
- Mid-tone pastel paper, oil sketch paper
- Rags
- Turpentine
- Palette

EXERCISE: **DRAWING THE FIGURE AND CLOTHES TOGETHER**

— OBJECTIVE: To synthesize clothes and figure

— MATERIALS: Charcoal, pastels, mid-tone pastel paper

— POSE/SET-UP: Any

— TIME: 1½ hours

Begin by making a simple drawing in charcoal. If you need to make corrections, simply wipe away the charcoal with the back of your hand and then lightly overdraw your adjustments.

The first element to achieve is the basic structure, reducing the body to a series of lines to represent the limbs and simple geometric shapes to represent the clothing. If the figure is wearing trousers, for example, ignore the crease folds and revert to stickman structure to find the angles of the legs, their relationship to each other and the rest of the body. Then you can sketch in the

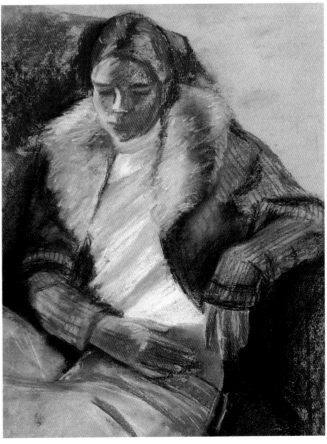

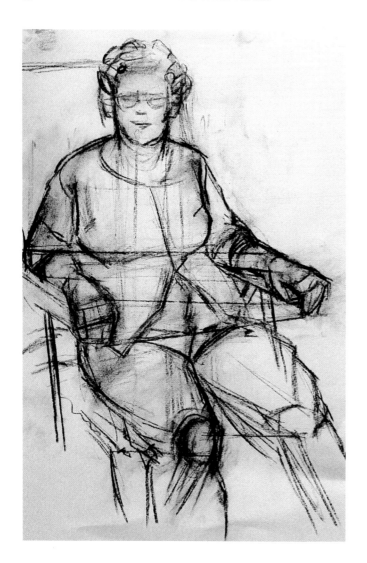

Spend time establishing the drawing and check
with horizontals, verticals and angle relationships.

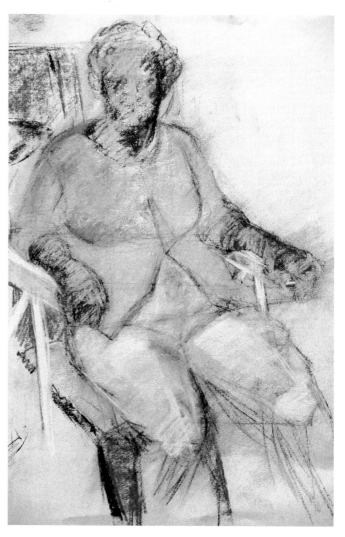

Basic colours of light and dark
skin tones applied very quickly.

flesh or in this case the clothing, delineating the major folds. Remember to use cylinder or tubular shapes to help you at first. Draw in light horizontal and vertical lines if they help you to see the balance and posture as well as the position of the knees, elbows, hands and so on. Spend time over this part of your drawing, since if you get it right you are more than half-way there.

When the figure is seated, draw the framework of the chair at the same time as the body structure. Depict what you can see, for the body mirrors the chair's structure. Remember that the front and back edges will run parallel if facing you – think of a cube. However, if the chair is angled away from you, the top and bottom edges will narrow in towards each other slightly as it tilts away towards the vanishing point on the horizon. Check the angles of the legs in relation to the feet and arm rests – these

indications are useful alignments with which to reference body placement and they make your figure look really seated. If you are stuck because you know that your drawing is somehow wrong but you cannot see where, look at it in a mirror. Because the image is reflected back in reverse, mistakes become obvious.

Before you start applying colour, lightly rub back the charcoal with your hand and blow or lightly dust with a cloth. This is just to get rid of excess charcoal and you will not lose your drawing unless you are very fierce! Working on a mid-tone paper makes it easier to see light and dark colours in relation to it but don't worry if you go wrong. Although pastel is more difficult to rub off, you can overdraw very easily.

You are now trying to build form with tone and you are doing so in colour. Stand back from your work every so often to have

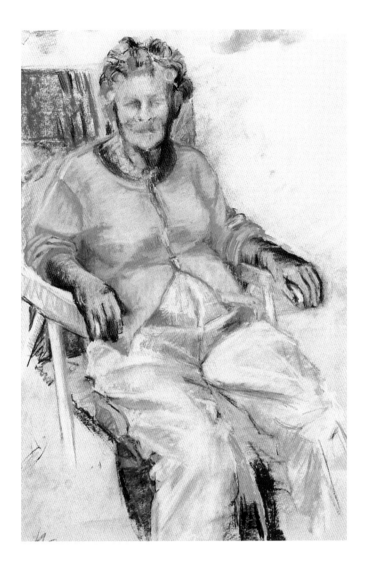

Areas of light and dark established on the
clothes in hatching and crosshatching colours.

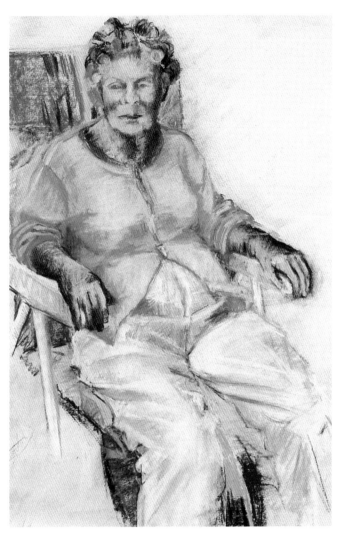

Note how many colours are seen in the trousers.
Compare the pastel shades of clothing to the
more intense, brighter colours of the chair.

a look. Try to unify your work by building the drawing overall rather than concentrating on one small section that may not relate correctly to the picture as a whole.

Start by putting on the light tones (not the highlights). Try using any of the following mixed either with white or each other: Naples yellow, lemon yellow and flesh pastel. For a mid-tone, yellow ochre is very useful and you can darken it with a warm bistre. For a darker tone, use bistre on its own or you could try brun rouge, which is a little cooler. For very dark areas, a cool terre umber or raw umber will do the trick.

However, regarding flesh tones, take a look at a Degas pastel and you will see that the range is almost infinite. So if you see a purple or a green in a shadow then trust your eye and follow it. To pull back colours either of skin or fabric, try blending in

some of the pale tints or white itself. However, white alone should only be used for the very lightest highlights and often these are still tinged with a hue. You can build colour mixes through layering or smudging them together directly on the paper. If you use the eraser quite aggressively it is possible to remove pastel but you can also take a fair amount of pigment off by brushing and blowing the grain away with a stiff hog hair brush. This saves the tooth of the paper, which can now retain the pigment afresh.

As you draw and colour the folds or clothing, be aware of distinctions. Are some folds darker or more linear with deep valleys in between – how dark are they? Other fold edges may be more tonal and the distinctions between dark and light less hard-edged, softly merging to create tubular or pipe folds without the crevasse

89

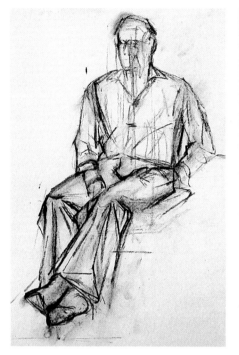 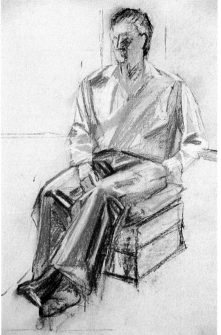 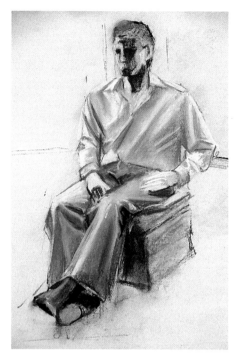

ABOVE LEFT: **Basic drawing with major cloth folds.**

ABOVE MIDDLE: **Some basic colour
and tone is established.**

ABOVE RIGHT: **Some of the tones are smoothed
so that one tone blends more into the other.**

LEFT: **Observe trouser hemline
and outside edge of shirt.**

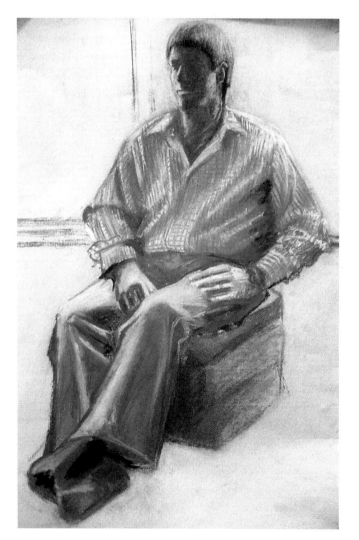

in between. Look to the edges of your sleeves, collars and hems. Do they follow the cylinder-like shapes of the body beneath?

Look at outside edges of material on the arms and torso. In what manner does the material fold and overlap, and how thick or thin are these overlapping folds? See how far the overlaps crease or fold back into the body – they often become cut off, interrupted by a change of plane or simply taper out. If the outside fold edges undulate, the dips will be where the cloth comes to rest on the body. Try to unify these dips as they follow the body form like the dips in a rolled-up sleeve. Do not be afraid to lightly draw in the position of the arm. It will soon disappear when you build up the darker tones to describe these dips. However, you will have the advantage of knowing that everything lines up and corresponds!

As you near completion, cast your eye over the ellipses of the edges of the clothing at the wrists or arms, neckline, rounded conical drop folds and hemlines. Attention to detail will help to make your drawing more rounded and convincing.

To broaden your experience of working in pastel, try using a different paper. A rough watercolour paper, for example, produces a texture that is very seductive. You can prepare your own coloured ground watercolour or gouache, either as a simple flat area of hue or, in the style of Degas, establish gouache underpainting upon which you then work. You can also experiment with applying pastel to dampened paper – this makes the pastel extremely intense. For a slightly more painterly effect, try giving your drawing a clear water wash.

Painting the Clothed Figure

As we paint the clothed figure we will be looking out for all the elements of clothing and folds that we have observed in the previous exercise. However, we are now going to be painting in oils and this medium has its own discipline and a variety of approaches and techniques. Some of these processes will be worked through and illustrated and alternative methods will also be mentioned. Before we start, it is worth looking at flesh tones

PAINTING TIPS

Try to get as close as you can to the mix you want using only a few colours. Aim to use no more than three because otherwise you start to lose the brilliance of the colours.

Use a palette knife to mix the colours rather than a brush. You can wipe off all the paint from a knife very easily but traces tend to get stuck into brushes and this can murk the colours. Also, using a palette knife for mixing will prolong the life of your brushes.

Be sure to wipe and clean your brushes as often as possible.

Use different brushes for each colour and shade of colour. If you have a light red and a dark red, you will not want them to be mixed up.

Note that some colours are opaque like yellow ochre and others are transparent like alizarin red.

Lay your colours out on the palette with the warm colours on one side and the cooler colours on the other. This helps to keep complementary colours further away from each other.

in more depth since we are now working towards the bigger picture with all the elements coming together.

Skin Tones

You already know that there is no one formula for skin tone. Remember that while skin colours vary from race to race, each individual has a different complexion, which can be fair, ruddy, dark, weather-beaten, pallid or perhaps even ashen. Whatever the skin type, it will also be affected by lighting and the environment.

Although you can buy a flesh colour, most artists make their own. You will probably have noticed that when you really look at the skin in light and shadowed areas, you are able to see a range of colours. For example, on the hands and feet, which are ruddier than other parts of the body and the skin is close to the bones, you may notice pale green undertones over which redder colours lie.

EXERCISE: SKIN TONES

— OBJECTIVE: To analyse skin colour

— MATERIALS: Oil paints– hues used for the skin tone will depend on the skin type and the light: titanium white, lemon yellow, cadmium yellow, yellow ochre, cadmium red, alizarin red, Indian red, light red, burnt sienna, viridian green, cerulean blue, ultramarine blue, and raw umber. Oil sketch paper, rags, a selection of brushes, a palette, turpentine

— POSE/SET-UP: None

— TIME: 45 minutes

Draw four strips across some oil sketch paper. Divide each strip into five squares and paint each square the mixture of the colours listed at the top left of page 92. Start in the central square with the medium tone, a mixture of equal proportions of the colours. Then mix in more white and put it in the square to the right, then add even more white to the mix for the square furthest right: this is the lightest tone. The two squares on the left work towards achieving the darkest values of tone, with progressively less and less white until you are using no white at all.

The palette includes warm and cool colours, which are helpful when trying to describe planes of the body in relation to space because warm colours will appear to come forward whilst cooler shades recede.

White with yellow ochre produces a good colour and tone for the lighter areas of the skin and by adjusting the ratio of white to ochre you can produce skin tones that range from off-white and ivory to quite warm, creamy or tanned skin colours. It can also be a basis for much darker skin. You can vary these skin tones with the addition of other colours, as in the adjacent palette.

STRIP 1: LIGHT VALUE
Yellow ochre + White

STRIP 2: MIDDLE WARM
VALUE
Yellow ochre/Light red/
White

STRIP 3: MIDDLE COOL
VALUE
Yellow ochre/Raw umber/
White

STRIP 4: DARK VALUE
Yellow ochre/Raw umber/
Light red/Ultramarine blue

Yellow ochre/Alizarin
red/White

Yellow ochre/more
Alizarin red/less Viridian
green/White

less Alizarin red/
more Viridian green/
White

Viridian green +
Alizarin red = Black
add White and vary ratios;
add Raw umber or
Ultramarine blue

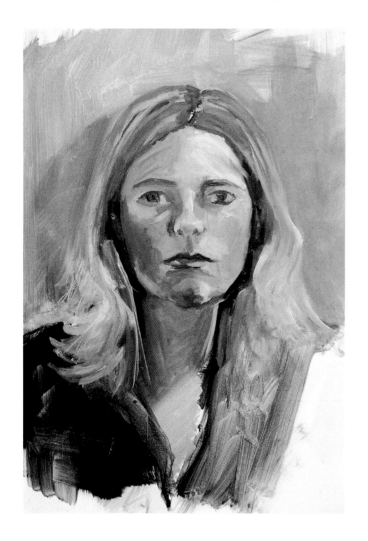

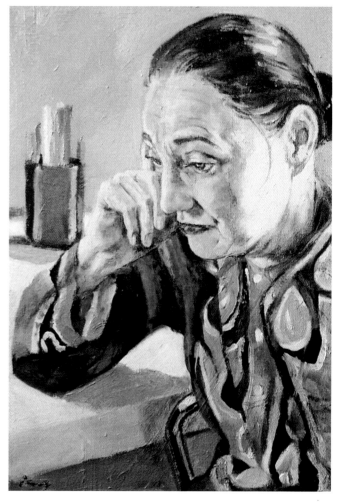

OPPOSITE PAGE:
TOP LEFT: **Earth skin colour tones.**

TOP RIGHT: **Alternative skin tones.**

BOTTOM LEFT: **This study has been painted using white, yellow ochre, Indian red, raw umber and French ultramarine only.**

BOTTOM RIGHT: **These skin tones are cooler.**
ARTIST: ALLAN DAY

THIS PAGE:
BELOW: **This woman has a pink complexion.**
ARTIST: PENELOPE PAUL

BELOW RIGHT: **Hues used for skin: raw sienna, cadmium red, cobalt blue, cobalt violet and terre verte.**
ARTIST: PENELOPE PAUL

Two mixtures are suggested for the mid-tones. For a warm hue: yellow ochre, light red and white. For a cool mid-hue: yellow ochre, raw umber and white. Of course, less white will be needed for these two mid-tones and again you can make a range from light to dark.

For the very darkest tones, mix yellow ochre, raw umber and light red. Instead of white, you could add a touch of ultramarine blue. Alternatively, you could substitute raw umber for burnt umber, which is warmer in comparison. You can also use the cooler Indian red instead of light red. White, broken with blue and a trace of yellow ochre, is useful for reflections in the flesh.

For alternative hues, try mixing yellow ochre, alizarin red, viridian green and white. Again, vary the proportions of colours in the mixture to produce a wider range of hues and tones. To cool and darken some of the hues try adding some raw umber to the predominantly viridian green mix. If you mix viridian green and alizarin red you will make a black. Burnt sienna is very useful for making skin tones as is cadmium red, which brings out warm pink tones.

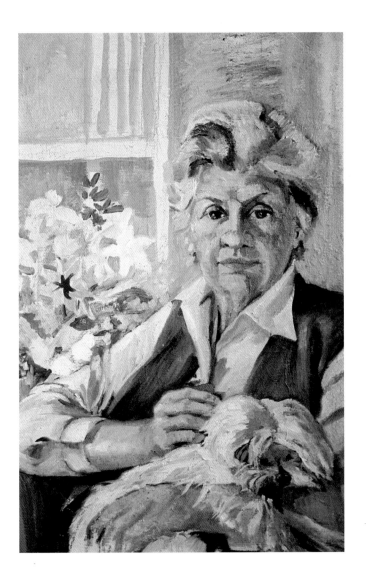

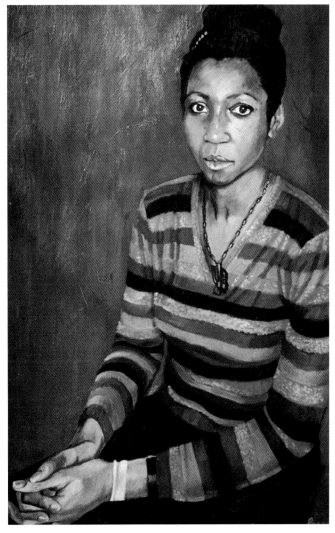

As you can see, you can go on and on producing flesh-like tones. It is up to you as the artist to select the one that is the most appropriate.

EXERCISE: **PAINTING THE CLOTHES AND FIGURE TOGETHER**

— OBJECTIVE: To paint directly or *alla prima* on a coloured ground canvas

— MATERIALS: White or coloured canvas or board. Oil paints: titanium white, lemon yellow, cadmium yellow, yellow ochre, cadmium red, alizarin red (use permanent rose for a purer red), Indian red, burnt sienna, viridian green, cerulean blue, ultramarine blue, and raw umber. Oil sketch paper, rags, a selection of brushes, a palette, turpentine

— POSE/SET-UP: Be aware of the daylight changing. Set up electric lighting so that your shadowed areas are consistent

— TIME: 1–2 full days

Alla prima is an Italian expression meaning 'at first go' signifying starting and finishing the final surface of the painting in one go or whilst the paint is still wet. Sometimes this technique is referred to as direct painting. You do not have to work on a white ground; you can prepare the canvas a day or two beforehand with a coloured ground of your choice. This could be an imprimatura (stained) or a toned ground (opaque colour applied evenly and flatly over the surface of the canvas). An imprimatura should dry overnight but the opaque ground will probably need a couple of days or more, especially when a white such as titanium is part of the mixture. Try to keep the paint fairly thin, which you can do by using some turpentine and not adding any oil. For alternative quick grounds you could stain the canvas with a watercolour wash or mix a coloured ground in acrylic but keep the mixture thin and smooth. Remember that you can paint in oil over acrylic but not the other way round.

The advantage of having a toned ground is that its mid-tone value will make it easier for you to judge light and dark colours in relation to it. Your painting will have a more finished appearance far more quickly compared to working on a white ground. This is because the ground colour, where seen coming through

THIS PAGE:
BELOW LEFT: **Thinned raw umber used to draw on a white ground. Simple floor–wall divide for background and some tone brushed in with a flat brush.**

BELOW MIDDLE: **Basic values in colour have been roughly blocked in.**

BELOW RIGHT: **Flats have mostly been used to execute the trousers as they make good edges. Yellow ochre, white, Indian red and raw umber have been used for the skin.**

OPPOSITE PAGE:
Notice how stripes convey a rotund body form and see how the detail of white stripes has been added last.

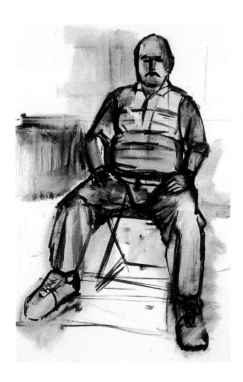 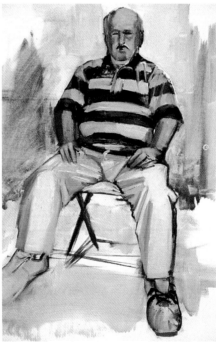 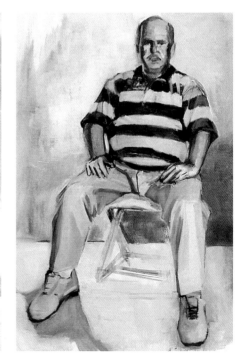

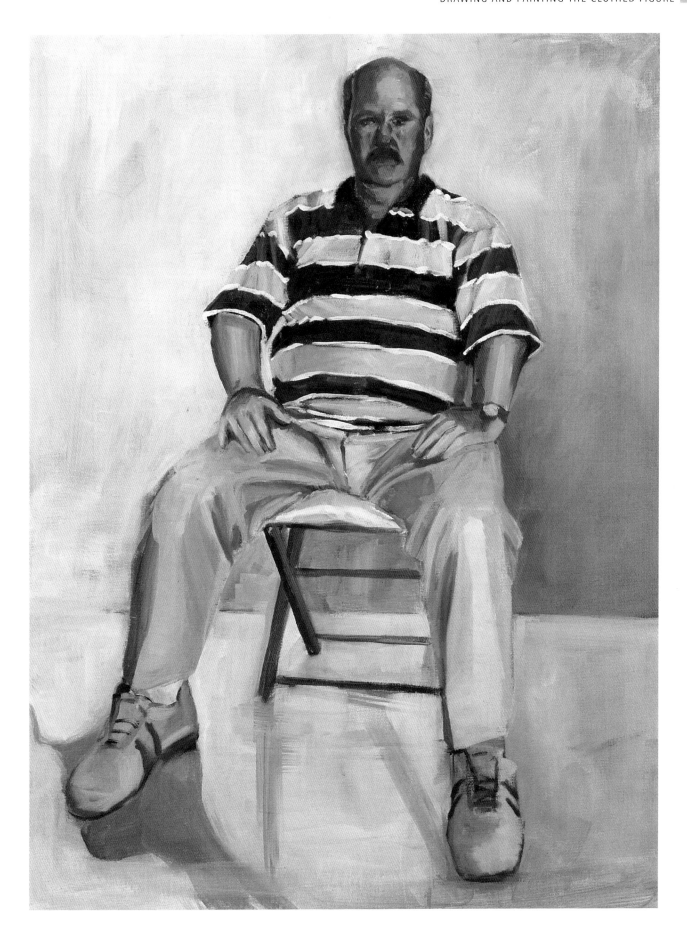

between gaps in the brush strokes, provides a unifying element to the painting. A completely white canvas entails much more work, as you need to fill the gaps so that you can begin to relate one colour to another. However, if you do work on a white ground, your colours will be brighter and more luminous.

First, lightly draw on the canvas in charcoal, dust it down and begin painting by blocking in the light, mid and dark values. Alternatively, draw in a very thinned-down oil paint such as raw umber (*see* below left). You can denote larger areas of tone with a broader flat brush. Look to see where the light is coming from. If necessary, squint in order to see better. The important thing to remember when oil painting in colour is that dark values are better kept thin because they allude to depth in the areas of shadow. Mid-values and highlights can have more body but always try to build up from thin to thick. If the paint gets messy take it all off with a palette knife and repaint.

Use a long-handled brush with a small round head to paint the drawing. The more turpentine you use, the more transparent and thin the paint will be, so if you make a mistake you can rub it back very easily with a clean rag. Spend time getting the drawing right, measuring and placing the figure correctly. Check all the elements of clothing, especially angular and soft folds and thicknesses of fabric depicted by the edges of clothing and the volumes of material between folds.

Avoid the worry about whether an arm is in the right place when you start painting in the colours! As you draw your model, build up the space around the figure at the same time. A simple line to divide the floor from the wall, a window perhaps, or any other simple element. Backgrounds in painting become important as the spaces (areas of painted colour) help to define the body. The edges of this painted patchwork quilt also then become relevant because it becomes like handwriting, unified or disjointed. Wipe back areas if you make mistakes and redraw where necessary. Once you have drawn the image you will feel more confident about placing your shades and tints.

Tidy or clean your palette if you need to mix up some colours. Avoid making hues randomly because you will end up with too

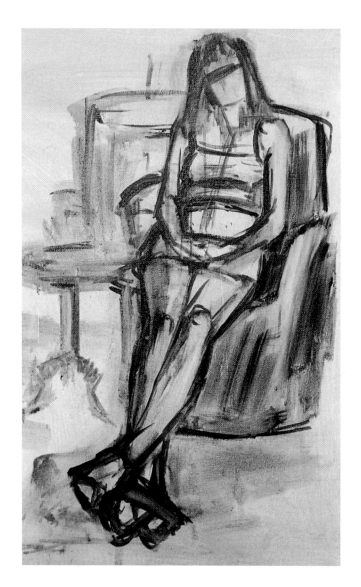

Outlines painted in raw umber on yellow ochre imprimatura.

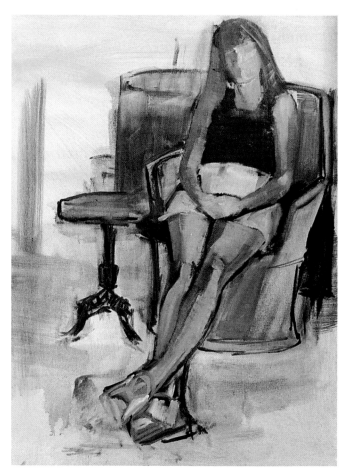

Basic colour values are blocked in.

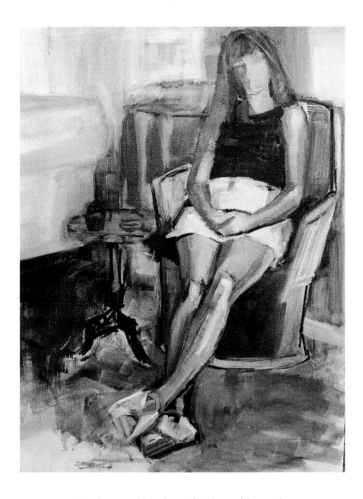

Background has been further addressed.
Skin tones have been made to appear
more golden with the use of burnt sienna.

with the painted marks you will start to colour mix on the canvas. This can lead to the hues becoming murky and the attractive textured brushstrokes will be lost. If this happens and part of the painting is spoilt, just scrape the paint off the offending area with a palette knife and rag and paint it again.

Although you may find the result has a sketchy or not very detailed look, it will nevertheless have a lively, spontaneous and immediate quality that is one of the attractions of painting *alla prima*. The lighter tones of the painting should be the ones applied the most thickly and be the ones you apply last. Reserve the white dashes of paint, which are considered the lightest tone in painting, until the end. Notice however, that seldom is the white highlight actually really white, it is usually slightly broken with another colour. The term 'broken' here means just breaking the white with another colour but it can also mean a colour that

White stripes are painted on wet red background.
Each stripe is a single brushstroke; the brush is
then wiped on a rag and reloaded with paint.

much on your palette and as it gets muddled so will your painting. Make the light, mid- and dark values beforehand. Mix a colour that is roughly the hue of the clothing you see and then mix a dark tone and a light tone in relation to it. For the moment, leave the raw umber as your dark flesh tone and make a skin tone range appropriate to the model. Although you may get the exact hue of the dress and the precise tonal range of your sitter, the hues may jar and skin tones might appear too orange when seen next to the blue of a dress, or too pink or red next to a particular green because of complementary colour relationships. So be prepared to adjust.

Also, think of the order of building the painting. If, for example, the model's hair falls over the dress, then paint in the background areas of the dress before you apply the hair-coloured paint that sweeps over it.

If the clothing is patterned, you can lay colour out side-by-side or boldly lay wet over wet layers. However, if you start fiddling

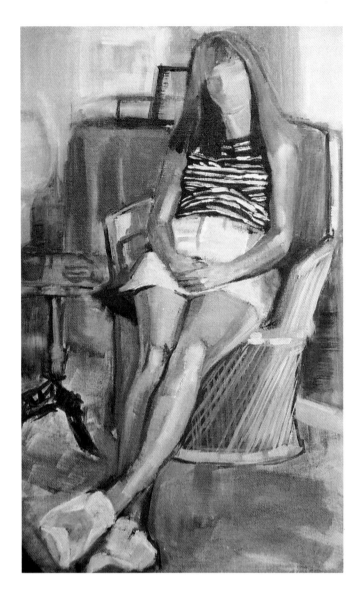

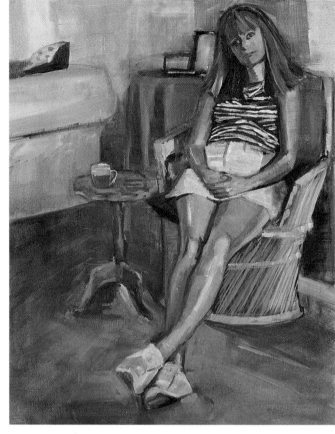

ABOVE: **Hair swept over t-shirt and other details are added to background.**

ABOVE RIGHT: **Highlights are painted last, like the light sheen catching the thigh and shin.**

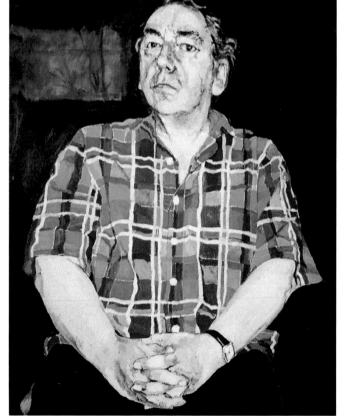

RIGHT: **See how effectively the check pattern squares describe body form with their folds. This painting has been executed in layers that have been allowed to dry in between.**
ARTIST: ALLAN DAY

is patchy or broken up by another hue that is adjacent to the first hue and applied in alternating patches or coming through from a layer beneath (*see* girl's shorts on page 84).

Painting in Layers

The picture (*below*) was started from life and carried on from a photograph. The man was delineated in oils using achromatic black, white and grey on a pre-primed acrylic ground of Indian red, white and yellow ochre. Dark tones were kept thin; light tones had enough body colour (opaque and slightly denser application) but were still sufficiently thin to shorten the length of drying time.

If the model is angled away from you, the body will be seen in perspective and therefore so will the clothes. Shirt collars and lapels on jackets are really useful to see angles in pairs to use as a guide. The perspective is very slight here. Note how the fabric of the trousers flows down, a rhythm can be seen in the crease line and then the excess fabric buckles and billows out upon reaching the ankles and feet.

Once the figure was dry, further modifications were made and detail added, such as facial characteristics and the hands. The glasses were painted as part of the face from the outset once the eye socket was established. When most of the figure was completed, the background was sketched in with diluted raw umber and shadow areas were quickly blocked in. Some white paint was brushed on thinly to give opacity to light areas. The painting was then left to dry.

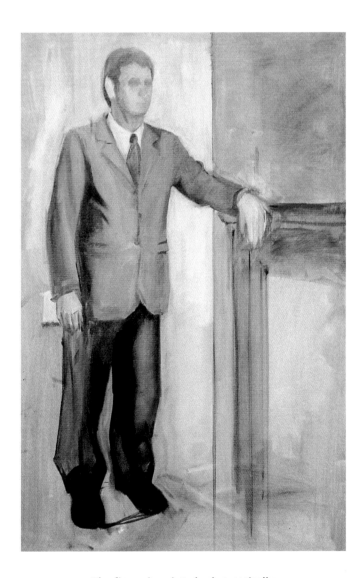

The figure is painted achromatically on a coloured ground.

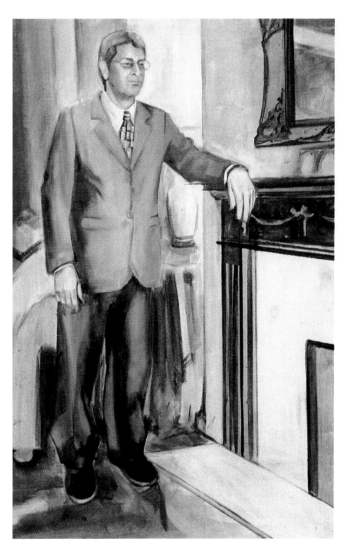

Facial features added and background sketched in. Painting left to dry.

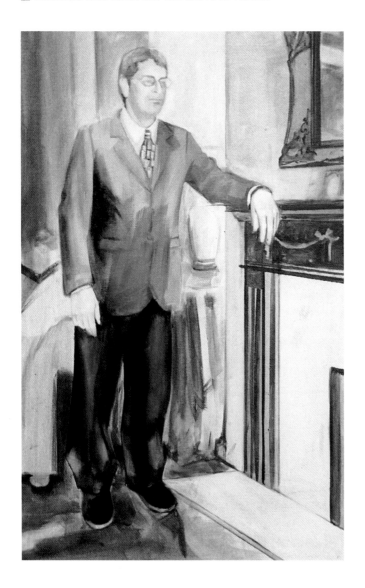

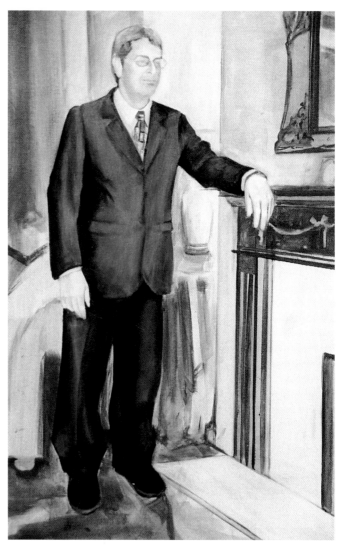

ABOVE LEFT: **Skin is given some colour.**

ABOVE: **Suit is given first glaze. Note that few folds in the fabric reflect the fairly static pose. A simple crease describes space between body and sleeve of the jacket's left arm.**

The suit was then glazed using ultramarine blue and in darker shadow areas a little black was added. Skin tones were painted in and blended. Ivory black was applied to some areas of the hair (the light tones were added later).

Basic colours were applied to the background – yellow and opaque white for the lamp, burnt sienna over the wooden mantelpiece and tablecloth behind, burnt and raw umber for dark areas of shadow. A little yellow ochre was used for the floor. Apart from the defined mantelpiece area and mirror, the rest was kept vague. Bigger brushes were used; consequently the background was established in minutes not hours. When the painting was dry, more thinned glazes were added, made more fluid by the addition of linseed oil.

Yellow ochre and lemon yellow were used gingerly, whilst raw and burnt umbers were used to darken as was black and ultramarine blue for the shadow areas of the suit. Burnt sienna was glazed in large background areas to help unify the painting.

Conclusion

In this chapter we have looked at drawing and painting the body and the clothes together using pastels and oil paint. Issues of form have come into play which naturally lead you to observe the stuff of cloth, its density and fold. We have also dealt with colour in relation to skin tones with emphasis on oil painting techniques. In the next chapter we will take another look at folds and identify some formal elements to think about when making a composition.

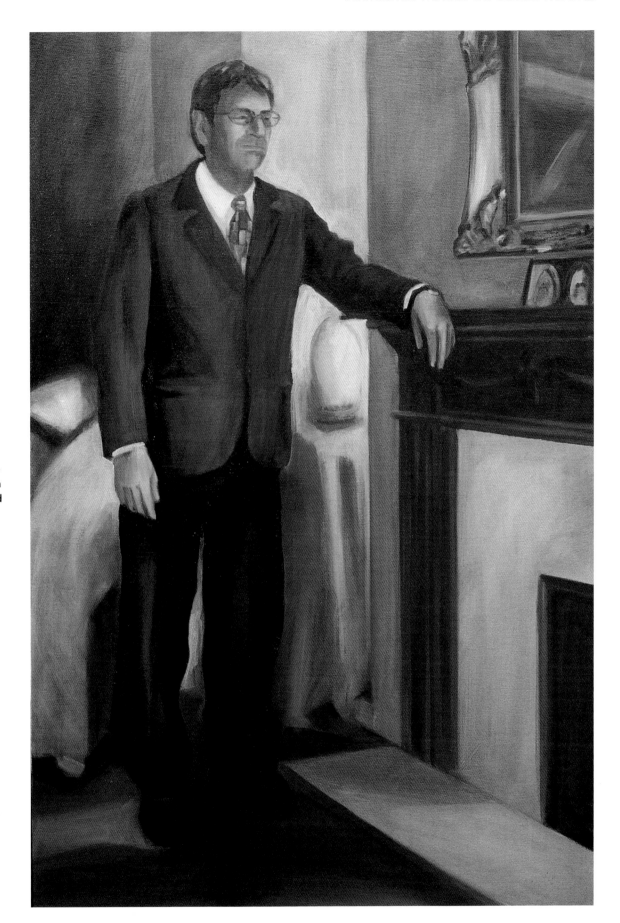

Once the background is painted and has dried, the whole painting is given relative coloured glazes again.

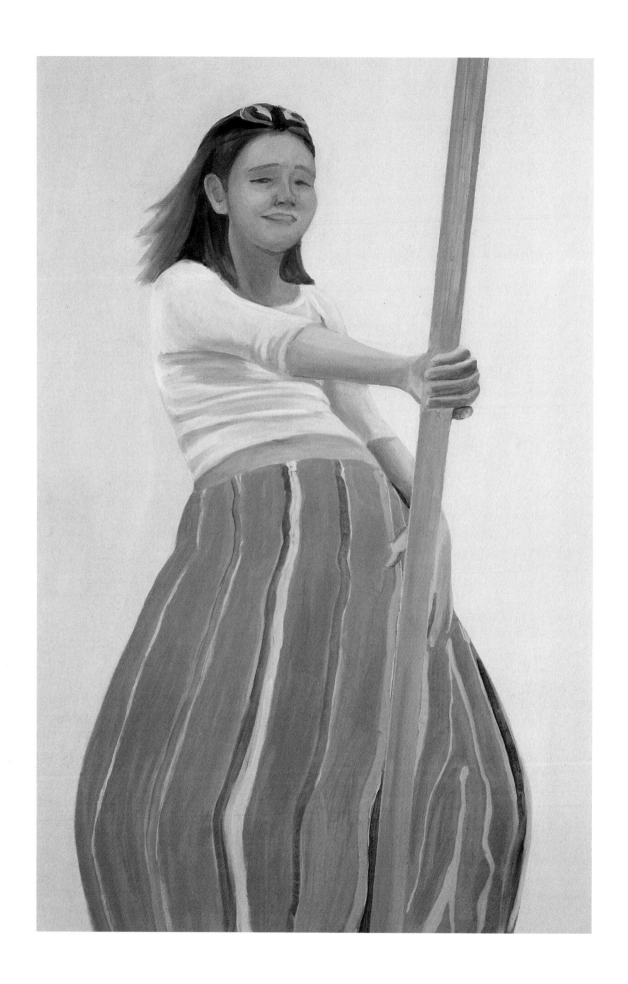

DIFFERENT POSITIONS AND COMPOSITIONS

This chapter will begin by focusing on the general type of folds to look for according to body posture as well as differences to be noted related to individual body characteristics such as age. The observations made will help to make the clothed pose look more realistic whilst at the same time increasing the awareness of body shape or size. We will then move on to elements of composition, focusing on observational drawing and the making of a picture. Different viewpoints will be explored a little further as will the various devices used for composition including more formal approaches. These can assist the artist to express an intended meaning, making a piece of work more effective as well as influencing how a picture may be perceived or read by the viewer.

Different Positions

We have already looked at the relationship of fabric to the figure and the various types of fold likely to be encountered. However, bearing in mind that people come in many shapes and sizes and stand in all manner of positions and poses, it would be useful to run through these laws of fold again and relate them to our clothing.

Making studies of individual clothed body parts will help you to really look and focus on the fold and form without getting worried about the rest of the body.

Leonardo da Vinci made studies of drapery in the clothing worn by his models, observing sections from the lap and knees to the ground as well as the sleeve and cuff areas of fabric in relation to the positions of the arm, wrist and hand. Clearly, creases in the draping fabric will fall or hang differently if the hand or arm is being held up in a gesture compared to being left hanging down to the side of the body in a relaxed position.

The following exercise will demonstrate how different materials may behave when the body is in the same pose. Use a model who should be prepared to change clothes for you and try a range of positions, especially those that people often hold, so

OPPOSITE PAGE:
THE STRIPED POLE DANCER.

THIS PAGE:
Sleeve collapses down.

103

Fabric flows with form.

that you can observe how the folds behave when key parts of the body are bent, relaxed or stretched.

Be considerate to your model – some positions, such as a raised hand, are very tiring to maintain. Part of the solution can be to use supporting props like an easel to hold on to or a windowsill to rest the fingers on.

You can also make further studies where and when the chances arise. Take advantage of any opportune moments – ask your

friends or members of your family if they would carry on sitting just as they are, but keeping their arm, or perhaps their leg, as still as possible for half an hour whilst watching the television, reclining on the sofa. Try to carry a sketchbook with you as much as possible and you will get into the habit of seeking and benefiting from such moments in a way that will not impinge too much upon your sitter's time. With luck, you should be able to capture a range of body types and shapes. You can also make some studies from your own clothed body parts reflected in the mirror. The sitting bent knee position is a good one (*see* page 105), as you can see yourself both from the front and sideways with the extra bonus of being able to take as long as you want on the drawing!

EXERCISE: **FOCUSED STUDIES**

— OBJECTIVE: To analyse folds as they reveal body shape and posture

— MATERIALS: Any drawing medium

— POSE/SET-UP: Various

— TIME: 20–30 minutes or longer for a highly detailed drawing. It will also depend on the complexity of the folds and the area under focus

THE STANDING LEG POSITION

When the figure is wearing trousers, there may be creases at the waist and, depending upon the cut, at the knees and ankles. The flow of the folds will be downwards, and subtle but easily visible folds radiating from the knees will indicate the leg positions and directional pull.

THE BENT LEG POSITION (SEATED FIGURE)

Notice the conical drop shape fold that occurs very often when a seated person is wearing trousers. The conical edge shape or the hem will be more angular when the material is pressed to have a crease line. The kneecaps can indicate a bony or fleshy body shape beneath, which in turn influences the creases or wrinkles radiating outwards with more or less abundance of fabric between the folds as the material either stretches or becomes baggier.

The knee is an angular hinge point of support from where the fabric falls. As the knee bends to change direction, the fabric imitates the form beneath and conforms by folding too. The manner in which it does so is angular and abrupt, causing flap-like shapes on either side of the knee when seen from the front and a half-creased fold, known as a half-lock, when seen from the side. The number of flaps will vary depending on the cut – clearly you will not see them if the material is stretched – but a half-lock will still be observable.

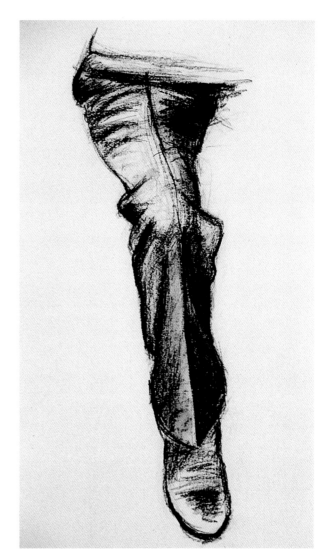

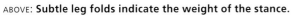

ABOVE: **Subtle leg folds indicate the weight of the stance.**

ABOVE RIGHT: **Notice knee flaps that form from the half-lock fold and the conical drop fold that is angular because the trousers are pressed.**

RIGHT: **Side view of half-lock fold, where two opposing directions meet.**

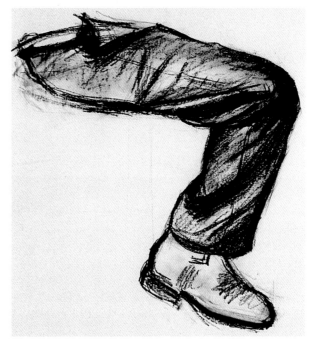

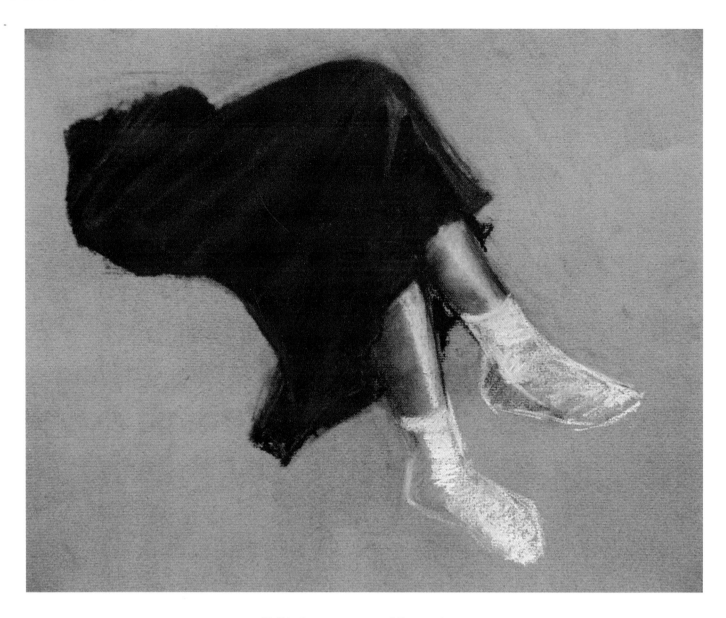

**Half-lock occurs on seated figure where
thigh and pelvis change direction.**

THE PELVIS THIGH POSITION (SEATED FIGURE)

Like the bent leg position, the torso of a seated figure behaves in a similar manner as the thigh bends horizontally whilst the pelvis remains or is directed to the vertical position. Note the half-locks at the angular bend on any non-elastic clothing, which includes fitted skirts. Where the legs are crossed beneath the skirt, draw in where you think they are in order to maintain the line of continuity. The folds themselves will help to indicate the position of the legs but they may also produce overlapping folds that hang over the edges of the limbs, so check to see that your limbs line up!

THE BENT ARM POSITION

As the arm bends to change direction, you will again note the half-lock fold. Like the knee area, if the garment worn is made of a crisp material such as cotton or a thicker material, you will see the extra flap-like folds of material when viewed from the front or back. Zigzag folds may appear on the sleeve as the material crunches up or compresses on the outside edge due to a stretch on the inside edge from armpit to elbow.

The planes of fold follow a kind of diamond-shaped pattern. Imagine that they are made of paper, folded in half and then opened again so that the planes of each diamond dip down to

ABOVE: **Half-lock is visible on the inside edge of the elbow. The visible elbow shape indicates fabric thickness. There is a rounded cuff.**

ABOVE RIGHT: **Half-lock at elbow and fabric indicates its thicker qualities; zigzags are formed too.**

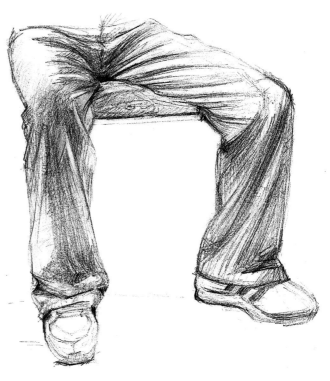

the middle and then rise up to the crest. However, these crests and dips do not really align but zigzag around.

Notice the pointed or more moderated angularity of the elbow itself, which will again indicate body type as much as the fabric.

This is also a good time to look at the edges of cuffs and sleeves in more detail, which as we have already noted, will be rounded, forming ellipses as they follow the cylindrical body shape.

Stress and Tension Points

Stress points are the areas such the underarm or the groin in trousers that are designed to accommodate the directional changes of the body. Check whether these areas are slack or taut: fold can indicate the fit of a garment. Maybe it is stretched and taut as the folds radiate out in the direction of a movement or stretch as indicated (*see* right) from the groin to the knee. The

Pipe folds radiate from the groin in the direction of the knee, which is the hinge point that stretches and pulls.

ABOVE: **Tension point at the waist where belt is attached.**

RIGHT: **From thigh to knee trousers fit more like a second skin.**

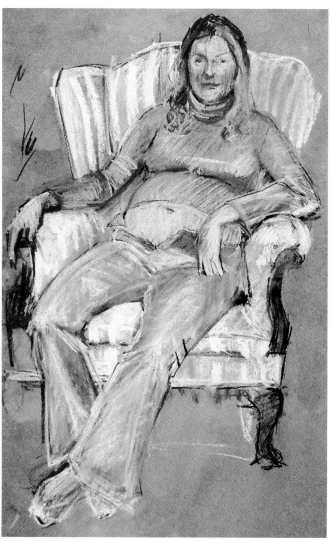

OPPOSITE PAGE:
This quick study captures the bony knees well, which serves to heighten the leanness of form.
ARTIST: ALLAN DAY

same rule applies to any fabric stretched from shoulder to elbow or perhaps elbow to wrist.

Tension points are areas of clothing that are fixed or anchored to the body through waistbands, belts, ties or buttons. These too will indicate posture or movement as well as the shape of the body underneath.

Different Body Shapes

Clothing will probably fit an overweight person more tightly unless the garment is free flowing. The material will stick pretty close to the body with shorter creases and folds radiating from the tension points at the underarms and waist. On thin people, the excess of material in loose or baggy clothing will make the garment appear to droop and will most likely be more full of folds.

EXERCISE: **POSITIONS AND POSTURES, SHAPES AND SIZES**

— OBJECTIVE: To make the clothes work for you

— MATERIALS: Any drawing medium

— POSE/SET-UP: Sitting, standing, lying down, perhaps bending or stretching

— TIME: 20–30 minutes for each pose

Try to notice the folds made in the clothing and pay attention to the hinge and tension points, which will be indicated by the pull of the folds and the stretch and direction of the actual pose.

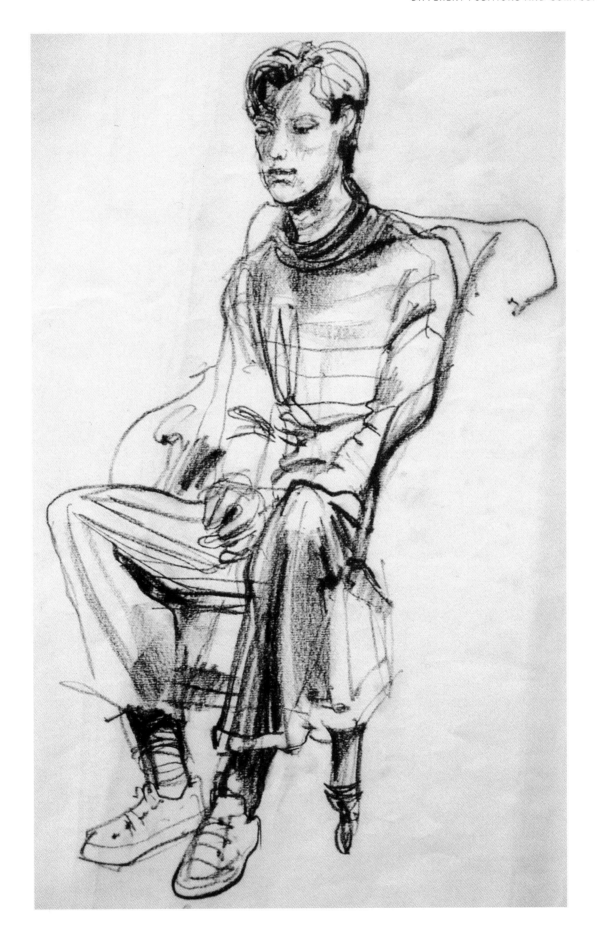

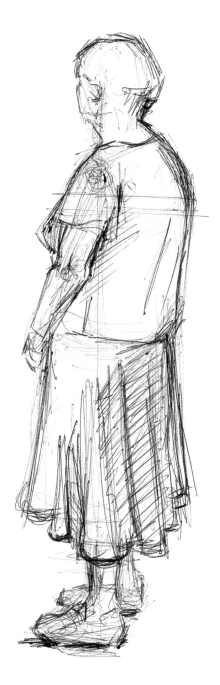

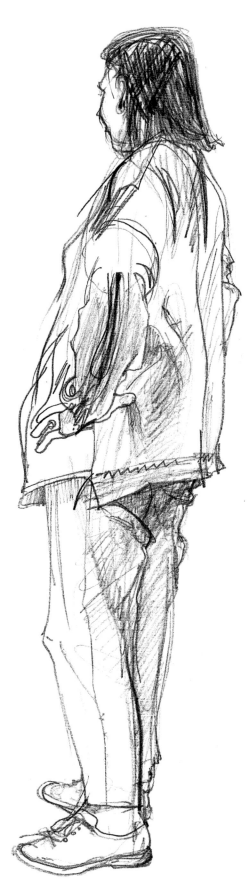

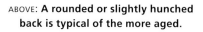

ABOVE: **A rounded or slightly hunched back is typical of the more aged.**

RIGHT: **This person is not so lean in parts as there is a suggestion of a tummy. But notice how baggy clothes get saggy or droopy suggesting an older person.**
ARTIST: ALLAN DAY

RECLINING MAN
Note the folds pulling in the direction of the stretch.
ARTIST: ALLAN DAY

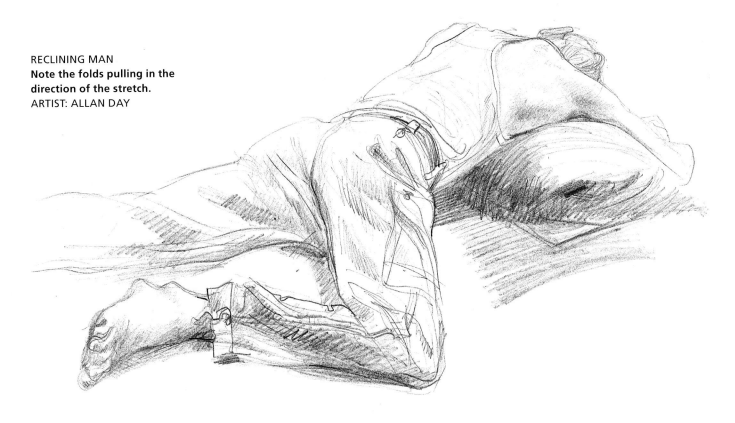

BELOW: **Collapsing folds on the girl's trouser legs.**

RIGHT: **Note the folds of this hooded sweat jacket that pull toward underarm stress point.**

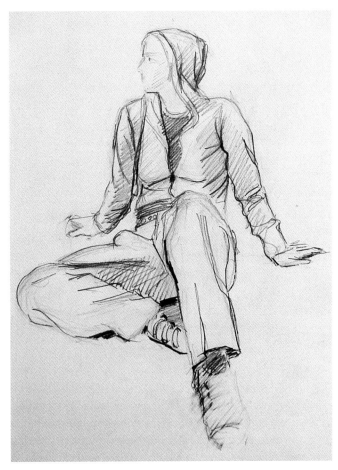

One snake line describes the movement
of the body from crown of head to toe.

Outside form mimics the central rhythm within.

EXERCISE: **BODY RHYTHM**

— OBJECTIVE: To communicate the main gesture, thrust or
direction of the pose.

— MATERIALS: Any drawing medium

— POSE/SET-UP: Stretching and bending positions that
exaggerate the pose or are more dynamic and only possible
to hold for a limited period.

— TIME: 3 minutes each

You can achieve a sense of the posture with minimal use of line
to indicate the skeletal inner structure. Work quite quickly, keep-
ing your lines curved and fluid, searching for the main continu-
ous sweeps that best describe the rhythmic pattern of the body.

Starting at a natural point such as the head or neck, draw the
central line through the body mass of the torso, down to the
crotch area and find the more accentuated leg. Whatever your
viewpoint, keep the line central to the mass even if you are
approaching this from a side-on view. Try to be aware of arches
and curves of the outer body edges, for these are mimicking the
rhythm of what is going on within.

Move your drawing tool to find the central line for each leg in
turn, and then in one fluid line describe the movement or stretch
from the thigh to the toes. Keep these curves simple as your own
hand sweeps in gesture, imitating the action of the figure. Now,
draw the arms in the same manner.

Once you have the basic structure, look for the longest outside
edge of the form that best describes the whole movement. Try to
accentuate this outer dynamic by observing the continuity on outside

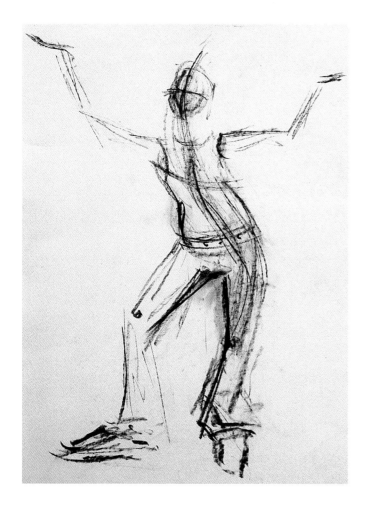

Quirky poses are fun.

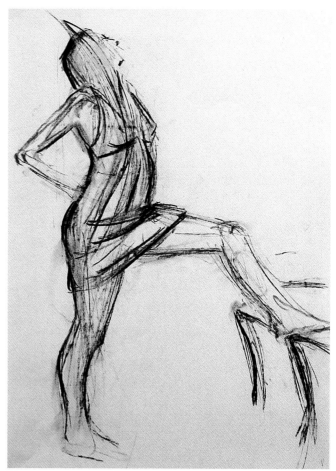

Folds describe stretch.

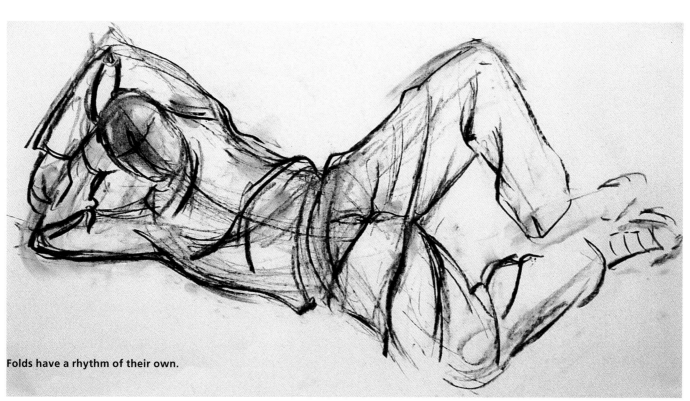

Folds have a rhythm of their own.

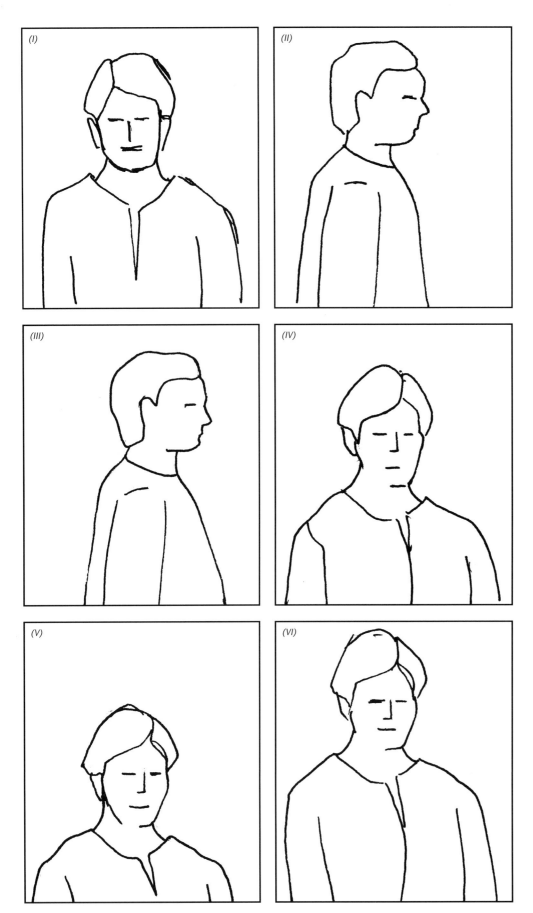

HOW PLACEMENT
AFFECTS THE IMAGE

(I) dead on
(II) side view
(III) walking out of the picture
(IV) three-quarter
(V) a little low
(VI) more harmonious.

edges where flaps, folds and bumps come back to the body form. Likewise, draw in and perhaps stress those folds that best describe the rhythm of the posture on the inside of the body.

Composition

Composition is the arrangement of different parts or elements such as line, tone, colour, perspective, scale and space that together make up the whole picture that we see. Most artists work by intuition when it comes to composition. However, when attempting to execute a painting rather than a study or quick sketch, the majority will probably have played around with some of the elements of composition, processing and selecting those that they find both visually appealing and likely to lead the viewer to the main focus of attention in an interesting or pleasing way.

Some decisions have to be made whether you make them consciously or not. Let us take a figure portrait – should it be full length, quarter length or just the head and shoulders? Should the figure be placed in the middle or just off-centre? What would happen if the figure was placed to one side?

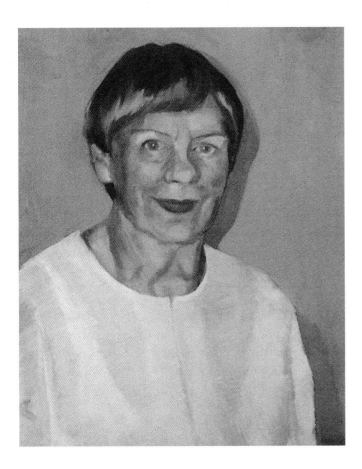

Head is placed a little to one side.

Framing the head and shoulders in the middle of the picture and facing the viewer square on will certainly draw the eye straight to the focal point. However, it might also make the picture appear a little like a passport photograph, particularly if the sitter stares straight back at you. If you position the top of the head slightly higher than usual, the picture will appear more natural and harmonious. Interestingly, if the head is placed too low, the impression is that the person is in the act of sinking down through the bottom of the picture. A side profile seems to need a bit more space in the front facial area rather than at the back of the head, otherwise the figure can appear to be walking out of the picture.

Although none of these positions are wrong, for an artist may compensate in a number of other ways to draw the eye back into the picture, you still might choose to avoid one or two when following a particular agenda. For example, if your mission is to portray an awe-inspiring personality then a sinking figure might appear a little odd if not comic.

You will also need to decide how much space should surround the figure and what scale the figure within this space should be – small, life-size or larger? (It is worth bearing in mind that it is more difficult to render a naturalistic figure portrait when the head is larger than life-size.) Is it to be a realistic background setting and if so, will it be done from life or built up from various studies and accumulated information? Alternatively, you may want the background to be fairly dark or modulated with shaded lighting or perhaps just painted in one flat colour. If you can make such decisions before you start a painting then you will be free to concentrate on colour, texture and tone.

If you already have a layout plan, you will know what you are aiming for and can refer to it as a guide. Following a plan will save you time and materials as well as quite a bit of frustration. It is also very useful for keeping the proportions of your figure in check – when you are deeply involved it is alarming how the easily the body can change in size in a most unintended way!

Composition can sometimes seem complex and rather dull, especially when you just want to jump in with the paints and get going. However, it is important that you should have knowledge of and understand the theoretical aspects of painting; otherwise it will probably show and weaken the picture as a whole.

Spending a little time thinking and playing around with possibilities should produce better results than just hoping it works out. The most spontaneous-looking works have often been pre-planned and working methods thoroughly thought out.

Composition will make you more aware of your own particular focus, what it is that really interests you. The most important elements are inspiration and to have an idea, so you are motivated to produce a piece of work.

There is a need to address the area surrounding the figure. This will probably have already become apparent to you when painting the clothed figure in the previous chapter. By dealing with the whole two-dimensional surface, it mattered how to

A dynamic and interesting self-portrait.
ARTIST: ALISON BOWLER

cover it in order to make the picture or painting appear complete. If you were working on a white ground canvas or will do so in the future, this necessity will be highly apparent. But before we begin to look at where spaces may occur or how much of it there could be on your two-dimensional surface, let us experience space by drawing it.

EXERCISE: **DRAWING NEGATIVE SPACE**

— OBJECTIVE: To see form in a different way by drawing negative space

— MATERIALS: Any black and white drawing medium

— POSE/SET-UP: Seated, backdrop of a plain-coloured rectangular screen or panel

— TIME: 1 hour

The aim of this exercise it to arrive at the form or shape of the object, in this case the figure, not through its outside edge but through the shaped space that meets the outside edge. This way of looking really helps you to see the form in a different way. Sometimes when we look at an object, we repeat the same mistakes. We cannot 'see' any more and although we know that it does not look right, we are unable to change whatever it is that is not working. However, if you look at the spaces between the elements of the body and convert these spaces to shapes, you can instantly see where you have been getting it wrong. This is because you are defining the positive mass by paying attention to what is around it and it has the effect of making you see everything afresh.

You may have trouble keeping your focus on the shapes made by negative space because your brain wants to revert to the outline of the form. Try visualizing these spaces as landscapes or the sea surrounding an area of land. From underarm to waist could be seen as a cove, where the sea meets the shoreline. You can also try imagining these spaces as parts or variations of geometric

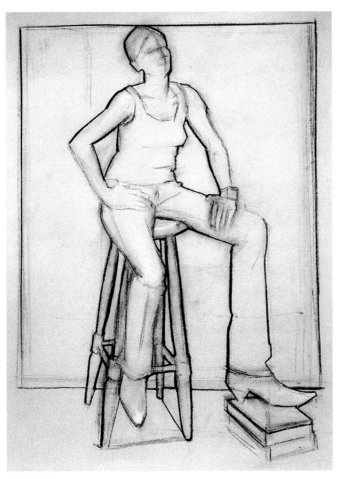

Drawing shapes of space to establish the figure.

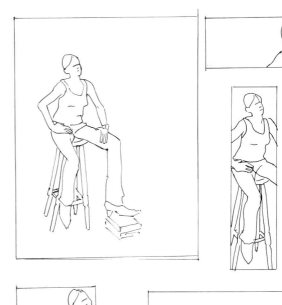

**Cropping and changing pictorial format
really changes the feel of the image.**

shapes. This approach is particularly helpful for checking your angles as well as simplifying perspective when drawing chairs, stools and the spaces in between the legs of both. The results of arriving at the representation of a figure using this method can be observed, for there is this paradoxical quality to the drawing – a solid sense of space.

EXERCISE: **PLAYING WITH SPACE**

— OBJECTIVE: To see how space can affect a composition

— MATERIALS: Pencil

— TIME: 30 minutes

Find a small figure drawing, perhaps one that you have done in an earlier exercise. If all of yours are too big, then reduce one using a photocopying machine. Trace the outline and then draw a series

of different sizes of paper or canvas on a separate piece of paper. Superimpose your tracing on to each one, and experiment with cropping and changing the position. Make a few choices so you can see how position and working dimensions can give you possible options.

EXERCISE: **STUDYING COMPOSITION**

— OBJECTIVE: To analyse different elements of composition through studying the old masters

— MATERIALS: Pencil, coloured pen, coloured pencils

— TIME: To be researched in your free time

There are books devoted entirely to composition but we will focus on just a few of the basics, establishing elements such as scale, space and perspective in the process. The following

exercise will help you to be more conscious of the composition-al pattern as the picture is created.

Choose an artwork that interests you from any era and make small thumbnail sketches, simplifying the elements of composition to the basics. However, to analyse the golden section below, you will need to be precise, so photocopy (and reduce if practical) your picture or make tracings.

When a picture works it is usually because there is a striking or pleasing arrangement of the position, line direction, tone and colour not to mention echoing shapes, texture, rhythm and space. When you study your chosen works or indeed take a critical look at your own drawings and paintings, ask yourself which elements of composition are inherent in the work. You may be pleasantly surprised to find that you have instinctively achieved one or two. The trick is to have the ideas first, and then consider the elements of composition that may enhance your work.

THE LADY WITH THE ERMINE
ARTIST: LEONARDO DA VINCI

Notice how the golden section falls between the eyes of the woman; the hot spot falling on the ermine is significantly interesting.

Placement and the Golden Section

Electing to place the main object of focus at the centre of the composition will produce a harmonious and symmetrical effect and the viewers' eyes will naturally be directed straight to it.

However, during the Renaissance there was a revival in the popularity of a mathematical rule called the golden section, first devised by the Ancient Greeks. This rule states that any line divided such that the ratio between the smaller and larger sections is the same as the ratio of the larger section to the whole, is particularly visually attractive.

The ratio of the relationship between the two sections works out to approximately 1:1.618 and this is known as the Divine Proportion. There are many books on the subject and it can become quite complicated, requiring mathematical skills. However, it is worth bearing the principles in mind so that when you place your object, figure or divided sections of space they can fall into a similar arrangement, making the picture a little more interesting as well as harmonious and appealing.

Hot Spots

The intersection of two golden sections is called a hot spot, and because both golden sections draw the eye to this point, they can be a particularly effective compositional tool.

As an example, this portrait by Leonardo da Vinci (*left*) was thought to be of Cecilia Gallerani, the mistress of Lodovico Sforza, the Duke of Milan. One golden section crosses through the woman's innocent face and the hot spot occurs right on the ermine's predatory eye, which was one of the emblems on Lodovico's coat of arms.

In *Marriage Settlement* by William Hogarth it is interesting to see that the horizontal golden section divides the spatial arrangement of the figures, restricting them to the lower two-thirds of

TO DRAW A GOLDEN RECTANGLE

Start off with a square. Draw diagonals to find the half-way mark of the bottom edge then draw a diagonal from there to a far corner. This diagonal is the exact extra measurement needed to form a golden rectangle, its starting point being at the same half-way point of the square. The red line is a golden section and anything placed along this line appears visually harmonious or pleasing. By mirror imaging the dimensions you can find the golden section for the opposite side.

THE MARRIAGE SETTLEMENT
c. 1743.
ARTIST: WILLIAM HOGARTH

The sections divide the narrative, creating interest.

BELOW:

(I) Diagonal dotted line is the length needed to make the golden rectangle begin from the same point of origin.

(II) Red line is the golden section within the golden rectangle.

(III) The ratio of the smaller section to the bigger section is the same as the bigger section is to the whole.

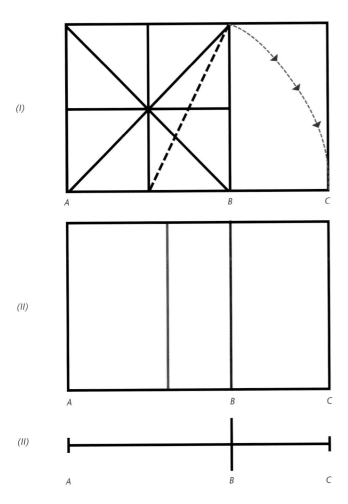

(I)

(II)

(II)

the painting. Find the vertical golden section and mirror it to attain the other side. Note how the lines divide the figures, which neatly reflects the narrative of the story. The section on the left contains the ill-fated couple along with her future lover; the middle section contains the bride's miserly merchant father, the money settlement and a creditor pestering the impoverished earl, who sits in the band on the right along with his family tree, which is all he can offer in return.

You can also make a golden rectangle or find the golden sections within a unit of length by using the following formulae.

If you have already have a dimension that you would like to be the small golden section in relation to the greater length, then multiply the small dimension by 1.618.

$$BC \times 1.618 = AB$$

If you have the larger dimension and would like to know the smaller golden section, multiply the dimension by 0.618.

$$AB \times 0.618 = BC$$

If you have the smallest unit but would like to find out the length of the whole unit, you will have to calculate the intermediate length first. Multiply the smallest unit by 1.618 then add it to the smallest dimension which will give you the whole unit of length.

119

$$BC \times 1.618 = AB$$
$$BC + AB = AC$$

If you have the length of the whole unit and you want to find the shortest unit you will have to calculate the intermediate length first. Multiply the total length by 0.618 and then subtract it from the longest unit to find the smallest golden section.

$$AC \times 0.618 = AB$$
$$AC - AB = CB$$

If you choose to place a large mass at one end of the picture, how would you distribute mass on the other side? You must rely on your own sense of what you feel looks balanced and remember that it does not have to be symmetrical – it can be quite scattered and of different proportions.

Horizontal and Vertical Line Direction

What is meant by line direction is not so much the quality of lines used in a particular form (although that is important too) but the simplified direction of that form. A figure standing straight, for example, translates to a vertical line and a horizontal figure to a horizontal line. These directional lines can convey qualities – the vertical and horizontal line structures suggest something static or still, or may allude to security and strength.

Try to remember to add interest to the main upright thrust of a standing figure otherwise the composition may appear monotonous. You could, for example, modify it with horizontals. Since in the western world we tend to read from top to bottom, without some device such as modification of body posture, tone, colour, lighting and so on, the general direction of the line may cause the eye to start at the top of the picture, run down the length and off

MR AND MRS ANDREWS **by Thomas Gainsborough presents an interesting arrangement of balance.**

Simplifying the masses shows how the tree shapes stop the composition from tipping one way.

(I)

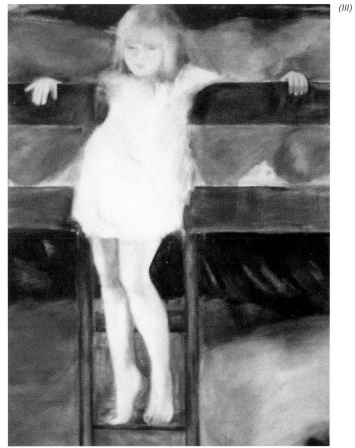

(III)

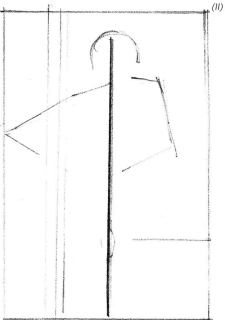

(II)

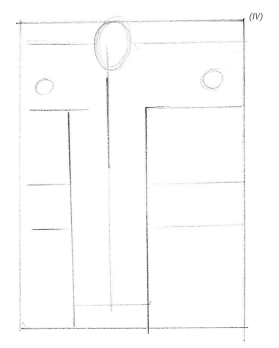

(IV)

(I) Evaluating simple compositional line direction of a Max Beckmann self-portrait (1927).

(II) Note the strong verticals are broken with horizontals and diagonals.

(III) Vertical compositional line is balanced with counteractive horizontals.

(IV) Analysed line scheme.

121

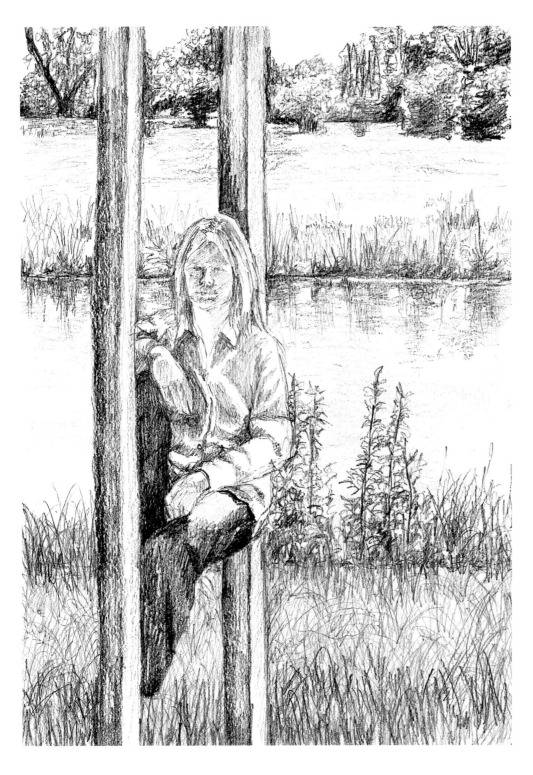

**Landscape strips balance
the strong vertical line.**
ARTIST: ALISON BOWLER

the canvas without stopping. Imagine either of these predominantly vertical compositions without the horizontal bands. Likewise, when drawing a horizontal figure in repose, think of some objects and shapes that could be brought into the design to create not only interest but to break up horizontal bands of line.

Diagonal Lines

Diagonal lines lead the eye right into the picture. They can create depth like the linear perspective of a road converging on the horizon and make your eye travel across the picture plane from

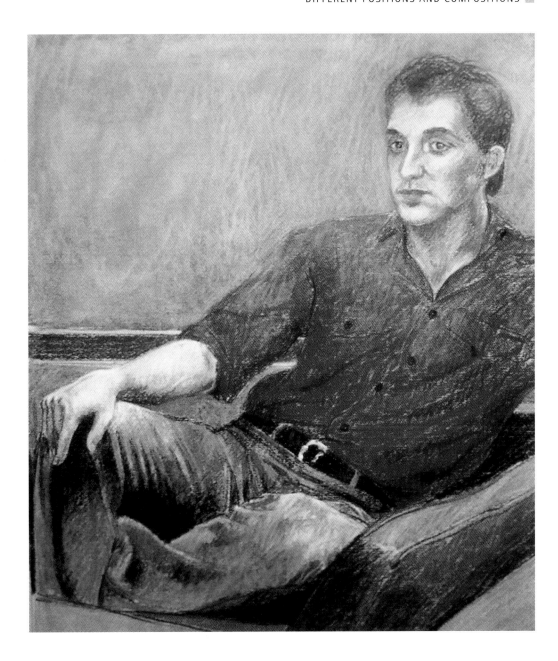

The eye travels diagonally up the figure to the face.
ARTIST: ALLAN DAY

one side diagonally across to the other, following the direction of a form. Diagonal lines also suggest movement. It is interesting to note when drawing a moving figure that if you draw the form using only diagonals, the suggestion of movement will be far greater than if you had used some more stable or static verticals. The diagonals that make up the figure are of course a separate entity to the diagonal that the entire figure may make to the whole in the composition.

The figure postures lead the eye diagonally across the image.

TOP: **Perspective diagonals lead the eye into the picture.**
ABOVE: **Emphasized diagonals give the figure more movement. Compare the two.**

It is worth pointing out however, that the diagonals of a pyramid do not convey movement but stillness. These diagonals lead the eye upwards towards the sky and hence this configuration was much used in religious paintings.

Circular Lines

Circular or curved lines convey fluidity, rhythm and grace. Figures set out in such a configuration are usually depicting movement, but carried to the extreme it can convey turmoil just like the swirling patterns in a Van Gogh or in *The Scream* by Edvard Munch, 1893 (*see* right).

(I)

(II)

(I) Swirling circles...
(II) ...convey turmoil.

(III)

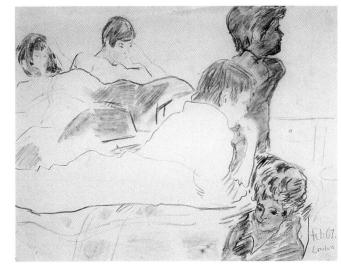

(IV)

ABOVE:

(III) Circular line compositions...
(IV) ...convey a fluid grace.
ARTIST: CARYL STOCKHAM

RIGHT: **Photocopy to render the image in black and white so you can analyse the pattern and number of values.**

Tone Pattern

Even though a picture may represent illusionist space it remains a flat two-dimensional surface and whatever you put on it is essentially a pattern. In tonal terms the pattern is the arrangement of light to dark values. This is not to be confused with light and shade to model the form. If you group the tones into light, mid- and dark, you can arrange them with a sense of balance in mind that is completely separate from tone that describes the form.

Sometimes, whilst concentrating on the illusionist forms of light and shade, the pattern of the overall layout of light to dark is forgotten. When considering areas of light and dark, try to visualize a set of scales or a seesaw to see whether there is a satisfying distribution of weight or if your composition tips down in one direction.

Another aspect of tone to be aware of is that the eye seems to be drawn to the areas that contrast the most. *The Young Man Holding a Skull (Vanitas)* 1626–8 by Frans Hals has a basic four-tone

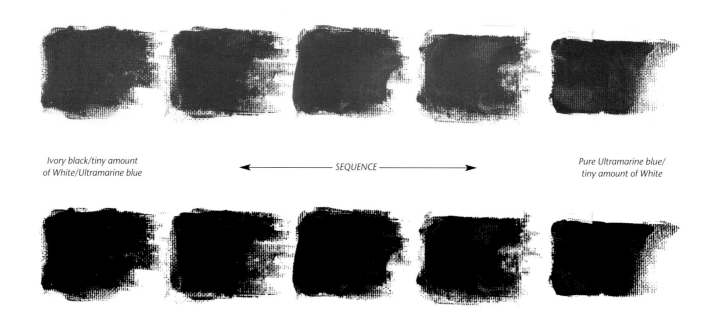

Ivory black/tiny amount of White/Ultramarine blue

← SEQUENCE →

Pure Ultramarine blue/ tiny amount of White

These blues are of approximately equal values.

pattern. A useful tip to remember is that if you want to let the eye pass over unresolved areas keep the tones quite close.

Colour Schemes

As noted in Chapter Three, colour plays a big part in the arrangement of a composition, and just as extreme contrast in tonal value will attract the eye, so will the most contrasting colours, which are positioned opposite each other on the colour wheel and known as complementary colours.

Discordant colours are not adjacent to each other on the wheel but somewhere in-between: green and purple, yellow and blue, orange and purple, or red-orange and purple.

Just as tonal values create depth so does colour. We know, for example, that blue recedes. It is also worth repeating that it is possible to have greyed-down colours going through to intense colour whilst keeping them all at the same value of tone. Theoretically, you could paint an image in colour that when photocopied in black and white would read as just one even value.

You may also wish to balance a fairly muted or neutral colour composition by drawing attention to a particular spot through intensity of hue as well as tone – think of a bright London bus in a grey city scene. However, if you have strong colours jarring for

attention everywhere then it will be demanding on the eye, so if you wanted to convey a meditative mood, this would be a scheme to avoid.

EXERCISE: **PAINTING *CONTRE JOUR***

— OBJECTIVE: To analyse light and dark tonal range in colour

— MATERIALS: Oil paints, acrylic paints or gouache

— POSE/SET-UP: Seated in front of a window or very light backdrop in an otherwise fairly dark room. Alternatively, backlight the model with an artificial light

— TIME: 6–12 hours

You will get a silhouette-like effect contrasting the very light backdrop to the quite dark tone of the figure. However, you should also be able to discern a slightly lighter tone catching outlines of the body and cloth. Squint your eyes to see how much change in value there actually is and remember this will be the value you will give to the colour you use.

As you find your preferred viewpoint, try to keep the elements of line in mind. Horizontals and verticals for the windows, perhaps diagonals for the wall or another object that may lead the eye in

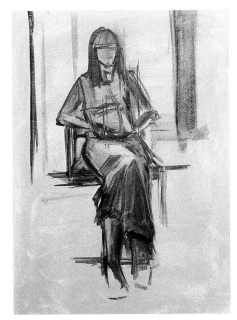

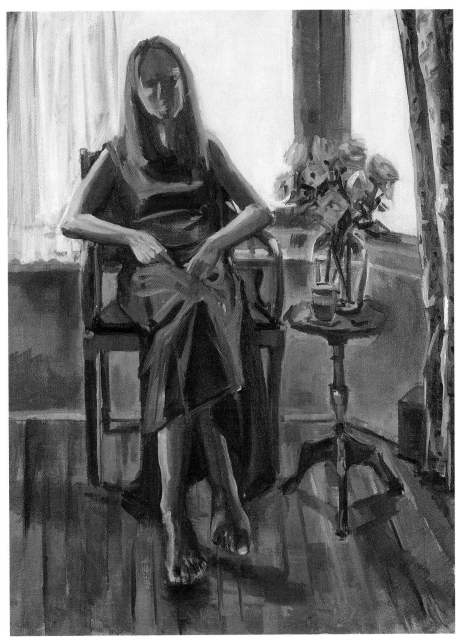

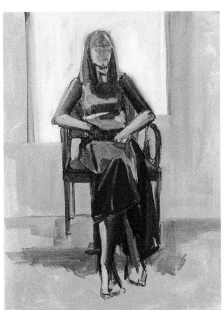

TOP LEFT: **Diluted raw umber for initial drawing and indicative tone.**

BOTTOM LEFT: **Dress colours established and light/darks of skin tone added.**

ABOVE: **The final picture.**

towards the model. This simplified, contrasting tonal arrangement of the dark figure placed against the light is an opportunity to make the hue of a colour describe the roundness of form instead of its value of tone. Remember that warm colours come forward and cool colours recede. If you apply this colour method to the body and clothes, you can convincingly describe the physical volume of form. While you will be able to see some degree of difference in the tones within the darker areas, the aim of this exercise is to enable you to make colour work for itself whilst maintaining this similarity of value.

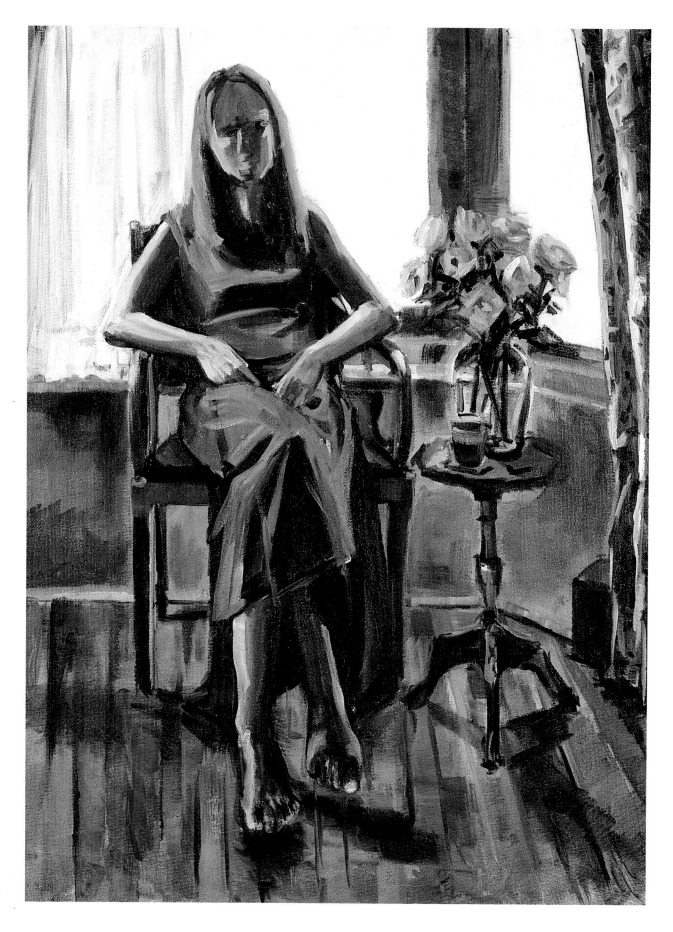

OPPOSITE PAGE:
This is a black and white version of the painting on page 127, which shows how much strong contrast there is between light and dark. The brighter colours are darker than you might think.

Different Viewpoints and Perspective

When working directly from life it is easy to repeat the same position without considering alternatives. It is good practice to look at the subject from different angles. This will inform you about what is happening on all sides as well as opening up new possibilities.

This is especially useful if you are working in a group and some of you wish to continue with the same pose whilst others would rather have a change. If you are one of those waiting for a different pose, do not waste any more time, just change your position and you will be amazed at how you will always be able to find a new take on things.

Remember that as you change position, your viewpoint will vary in terms of a seen or imaginary horizon. Keeping your eyes level with your subject will involve the audience with ease, a high viewpoint will incorporate the viewer into the space and a low viewpoint will make your figure appear monumental, towering like a giant, which could be an opportunity to create an awe-inspiring or intimidating image.

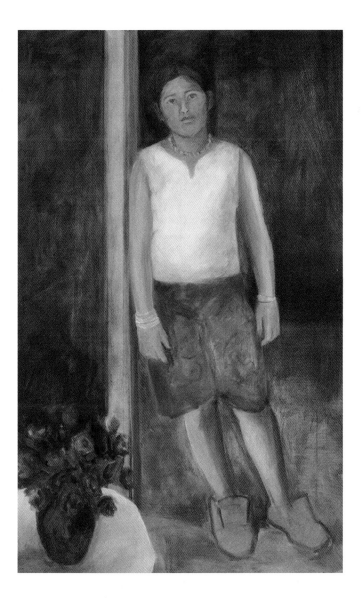

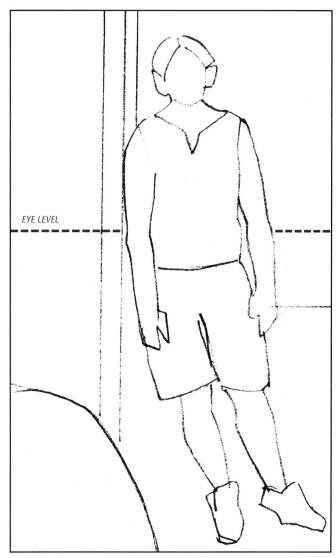

EYE LEVEL

An average level horizon line is engaging but not demanding.

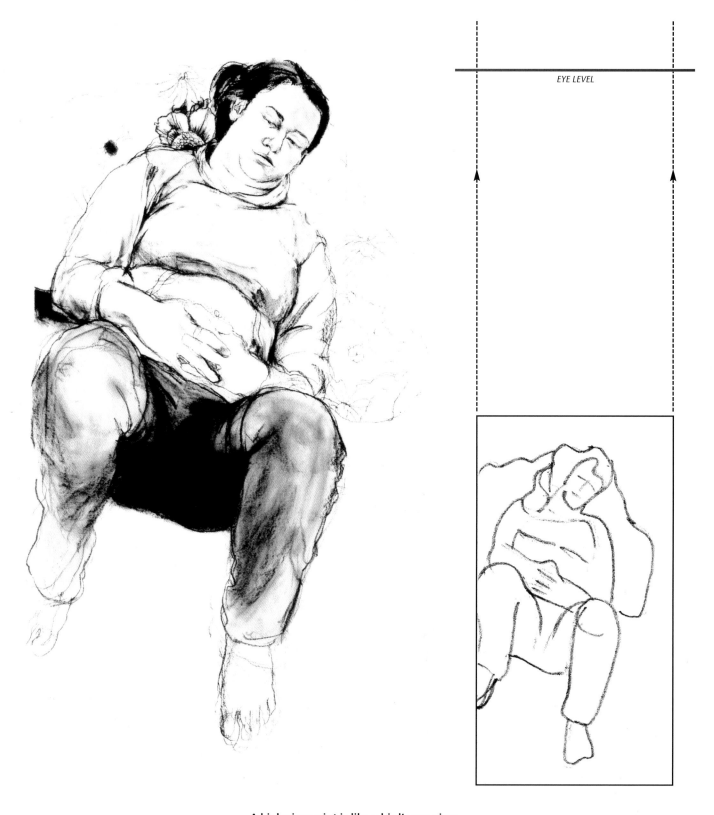

EYE LEVEL

**A high viewpoint is like a bird's-eye view,
incorporating the viewer into the picture.**
ARTIST: RACHEL LABOVITCH

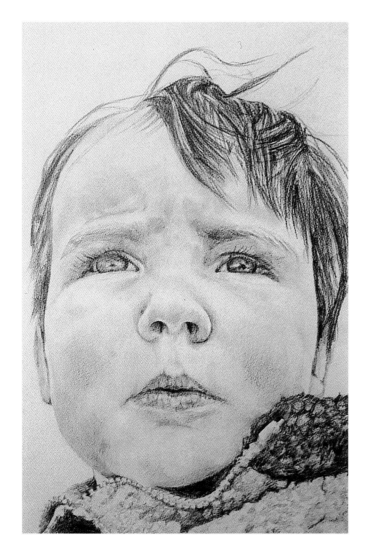

EYE LEVEL

This low viewpoint makes this small child appear monumental
which is a nice paradoxical play. Note the different pencil
marks used to describe a full range of textures.
ARTIST: ALISON BOWLER

EXERCISE: **VIEWFINDER AND THUMBNAIL SKETCHES**

— OBJECTIVE: To examine different viewpoints,
scale and perspective

— MATERIALS: Any drawing medium

— POSE/SET-UP: Seated

— TIME: 30 minutes

Look through the window of your viewfinder to select a viewpoint
from which to draw. Remember, if you hold the viewfinder closer
to or further away from your line of vision, the amount of space
you see around the figure will change from far away to an extreme
close-up. You can alter the shape of your rectangular viewfinder
right through to a square by adjusting the two pieces of card.

First of all, draw the shape of the inside of the viewfinder,
which will be the shape of the canvas or the edges of the paper
and where your drawing will ultimately be cropped or framed.

Start recording what you see through the viewfinder by making
little thumbnail sketches of what you find inspiring or interesting.
They need be no larger than an inch or two. Draw the sketches
side by side so that you can make sure that there is not too much
similarity between them, otherwise it is very easy to just carry on
repeating the same format or arrangement.

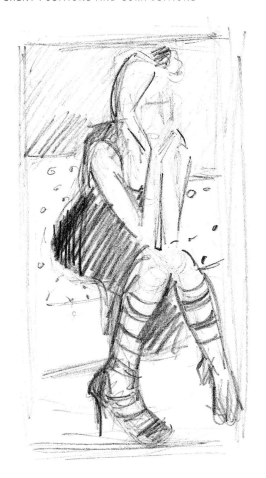

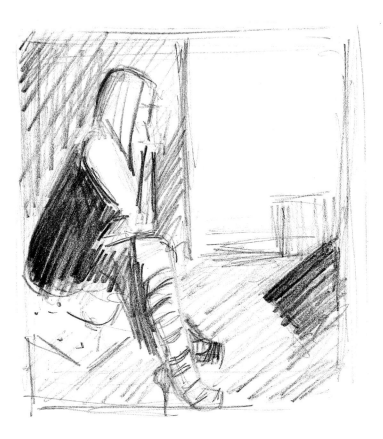

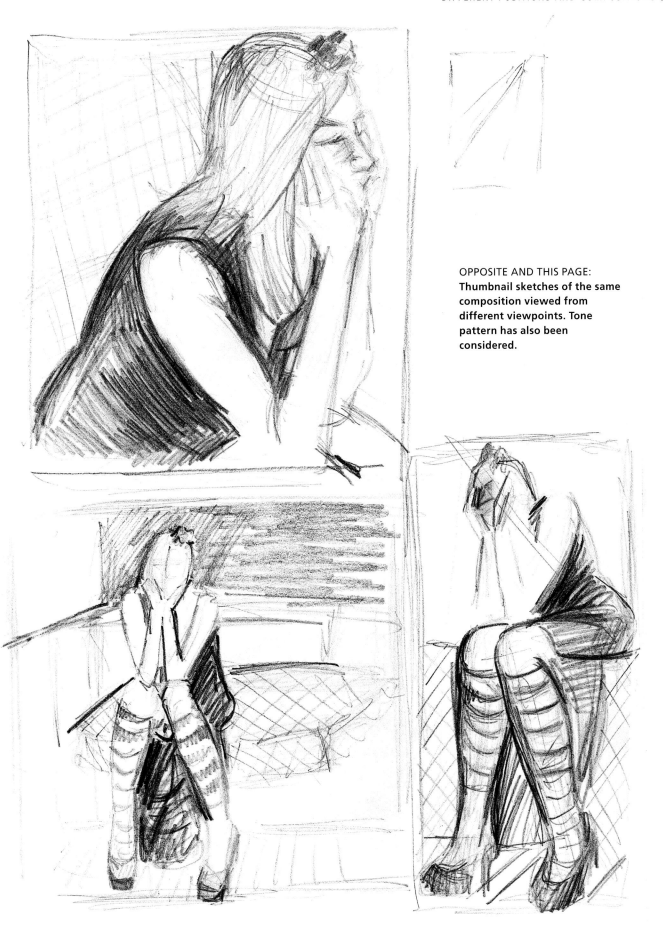

OPPOSITE AND THIS PAGE:
Thumbnail sketches of the same composition viewed from different viewpoints. Tone pattern has also been considered.

EYE LEVEL

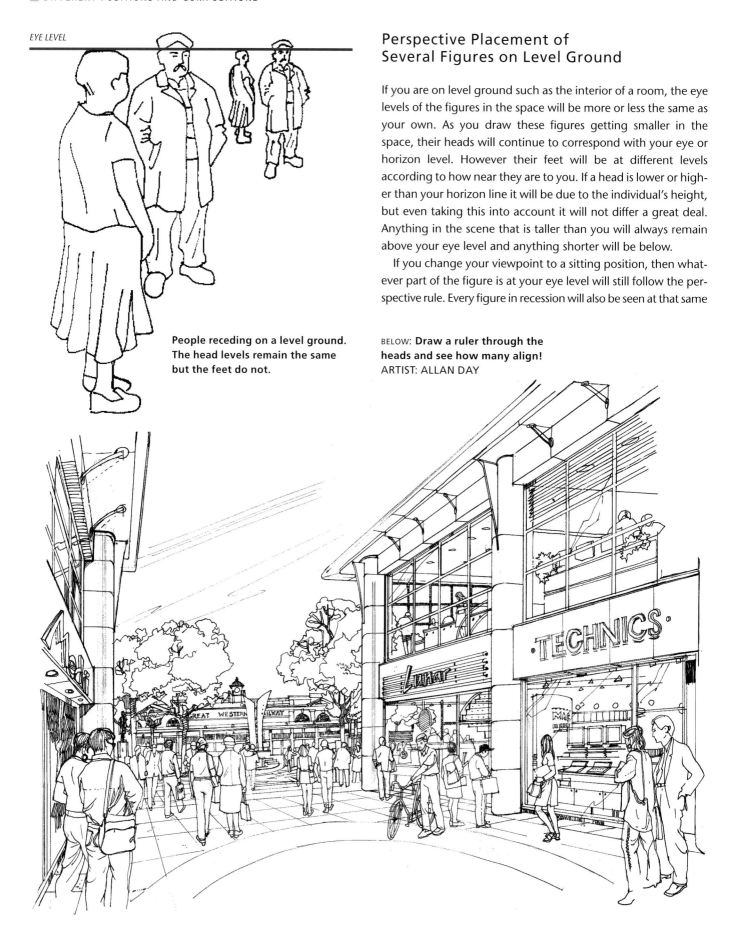

People receiving on a level ground.
The head levels remain the same
but the feet do not.

Perspective Placement of
Several Figures on Level Ground

If you are on level ground such as the interior of a room, the eye levels of the figures in the space will be more or less the same as your own. As you draw these figures getting smaller in the space, their heads will continue to correspond with your eye or horizon level. However their feet will be at different levels according to how near they are to you. If a head is lower or higher than your horizon line it will be due to the individual's height, but even taking this into account it will not differ a great deal. Anything in the scene that is taller than you will always remain above your eye level and anything shorter will be below.

If you change your viewpoint to a sitting position, then whatever part of the figure is at your eye level will still follow the perspective rule. Every figure in recession will also be seen at that same

BELOW: **Draw a ruler through the heads and see how many align!**
ARTIST: ALLAN DAY

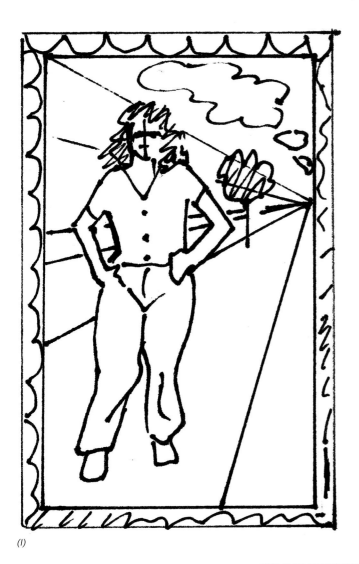

(I)

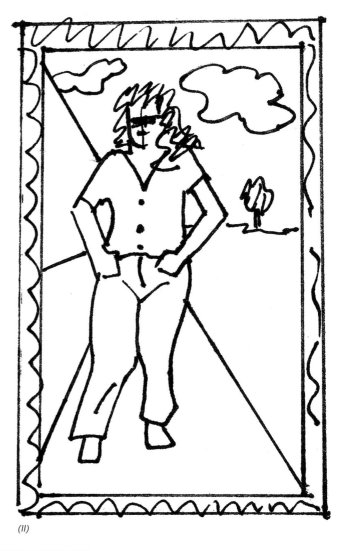

(II)

BEWARE OF PERSPECTIVE PLACEMENT
Compare these two:
(I) your eye passes over the figure;
(II) you focus on the figure.

viewpoint. Try it out by reducing photocopies of one of your figure drawings. Each time you reduce, cut and paste the different sized versions on to a sheet of paper with the heads all corresponding similarly to this horizon line.

Although the perspective rule is very useful to know, this does not mean that it can never be broken. There are many pictures that deliberately incorporate several viewpoints within the same composition in order to create tension and interest.

As we already know, linear perspective is a device used to create depth within a picture. We also know that it is the direction of the line that leads the eye. But where do these converging lines end up? If it is outside the picture it probably will not

matter, but if most of your lines converge near the edge the eye will be led there, having all too quickly passed over the figure that you intended to be the main point of focus!

Aerial perspective is another useful element to be aware of in composition. As you already know, objects seem to lose their sharp contours of form as they recede into the distance, rather like a camera out of focus. They also appear to get paler the further away from you they get. For example, if you were painting a figure in a room that had a window looking out upon a view, you could create recession by using aerial perspective. Keep the immediate foreground strongest with the darkest value and brightest contrast. The figure, which may be part of the middle ground, could be a

little more subtle in colour and the landscape through the window would be hazy and pale. Recession tinges its subjects with blues, washing out to greys as they fade from the picture.

Group Composition

Decide what you want to depict. For example, if your figures are small in a landscape, it is the landscape that the viewer will notice.

ABOVE: **Aerial perspective.**

WHAT DO YOU WANT
TO CONVEY?
(I) **landscape with figures;**
(II) **interaction between
 two figures.**

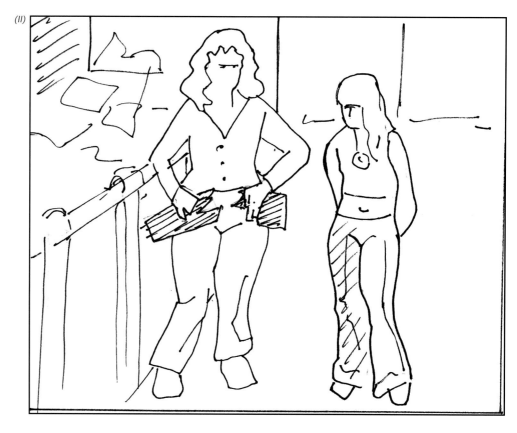

So, if you want to represent the interaction between two figures in the landscape or any other setting then you must make sure that they are sufficiently large to make the background a secondary feature of the composition. This may seem obvious but it does get forgotten.

If you can, find ways to link groups of people by using perspective, line and so on. Think in terms of patterned arrangements like friezes. An overlap of a body part, a pointing finger or the direction of an arm all helps the eye to follow a trail around the pictorial scheme.

Try to position people so that it does not look odd or regimental even if you are aiming for a more formal arrangement. There are the usual standing, sitting or lying down positions to choose from but do not forget others such as kneeling or leaning. Each position can be seen from all sides – try not to forget the rear view.

If your group is composed of several people you will probably need to begin by making quick sketches of where you would like everyone to be placed. Use gestures, the direction of gazes, the positions of the arms, legs, hands, feet and so forth to make visual links between the individuals. You will probably need to record group positions with a series of photographs. You can then get each person to sit for you individually if you are aiming for group portraiture. Your sketches, studies and photographs will be useful for future reference.

Interestingly, if you put two figures together in any one composition you will immediately have the suggestion of a possible psychological narrative. This is true whether it is a portrait of two family members or possible interpretations of tension created by a sense of non-communication between two figures within a specific space.

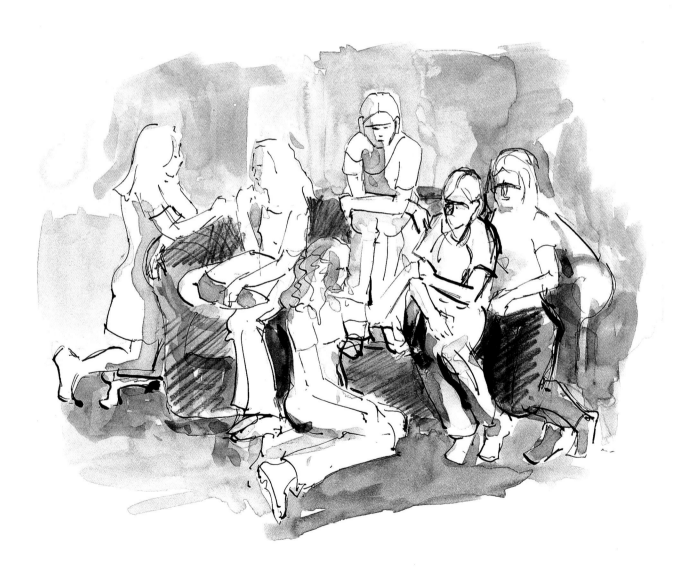

Body positions and gestures can link figures in an informal grouping.

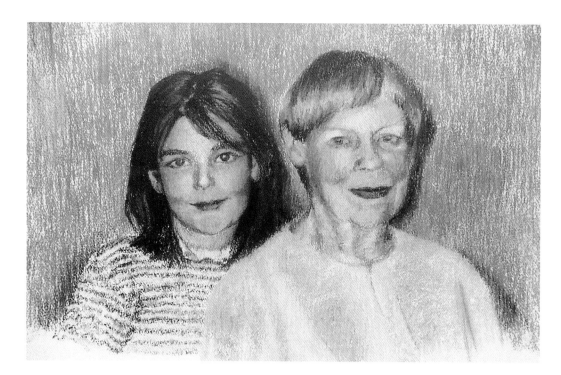

Informal, relaxed
double family portrait.

BELOW LEFT: **There is
psychological tension
between the isolated
figures.**
ARTIST: ALLAN DAY

BELOW: **The girls are united
in their playful actions.
Once you are happy with a
composition it is time to
scale up (see page 139).**

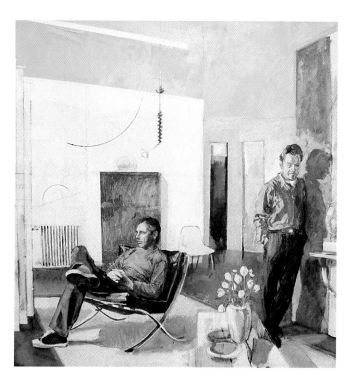

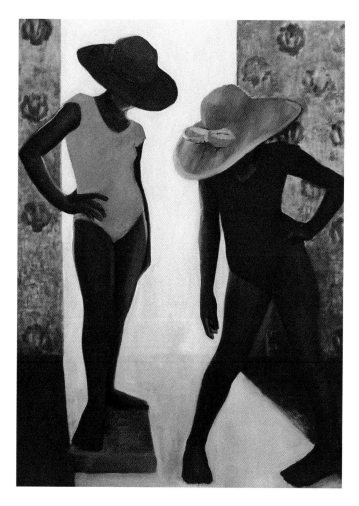

In the picture (*above*) it is interesting to note that because the
two men do not touch in any way and actually turn away from
each other, they become isolated, lost in their own particular
worlds. This sense of 'aloneness' is one with which the spectator
will either feel empathy or discomfort.

In contrast, the two girls (*right*) parading their hats may not be
touching physically but they are unified in their playful actions.

Scaling Up

One simple method of scaling up the dimensions of your rectangle is to draw a diagonal from the bottom left corner to the top right corner, allowing it to overshoot the original picture to the size you would like. Extend the length and width of your picture to your satisfaction and then draw the top and bottom edges to converge with the diagonal line. In this way you can have any size you want without making any calculations. Otherwise multiply existing width and length by the same multiple.

To transfer a drawing to a large-scale picture, make sure that the larger rectangle has the same proportional ratio as explained above and then think of the Union Jack. In your working drawing, mark in the diagonals from corner to corner and then the horizontal and vertical half-way marks. You can break down the drawing further by repeating the same process in each of the four subdivided rectangles. Now draw the Union Jack on the larger surface using the same method. Look at each segment of your working drawing and copy the same arrangement to the corresponding segment of your bigger picture.

Conclusion

In this chapter we have looked at the rules governing folds in a variety of positions. In doing so we have become more aware of those folds that help to stress movement, rhythm and flow. We have continued to study different positions and analyse them further in terms of composition. We have also explored some of the formal elements that are integral to composing a picture and expressing ideas. In the next chapter we will be looking at props and accessories, which can also help us to reveal another part of the picture.

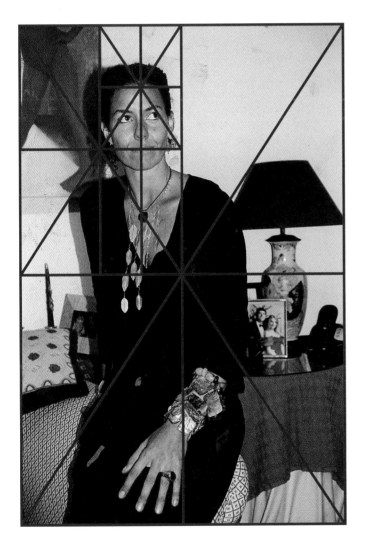

**Image is dissected in
pattern of British flag.**

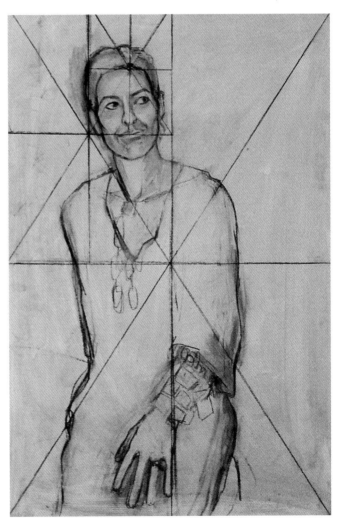

**Relative proportions are maintained and
the same format of dissection is used.**

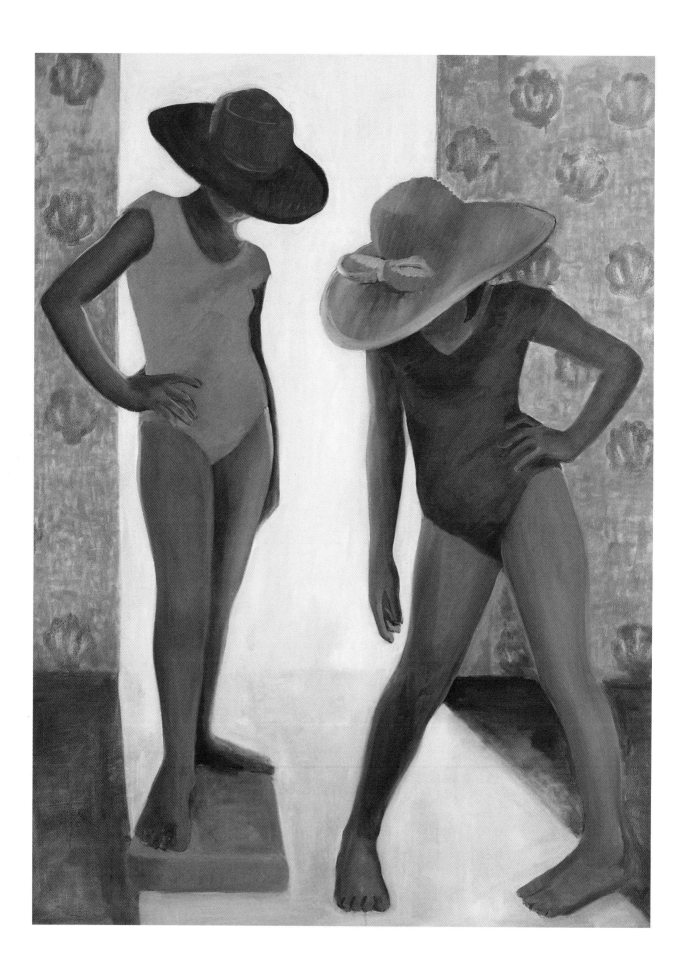

ACCESSORIES AND PROPS

In this chapter we will look at a selection of accessories and props, ranging from everyday items such as shoes to some that are less familiar. Accessories can help you convey individual characteristics of a personality to the viewer as well as their hobbies and other interests. They can also be used to emphasize form, give aesthetic pleasure, tell a story, convey a mood, and say something about the environmental elements. Cloth accessories can be very useful to articulate and accentuate body movement and we will take a look at the body in action later in this chapter.

OPPOSITE PAGE:
THE TWO GIRLS WITH HATS.

Shoes

Shoes can often appear a little intimidating to draw. If you analyse the shape of the shoe in isolation to the rest of the body it can seem a little odd, only making sense when viewed as part of the rest of the drawing. This is especially true when the foot or shoe is viewed from different perspectives.

The most common mistakes are the same as those made when struggling to draw the naked foot. There is a tendency to draw the feet too small in proportion to the body and the relationship between the feet at ground level is often badly aligned. When the foot is encased in a shoe, especially one with high heels, you also have to deal with the alignment of the heel to the toe. The other important element to note is the angle of the foot or shoe

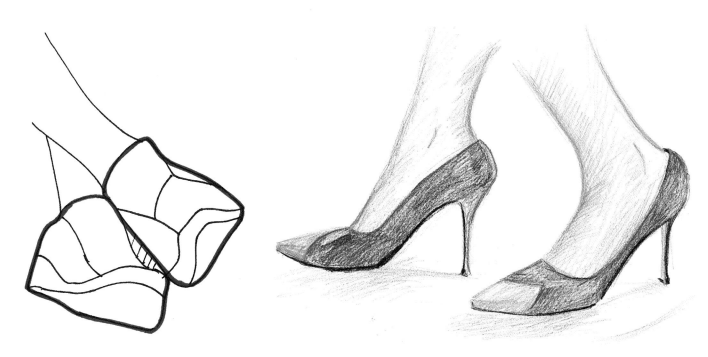

When you isolate the shape of the shoe they can appear odd.

Heel alignment to rest of foot.

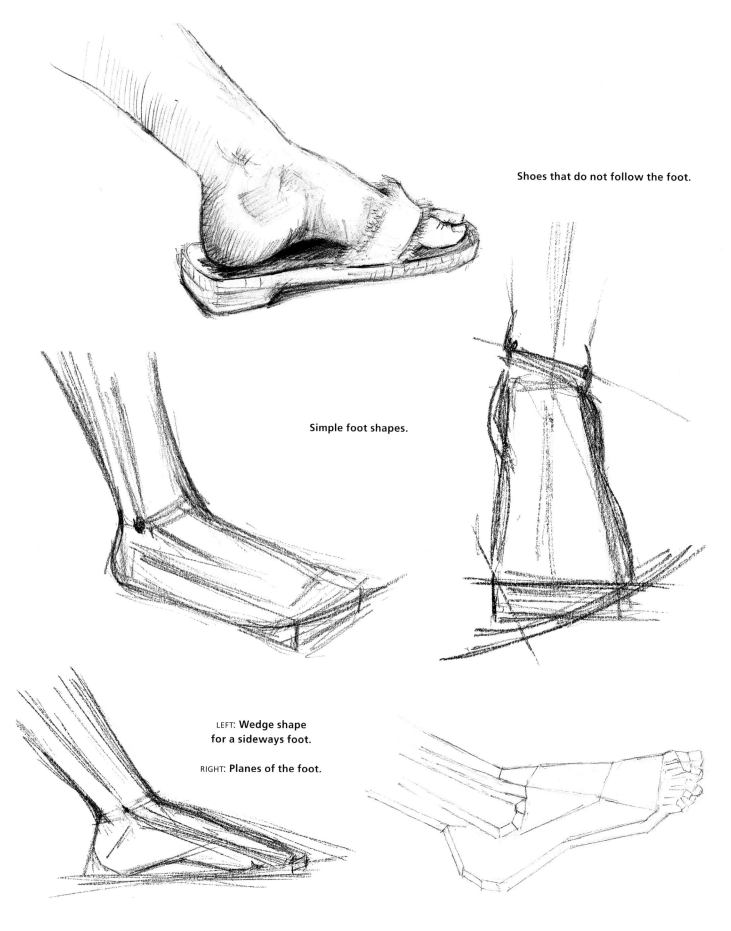

Shoes that do not follow the foot.

Simple foot shapes.

LEFT: **Wedge shape for a sideways foot.**

RIGHT: **Planes of the foot.**

in relation to the ankle and leg. Just like the naked foot, if this angle is not established correctly from the outset, then no amount of perfectly detailed shoe drawing will be convincing.

To a certain extent, closed shoes follow the shape of the foot. Exceptions are the toe areas and the platform or base of the shoe. The toes of shoes may be rounded or pointed; the former are more usual in children's shoes, the latter can commonly be seen in women's court shoes and in cowboy-style boots worn by both men and women. The base of the shoe can be experimented with to a degree. However, where parts of the foot such as the heel, the ball of the foot and the toes adjoin this base, the shape of the foot must be considered.

It is worth having a look at the naked foot since closed shoes basically follow the same shape. This will also be helpful when it comes to drawing open shoes such as sandals and other designs of footwear that do not follow the foot; flip-flops, for example.

Simple Shapes and Planes

Visualize the foot as a very simple structure in terms of plane and space occupation. Try to imagine a rectangular shoebox made to hold just one shoe. The longer sides of the box would represent the outer and inner planes of the foot; the shorter front and back ends would correspond to the heel and tips of the toes; the top and the bottom of the box would be the top plane and the flat underside of the foot respectively.

Of course, when describing the foot in a more detailed way, the configuration is a little more complex, as can be seen in the example (*see* page 142, bottom right). The top side of the foot tapers down to the toe rather than straight across. Likewise, the top plane slopes downwards at the tarsal area in a slanted direction as these uneven bones configure to make part of the arch of the foot. Therefore, when the foot is seen sideways or at an angle, it is often easier to simplify it into the shape of a wedge. The other adjustment to be made to the geometric box shape is the squared-off end representing the toes. To modify this, simply draw a half arc with the peak placed at the corner to represent the big toe of either foot. Curve it down and across to where the little toe would be.

The different positions of the foot and your viewpoint mean that you will have to take the altered perspective into account. For example, if you are looking down at your own foot, the width from the ball area across the foot will narrow and taper down at the toe tips. However, from a front-on view, just as if

The toes taper from a high viewpoint but the breadth of toes is wider when viewed from a front and lower viewpoint.

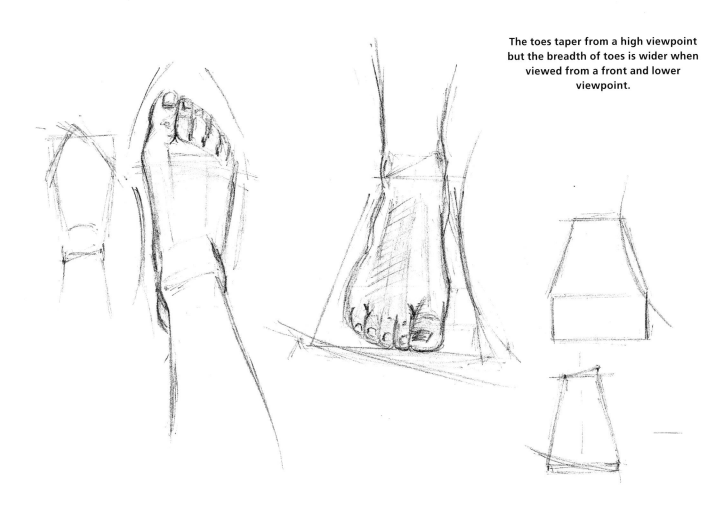

you were to look at the rectangular box, the end nearest you is the widest because it is seen in perspective. This principle remains true when looking at the foot from the same viewpoint. The width from big toe to little toe will seem greater than the rest of the foot, which is receding towards the ankle.

EXERCISE: **SIMPLE SHAPES AND STRUCTURE**

— OBJECTIVE: To draw the foot

— MATERIALS: Pencil, pen or conte crayon

— POSE/SET-UP: Sitting position with the foot or feet firmly on the floor. Try front, angled and side views

— TIME: 30 minutes

You can use a model but you have easy access to your own feet! Change positions and perspective by either looking directly at your foot or indirectly through a mirror to observe a wider variety.

Begin by determining the position of the foot in relation to the leg and the angle of the foot in relation to the floor. You are just trying to establish the correct angle or direction of the foot so this need be no more complex than two matchstick lines, one representing the leg and the other the foot. You will want to add flesh to these lines but for the moment imagine the volume in a geometric or simplified form. Refer to your rectangular box or wedge-like shape and lightly sketch in, avoiding any detail whatsoever.

Bulk the ankle and lower leg, keeping to geometric or tubular form if you prefer. Look for the protruding ankle bones and mark their articulation points. These are formed by the base of the bones made by the tibia on the inside leg and by the fibula on the outside. Remember to check and draw in the line of the angle made between these two bones, noting that the tibia is higher up than the fibula. This will help to make the position of the foot look structured and convincing.

The naked foot.

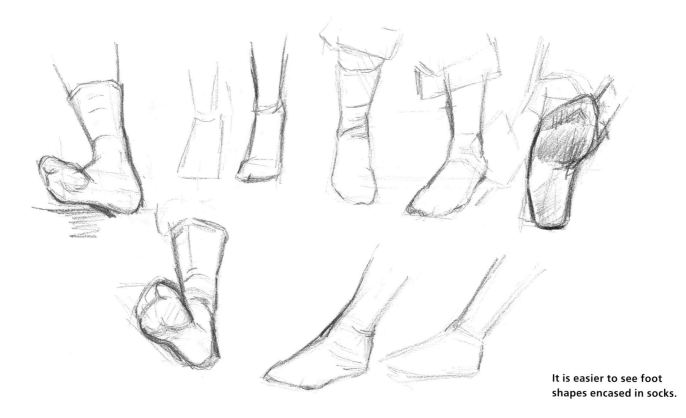

It is easier to see foot shapes encased in socks.

Sometimes it can be helpful to draw matchstick lines to represent the metatarsals and the three bones of each toe (except the big toe which only has two). Some of the metatarsals are quite visible, depending on the position of the foot and body weight. You can refer to skeletal drawings and feel your own joints to help you discern where the metatarsals and articulation points or joints occur. When all or just some of these bones are visible they will affect the way the foot is then modelled with light and will add solidity and structure to your drawing.

If you are familiar with the simplified skeletal framework, you will naturally notice the stretch and tension points, discerning light and shade of the flesh and skin tones that reinforce the foot.

Try to seek the form by using circular shapes while keeping the drawing tool moving fluidly on the paper. It will be easier for you to concentrate on the shape if you ask the model to wear plain socks. Be aware of which foot you are describing, if unsure look at the big toe.

The Enclosed Foot

Shoe shapes sometimes exaggerate the form of the foot. When we look at the inner foot soles of a shoe pattern, it is with the same surprise as when we see our footprints on a sandy beach. The imprints are narrower and the instep much less visible where the foot curves in and up. Shoes follow similar form in the sense that the instep is concave compared to the more convex form of the outside edge.

Make sure that the heels align with the front of the foot by lightly drawing in the related angle between the two. When you have difficult perspectives, use the horizontal and vertical alignments as well to help to see where the angled form is in relation to your plumbline. Re-affirm this angle by looking at the space as a concrete space around the various parts, inlets, of the foot.

Patterns, seams and straps can demarcate the planes of the foot and show you the contour. The amount of detail necessary to

Shoe shapes often emphasize a convex and concave form.

Slipper trainers.

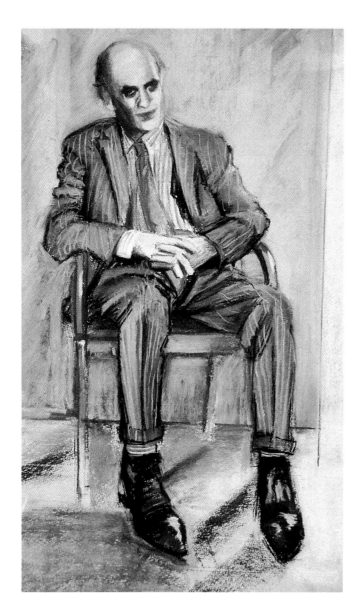

These very particular shoes reflect a real character.

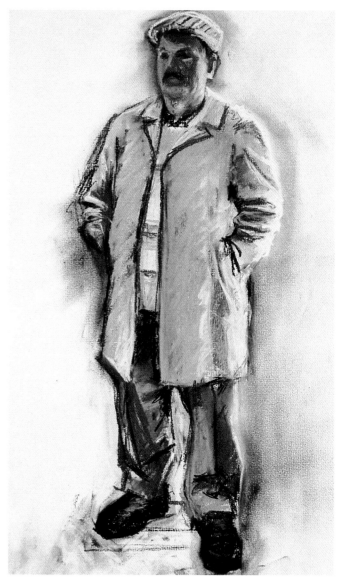

The cap evokes a general character.

describe this will depend on your painting or drawing technique and intention. For example, the girl's shoes in *Flick* (*see* page 84) have very little detail but it is clear nevertheless that they are a fairly clumsy pair of trainers, conveying the tomboyish quality in her character. In contrast, the shoes in the drawing (above left) are more specific. If you do decide to commit to detail, be thorough in articulating the patterns, laces, surface texture and thickness of the material. Remember to include shiny surfaces and make sure there is strong contrast of light and dark. Always check your measurements and remember that if the model is close to you, the shoes are likely to be the nearest part of the pose, so foreshortening and perspective will be more pronounced.

Hats

Available in all shapes and sizes, hats can be made up from a wide range of different materials – netting, feathers, leather, fur, straw and velvet, to name just a few.

When depicting a person wearing a hat, as well as thinking about the hat itself, consider whether it reflects or accentuates the personality of the subject in any way. If your picture is to focus on the person, then take care that the hat does not distract attention away from the face.

How a hat is worn can reveal what the person is feeling or choosing to portray to the world. As most of us will probably

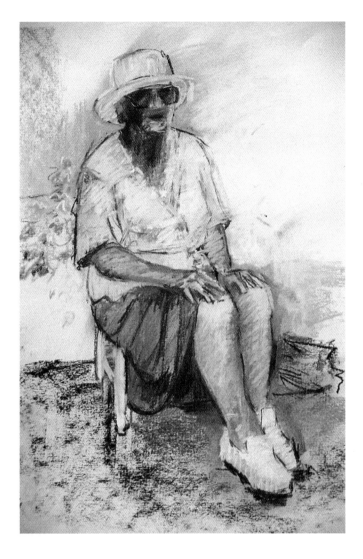

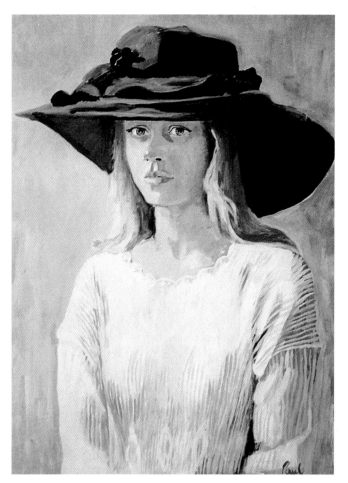

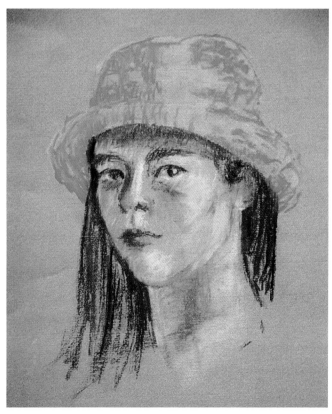

ABOVE: **An informal sun hat.**

ABOVE RIGHT: **An occasion hat.**
ARTIST: PENELOPE PAUL

RIGHT: **A confident air.**

have experienced, clothes and accessories can be like personal armour, giving us courage to present an image to the world.

For example, next time you change your clothes see which feels more powerful, a business suit or jeans and a T-shirt. Then ask yourself which outfit would help you to perform better at an interview. Of course, these very same clothes and props can be used to hide away from people and to disguise who we really are.

If you are studying a person from life, keep the atmosphere informal, chat away while at the same time observing little nuances. Look for clues and wait a while to see whether the wearer carries the hat with any kind of attitude.

To recapitulate, the hat can suggest many things from formal events like weddings and funerals to casual moments spent in the sun. Hats can be used as disguise or to hide away from people. Hats can denote nationality and culture, power, superiority, fashion and wealth, as well as position in the work and social environment – think of Ladies' Day at Ascot.

You may decide that the hat itself should be the subject of your composition, and the face secondary or even hidden. Remember that the hidden face can lend an air of mystery to the picture.

Drawing the Hat

Some hats, such as a cap, follow the shape of the head. Others, such as the top hat, have an inbuilt structure and stand away from the head. To draw the initial structure you must remember the form underneath just as you do with clothing. In the case of the head, begin with an oval shape and add the position of the neck. To ascertain the position of the hat and its structure, look for the line that separates the brim from the crown, which often falls about half-way down the forehead. If the eyes are more or less half-way down then the middle of the forehead will be approximately one third up from that. However, you will have to check these measurements each time as everyone is different.

As well as style, perspective or personal viewpoint are also very important. For instance, if the head is looking down you will hardly see the face at all; looking up, it is the brim that will be seen most. Whatever your viewpoint, check to see where the crown of the hat is formed in relation to the jaw and neckline. There is normally a line of continuity as the crown often follows the head shape albeit at altered angles and depths. If the hat does not follow the top of the head like a swimming cap, draw in where you think the head would be.

Check the measurements against each other, for example, the line from the brim/crown to the top of the hat compared to the line from the brim/crown line to the chin. In the same way you can measure the width of the brim and check where this aligns with the shoulders. When hats are worn at a tilt, see what part of the face each side of the brim aligns with. The negative spaces between the shoulders and hat brim will help you to see the form. Look to see if the brim casts a shadow on to the eye line or part of the face.

THIS PAGE:
ABOVE LEFT: **Draw your oval head and position the brim.**

LEFT: **The floppy but thicker padded beret stands away from the head.**

OPPOSITE PAGE:
TOP LEFT: **You cannot see the peak of the cap but you can ascertain the space to the forehead.**

TOP RIGHT: **A different viewpoint and notice the shadow cast on the face.**

BOTTOM LEFT: **A sports cap follows the head quite closely.**

BOTTOM RIGHT: A **woolly hat extends up beyond the head.**

INSET: **When depicting a scarf-encased head it becomes very important to establish the shoulders and drapery folds.**

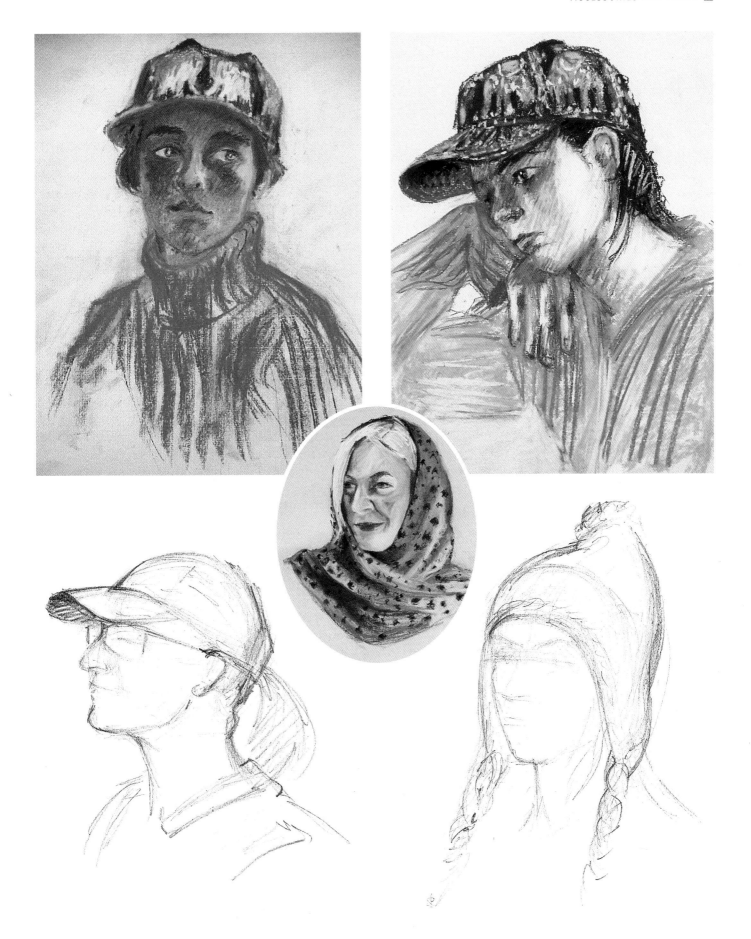

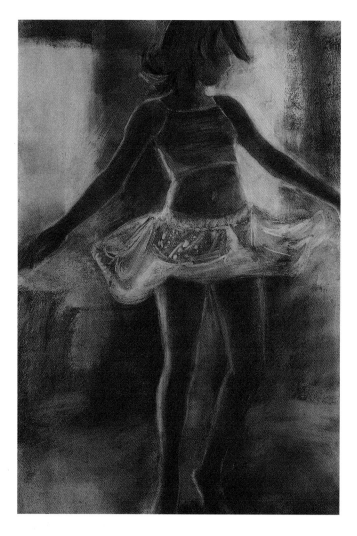

DANCING GIRL
A blurring of edges is suggestive of movement.

The body is capable of a wide range of movement. This arena is a useful pool of resource since there is so much data recorded daily and it also offers another element to consider. If the action of the figure is theme based, the costume will also help to reinforce the motion taking place. This is because not only has the viewer inherent knowledge, conscious or otherwise, of the body experience, the viewer will also have degrees of information indelibly etched in the mind through imagery seen constantly in the mass media and such. Bearing all these things in mind, you can use your own artistic license to exaggerate and create your own flying, breezing clothes to better convey the motion. However, before you start to let your imagination take flight, it is always a good idea to have a look at what happens to these moving clothed figures in real life.

Whilst it is impossible to make precise and detailed drawings from a figure that is constantly in motion, there is much that can be done to develop memory skills and powers of observation. You may be wondering what the point of this would be since we can use photography and film to record exact sequences of movement or isolate a pose to study and draw from at leisure. However, it is through looking at the subject and the rapid sketching that takes place, often simultaneously, that you will develop a sense of rhythm and movement in the drawing process. As you become more adept, these skills can be used to your own advantage when copying a documented photograph precisely because it is based on your own visual experience. For example, an 'action' moment can still sometimes look stilted even when you have copied every detail just exactly so, but a drawn gesture translated perhaps with an abstract flick or a line drawn rapidly in the right place can convey speed as well as breathe life back into the picture.

EXERCISE: **EYE TO HAND DRAWING**

— OBJECTIVE: To really look at your subject following the outside shapes

— MATERIALS: Pencil, pen or crayon, A1 paper for the 30-minute pose, individual sheets of sketch paper, A3 minimum, for quick poses

— POSE/SET-UP: Sitting

— TIME: 20 minutes, 3 minutes for quick poses

The aim of this exercise is to draw the outline of your model without looking at the paper. This approach will prepare you for when you come to sketch the body in motion when you will not have the time to look down. However, it is something you ought to be doing when drawing any figure. It is quite a common mistake to spend more time looking at the drawing than the figure; consequently the drawing is less likely to be based on what is actually seen, which often results in unwanted distortions.

Clothed Figures in Movement and Action

In Chapter Five we saw how clothes can help to accentuate movement of the body because the folds describe the pull and direction of the various stretches.

Clothes can also be used to good effect when you wish to capture the essence of the moving figure. Such actions are virtually limitless, from walking to running, leaping and jumping, falling and dropping – even flying. We only have to look at old master religious paintings to verify this and consider too, the still much-depicted heroes in contemporary children's and teenage comics. As well as the imagery of flying there are dance forms such as ballet and certain types of gymnastic activities and actions that momentarily allude to the reality of weightlessness.

In this exercise it will be impossible to end up with a technically correct drawing since you are only allowed to glance at it occasionally to see where another part of the body begins. This means that you will have to let go of any preconceived ideas of what you think your drawing should look like and free yourself to experience this much misunderstood or ignored act of looking.

Regularly practising this exercise will change unwanted habits and develop your powers of observation. When you find that the technique actually does work, your confidence will grow.

Use a drawing tool that does not smudge. Choose an outside edge to begin and then use your eyes to follow the shape. If you need to place elements such as facial features or any other contours then you may quickly look at your drawing. For example, you may have started with a shoulder, gone up the neck, around the outside shape of the ear, carried on around the head and followed it through to define the jaw line. You will then need to see where to begin the outside edge of the other side of the neck.

Follow this with several quick poses, ideally of the whole figure. This time do not allow yourself to look at the paper at all. If you place the thumb of your non-drawing hand on the paper, this will help you to gauge where you are in relation to your starting point.

ABOVE: **A twenty-minute (no looking at paper) drawing produces a nice feel.**

LEFT: **A three-minute (no looking at paper) drawing.**

EXERCISE: **FOLLOWING A SMALL SEQUENCE OF MOVEMENT**

— OBJECTIVE: To suggest transient body actions

— MATERIALS: Pencil, pen or crayon, charcoal or coloured chalk pastels

— POSE/SET-UP: Kneeling, rising to a standing position

— TIME: 1 minute for each pose, aim for at least five or six

There are various ways of approaching this exercise and it is good to try several of the options, which you should find liberating and very stimulating.

First of all, discuss a sequence of movement with the model and make sure that he or she can hold a 1-minute pose without toppling over. The movements can be very simple or you can

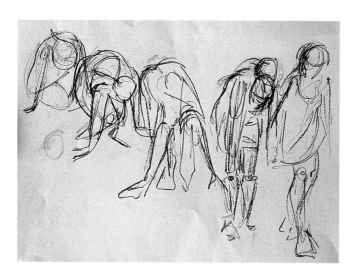

One-minute interval poses.

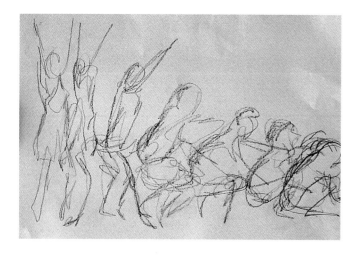

Slow but continuous movement.

make the sequence more dynamic by including stretches or fully extending the arms and legs. Make the model move across the floor so that you can reflect the space pattern across your paper. Aim for five to six sequential postures so that you can readily see the overall progression.

A second approach is to enact a sequence just once and in slow motion. This method relies heavily on the eye to hand method with very flickering glances at your paper at most. Because it is almost like contouring the shape of the figure, try thinking of it in terms of joined-up handwriting. As you follow the shapes of body movement fluidly and continuously, you end up with the completed word or sentence. Carry on following the figure until you run out of space on the paper.

A third approach is to mark particular posture or foot points on the floor so that the model can repeat a fairly similar sequence of movement for as long as it takes for you to master the basic gestures of the sequential movement. The model may move slightly faster than in the previous pose but it will still be very slow compared to normal motion. Because the sequence is repeated you can be ready at certain points to build up where you see your chosen action replayed. You may glance at your drawing to check but continue to use the eye to hand method. Really aim to capture the character and gesture seen. Allow your drawings of sequential movement to overlap where the position of the feet on the floor remains the same but if the model slowly moves across a floor space, then develop your figures across your paper space too. Because the figure is static, movements of dress or cloth are not going to spin or flare out. However, folds can readily delineate pull and stress action and you will also see that ghost underdrawings and shifted lines powerfully suggest movement. It can be useful for the model to wear a garment with a helpful characteristic like a cross-back dress as shown here (above left), which can become a strategic landmark to help you discern the posture.

You should be able to get a good drawing with between three and five run-throughs. Don't worry about discrepancies of exact body poses either, they will be similar enough – the aim is not to produce a measured drawing but for you to note if there is a line or gesture that you missed or one that could be accentuated with more strength.

Try some of these approaches with a flowing dress or robe and capture the hang of the drape.

Sketchbook

It is always a good idea to keep a sketchbook on the go to note down any ideas as they occur to you as well as to keep your hand in. Drawing and looking are the same as anything else that needs regular practise. If you allow yourself to get slack then it will slow down your progress, so get into the habit of taking a

**Sequence repeated
three or four times.**

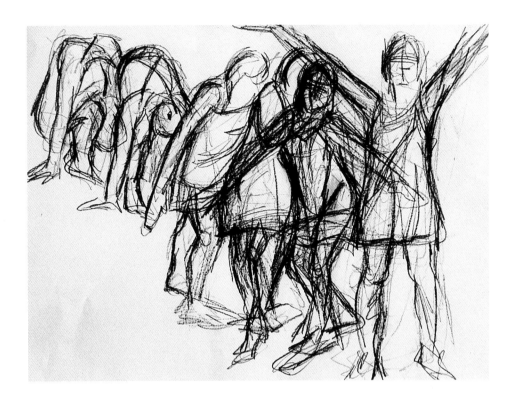

BELOW: **These quickly sketched
folds still describe tension
and movement.**

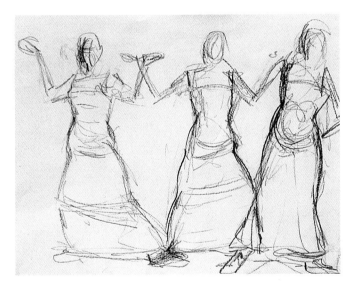

really would like privacy, sitting in a car is a good solution as long as you can park in a suitably busy place. This is a handy alternative when it is raining, windy or cold and perfect for umbrellas, running figures and swishing clothes.

A great advantage of sketching those around you is that you are watching these figures engaged in everyday actions that have not been posed for your benefit. Hence you will get natural body language be it an interaction between two or more people to expressive body language reflecting the outdoor elements. These observations from life will become important reference sources for future work in the studio.

The next exercise should prove useful to you in capturing the essence of the figures around you.

EXERCISE: **SKETCH THE GESTURE**

— OBJECTIVE: To capture the essence of the action.

— MATERIALS: Pencil, pen or crayon

— POSE/SET-UP: Movement – people out and about

— TIME: Seconds!

The aim of this exercise is to articulate the action made by the figure. This is a wonderfully liberating process because you simply cannot be prissy nor demand any kind of anatomically correct drawing. In fact, you are more than likely to look back at some of these sketches and wonder what the squiggles represented!

sketchbook with you everywhere, especially when you have a particular project in mind. Besides, it is really annoying when something or someone does inspire you and you have nothing to hand to draw on.

There are many opportunities to observe people and if your sketchbook is small and discreet you can scribble away mostly unnoticed. It is great for seeing a variety of bodies in action and gets you accustomed to speedy drawing due to the unknown set time of any given posture. It will also improve your memory skills.

Parks and beaches are good public sources, or maybe you would prefer a café where you can stare out on the world. If you

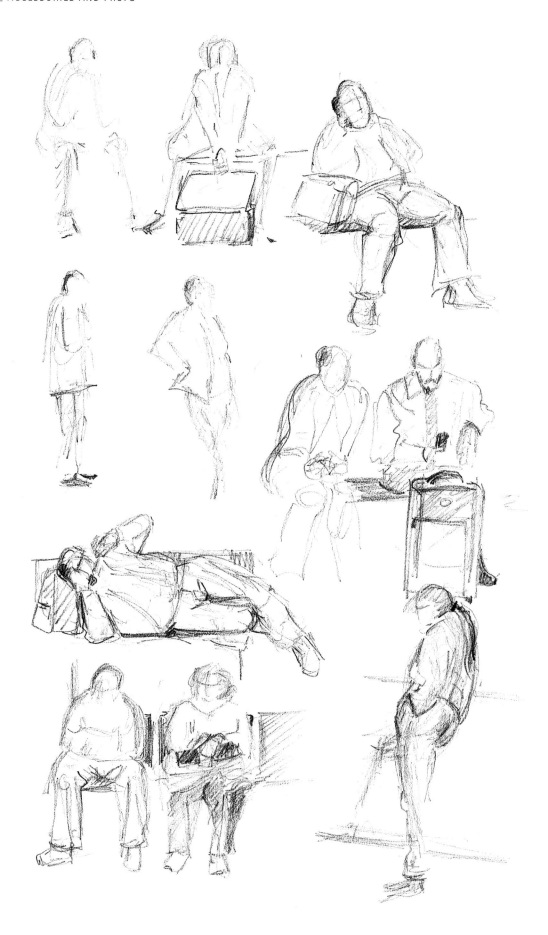

THIS PAGE:
Some quick sketches
of travellers at an
airport.

OPPOSITE PAGE:
Some of these have
the barest line but
they indicate the
movement and
sometimes suggest
attire or accessories.

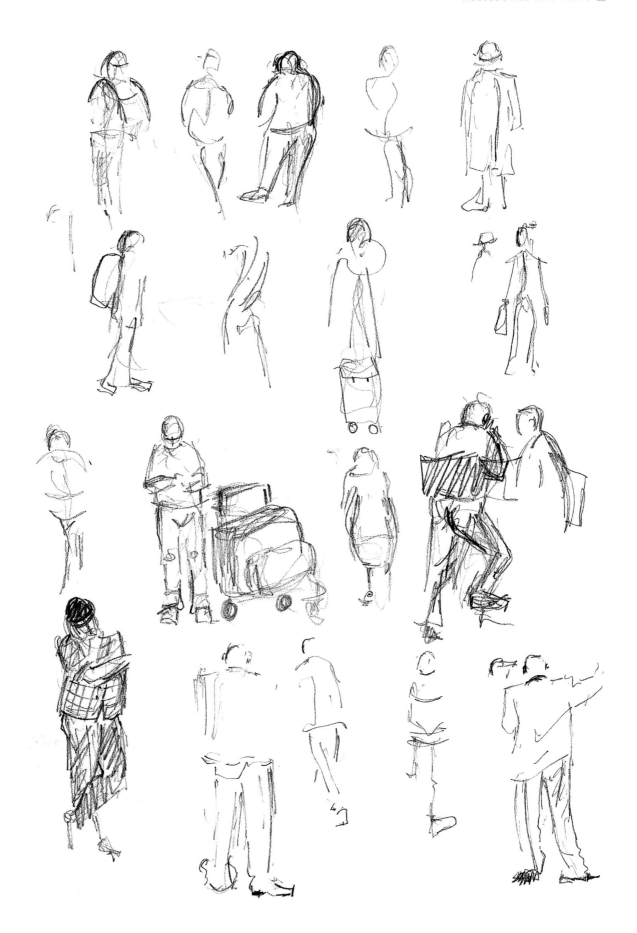

However, the concentration demanded in looking and eye to hand coordination will give you experience of drawing gesture and motion that will feed back into your normal work.

Keep the drawings quite small and on the same page of your sketchbook if possible. If you use a very small pad no-one will notice you are sketching, but use a clean page for different actions to avoid confusing results! However, it is the experience that is the most important part of this exercise. You will find that you are unlikely to be able to look at your paper much so do practise your eye to hand coordination skills first.

You want to be able to encapsulate the essence of the action in the most economic way. If you were to draw a shoestring properly, you would capture its tubular two-dimensional shape and give it further depth with light and shade. However, if you were to just record its gesture you would follow its action with line. This is what

you are trying to capture – not the body but what the body is doing. If you practise this exercise regularly you will become faster at getting the essentials and your visual memory will improve.

Body Support

You can use props such as books, chairs, walls and absolutely anything else that will do as a support for the various parts of the body. Lightly sketch these props in because they serve as alignments and references for attaining body pose. However, once you have the subject's position, take away the props and you have a figure which is off balance and composed in a different backdrop would heighten the sense of drama.

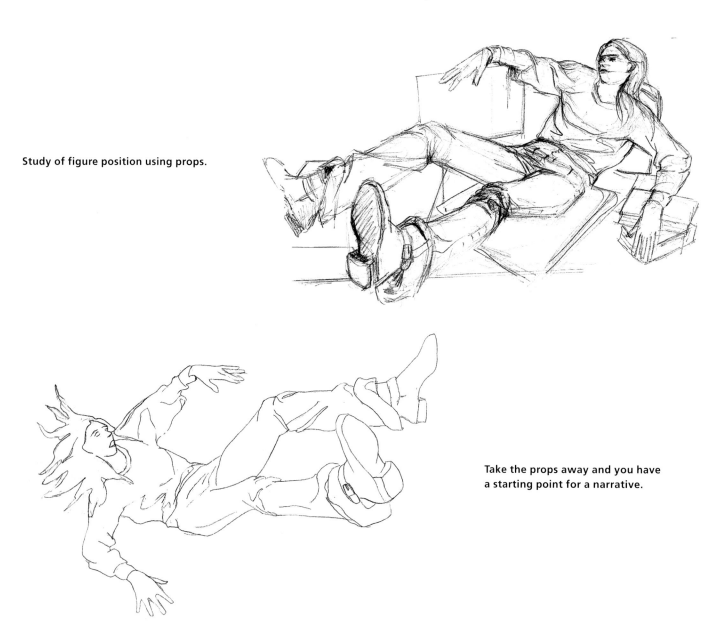

Study of figure position using props.

Take the props away and you have a starting point for a narrative.

Just one foot off the ground serves well to describe a running man.

Transforming Information Props

There is nothing wrong with using photography or video, particularly if you are trying to capture movement. It may be that you want to achieve a realistic image and will copy a photograph almost exactly. Even if that is not your intention, the recorded image is useful as an extra source of information, supplementing the ongoing 'life' study when your sitter is not there.

Photographs are a good way to practise memory and rapid sketching skills – look at the image, cover it and then draw as much as you can recall.

You can also use pictures from newspapers and magazines for inspiration. The trick is to use them well. Even in a moment of movement the figure can look a little static or frozen. This is where all that gesture sketching will come to your aid, enabling you to inject and exaggerate the movement because you have already 'felt' the actions with your eyes. In the same way you can create and exaggerate items of clothing – wind-tussled scarves, blowing coats, twirling skirts, fluttering fabrics or whatever you

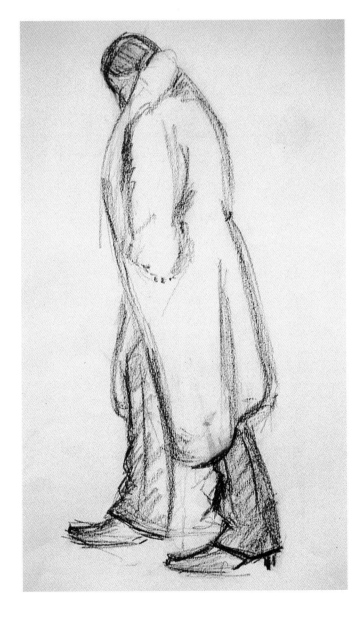

LEFT: **A model posed for a couple of minutes for these two sketches.**

RIGHT: **The outline was changed to suggest a blowing breeze.**

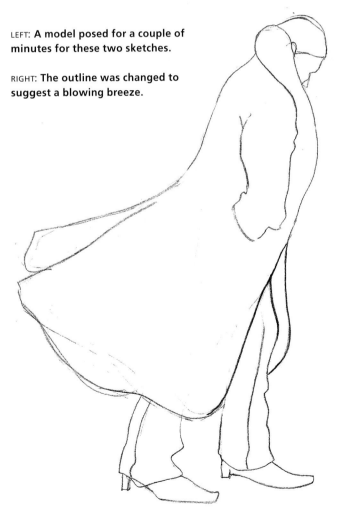

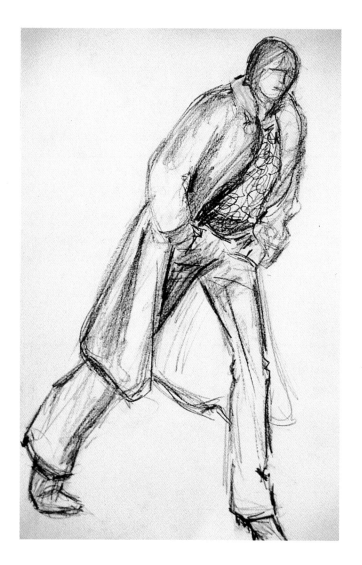

The drawing was exaggerated. Note the
two feet on the ground describing walking.

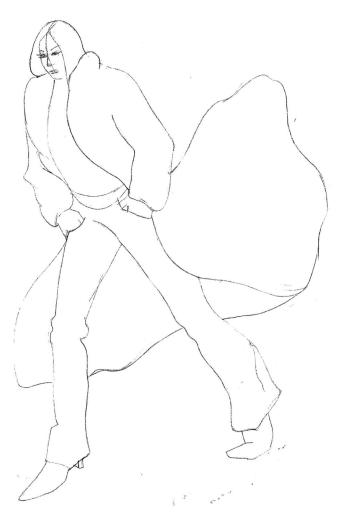

The coat was further exaggerated for heightened movement.
See these images used in the following chapter.

can think of. The coat examples above and on the previous page
both emphasize the movement and describe the elements.

When you come to compose a moving figure you will see that
some positions convey movement much better than others. For
example, when we walk, although for the most part the body
weight rests on either one foot or the other, the walking action
tends to be better described when both feet are on the ground.
Similarly, running is better shown with one foot off the ground
although in reality both feet are off the ground most of the time.
The leap can be described better with both feet off the ground
but it is important to show the effort in the limbs readying for
the next position. Jumping shows best with both feet off the
ground but they should be relatively closely positioned as the
body prepares to land with safety.

Using Personal Props

Different items of clothing or ensembles can be used to describe
the general 'look' of someone, which can speak volumes about
the figure being depicted as well as generating a certain mood.
We have already looked at a few possibilities regarding shoes and
hats but there are many others. If you walk down any high street
you will see many different styles of clothes and accessories being
worn. These can be particular to an individual or more universal
in terms of an age group, hobby or work environment. The pic-
tures on the following pages show a few different ideas.

To help you, these are some questions you might ask yourself
when observing an individual. Who is he or she? Is there any
detail that confirms or conveys an interest or job? Do the clothes

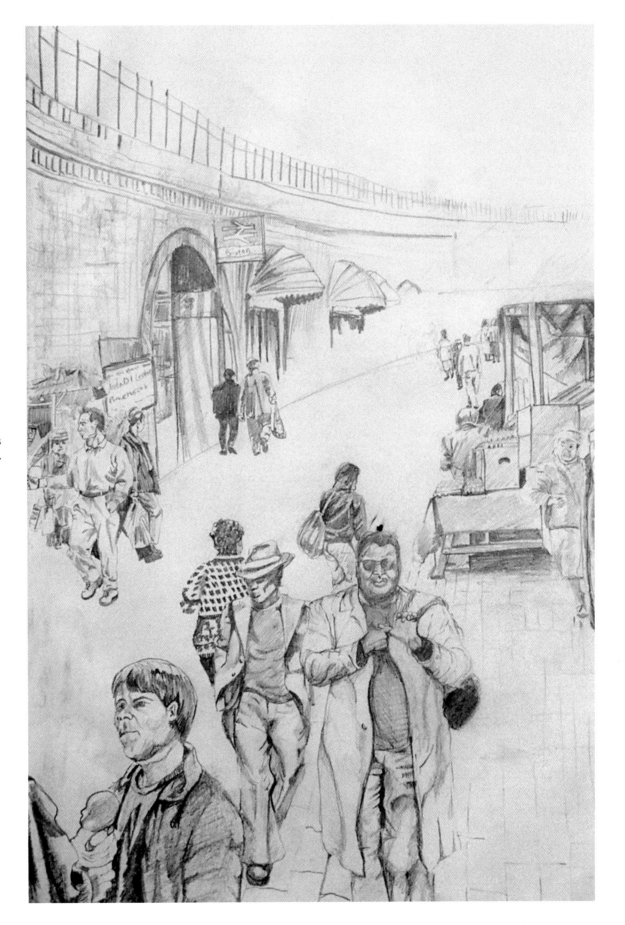

Note the various accessories here.
ARTIST: ALISON BOWLER

Both a particular and universal appearance.

BELOW: **A very sensual and romantic image has been created with this fur-trimmed coat.** ARTIST: CARYL STOCKHAM

BELOW RIGHT: **The body posture contradicts the 'party' feel of the clothing. Is she waiting for the event or disillusioned afterwards?**

belong to a particular workplace or reflect external elements such as the weather? Some accessories, for instance, will be very much more apparent because they may inspire you to make the work in the first place. Don't forget to be aware of the very nature of the body posture which when coupled with garments serve to create a certain mood.

Hair can be described as an accessory and can be very specific in both colour and cut. Think of punk hairstyles or an older woman's blue rinse. Hair is generally blocked in three basic values, pulling out strands or details where the light highlights or the shadows darken. However, you can make hair the focus of your composition, which again can describe either body movement or external conditions.

As hair can be used as a compositional device, so can other accessories. Umbrellas for instance do not have to be depicted only when it is raining.

Glasses are worn by many people but remember you do not have to always depict them on the face. They could be used as a descriptive item placed near at hand. However, when the glasses are worn on the face, to depict transparency, paint or draw what

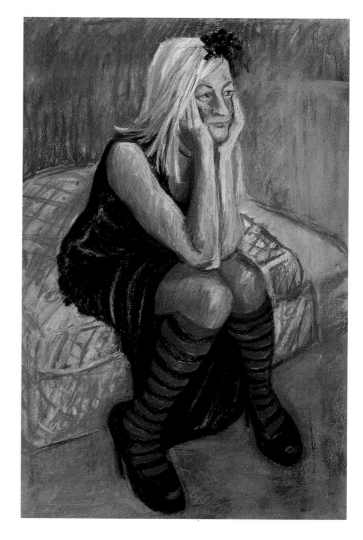

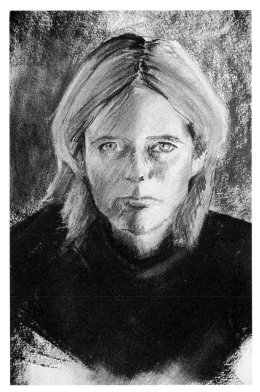

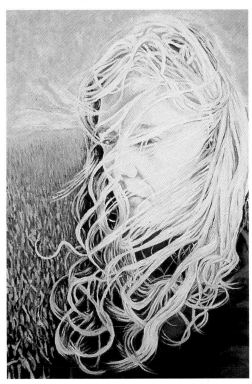

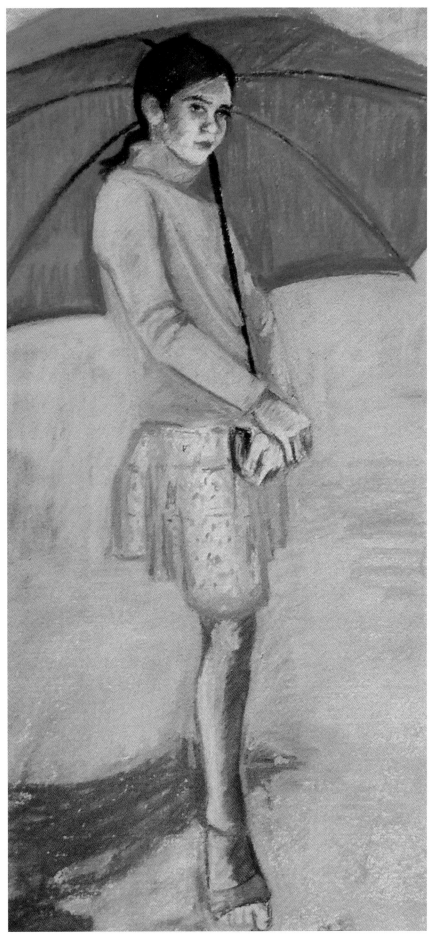

TOP: Hair blocked in with a few descriptive details to imply the mass.

ABOVE: A lot of separated strands of hair prove evocative in describing the breeze and the picture conveys an intensified reflective instant.
ARTIST: ALISON BOWLER

RIGHT: The umbrella as a compositional prop.

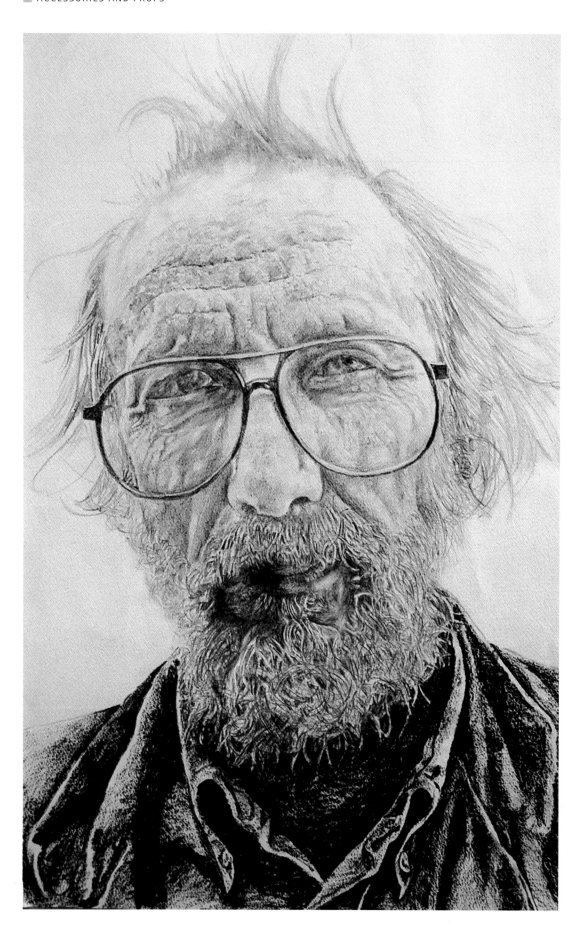

THIS PAGE:
Note the slight shift of alignment of the outer edge of the face seen through the lens.
ARTIST: ALISON BOWLER

OPPOSITE PAGE:
LEFT: The ensemble of coat, hat, shoes and handbag captures this lady to a tee!
ARTIST: ALISON BOWLER

TOP RIGHT: The suggestion of digging in her purse manages to describe the frailty of this older lady.
ARTIST: RACHEL LABOVITCH

BOTTOM RIGHT: The necklace curves as it follows the round cylinder form of the neck.

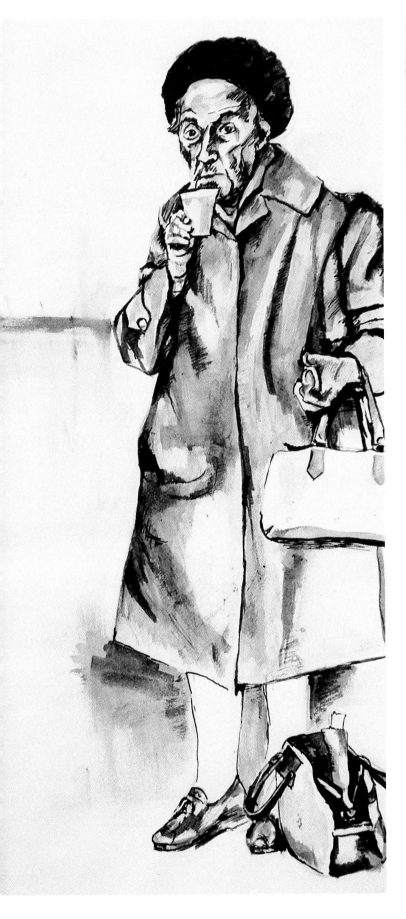

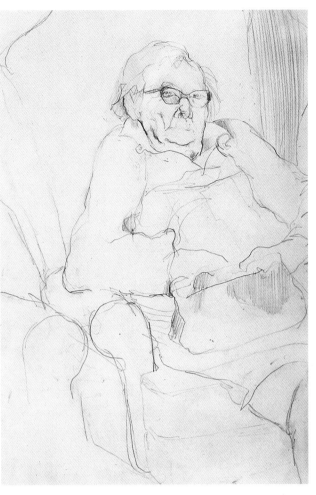

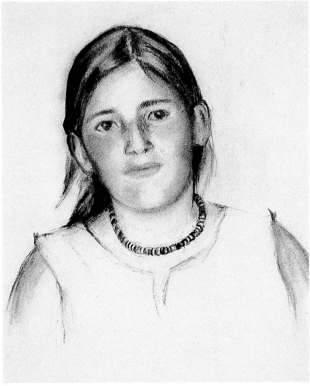

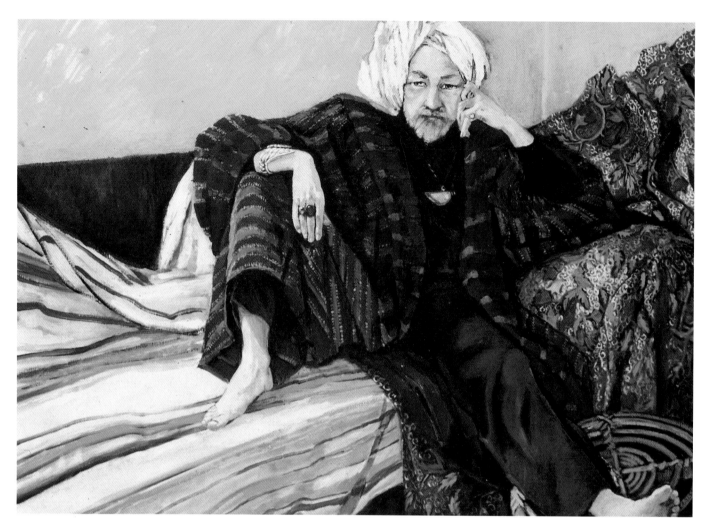

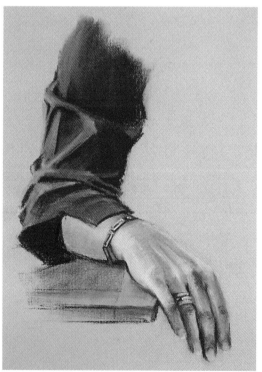

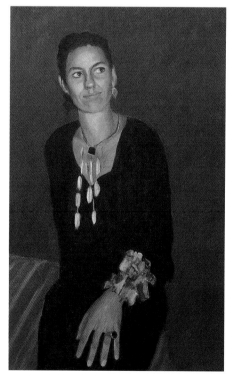

ABOVE: **Accessories from patterned drapes to the turbaned head richly convey this bejewelled figure.** ARTIST: PENELOPE PAUL

FAR LEFT: **Note the little shadow cast from the bracelet is rounded.**

LEFT: **Keeping the background and clothing flat serves to highlight the items of this jewellery designer.**

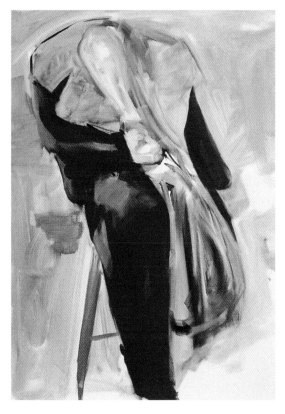

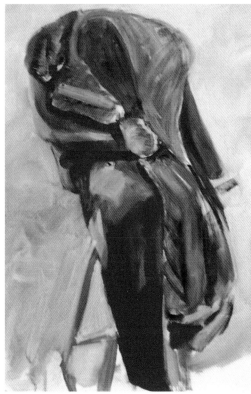

FAR LEFT: **Rather than depicting every single hair it is better to describe the shape or form of the cloth and its folds. The fur lining is established.**

LEFT: **The dark and light bands of the mink fur are loosely painted in. Shadow areas are still observed, like the collar is contrasted to the inner lining of the fur.**

BELOW: **Finally, using a fan brush sweep some of the paint in the direction desired. Load the fan brush with a light tone and brush on in the direction of the hair formation. Again, the red of the coat is resolved before dragging overlapping hair over the red.**

you see inside the frames. Look for any reflections cast back on to the glass and be particular with the highlights. Notice if there is a shifted alignment of an object or part of the face when you look through the lens to when you do not. This shift of alignment sometimes happens when the lenses are thick.

Bags are another useful item of description, from plastic bags to handbags. Note how these have been observed by the two artists (*see* page 163) and how particular they are to that age group.

Jewellery makes another good accessory. What is worth emphasizing is that jewellery, like clothing, often follows the body shape. Items such as bracelets, necklaces and rings will curve in an ellipse. Also, do pay close attention to small details that reinforce the round form of the body, such as any shadow cast by a piece of jewellery that is not close to the skin.

Conclusion

In this chapter we have looked a range of accessories, noting how they can be used to convey character or mood and how they may also be used as part of the composition of a drawing. We have also examined how to draw hats and shoes. In the final chapter we will use some of our existing drawings and images, as well as creating new ones, to explore different ways to push ideas further in terms of self-expression.

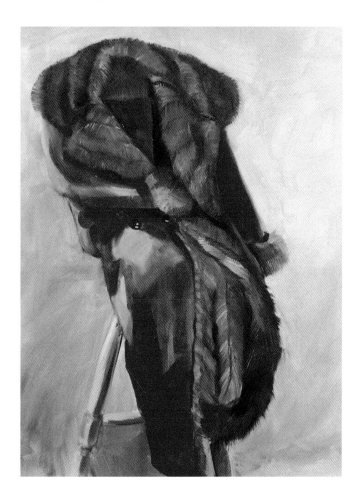

DEVELOPING SELF-EXPRESSION

Throughout this book you have been accumulating, observing and practising skills that will enable you to draw and paint the clothed figure with confidence. This chapter will now set about exploring some other possibilities that will spark off your imagination and help you to develop your own ideas.

Whenever you produce a piece of work it is expressing your personal viewpoint and, to some degree, this will be conveyed to the viewer. Initially, your aim was probably to render an accurate recording of whatever it was that you were looking at. However, after achieving a certain level of competence this may leave you feeling less fulfilled – possibly even a little bored. Besides, with the advent of photography, the need for an objective recording of a moment in time has now become somewhat redundant.

Whereas one could argue that too much emphasis on acquiring the formal skills can repress the immediate emotive response, little or no skill is unlikely to produce work of any merit, depth or long-lasting satisfaction, leaving you with no sense of how to go forward. Knowledge and practical experience of a craft will give you the context in which to apply subjective critical assessment in order to be able to develop your work. These practical skills also empower you to make choices, not only about what to include in your work but to be able to know when it would be more effective to exclude something. For example, if the most important aspect of a work is for the narrative to be read, then this may be conveyed more readily if the manner in which the story is painted or drawn becomes secondary, sympathetic or

OPPOSITE PAGE:
TICKLED PINK
**detail
(monochromatic
purple on purple).**

THIS PAGE:
MIRROR IMAGE ADULT/CHILD
**The colours heighten the
psychological instant portrayed
and the method has a contemporary
feel of a transparency negative.**

better still, symbiotic to the imagery being depicted. Similarly, vigour and gesture of brushwork might be used to not only evoke and describe the spectrum of human emotion but also to remind the viewer that the reality is in fact just an illusion made up of painted texture upon a flat two-dimensional surface.

In essence, art is simply the marriage of an idea and a technique, resulting in a piece of work that is then communicated to and perceived by the viewer. There are no limits to the subjects or themes – if you can think of it, then it can be done. The subject and style is totally up to you – restrained or passionate, bold or reserved, frenzied or calm. Whatever you choose, let it come from your heart, let it be true of you at a particular moment of time. There is no right or wrong – an exciting piece of work does not necessarily need to be technically perfect; works that speak volumes on a human level are often very naïve or crudely depicted. Self-expression is about feeling and expressing something that is unique to you.

GIRL AND DOLL
**The lightest pink tone appears
lighter than it really is.**

Materials

To complete the exercises in this chapter you will need the following equipment:

- Emulsion paint or acrylic gesso
- Household gloss paints
- Extender for oil paints
- Oil paints
- Watercolour paints
- Paintbrushes
- Georgian Rowney block printing medium for oils
- Printing rollers
- A baren (optional) – this printmaking tool is round like a flat disk with a handle on one side. It is used for applying equal pressure on the back of the paper in order for the paper to pick up the painted image from the plate. You can use the back of your hand when using thin paper.
- Sugar paper, cartridge paper (130gsm), Japanese paper – *Tosa Washi* (28gsm) or *Kozo* white or natural (32gsm)
- Rags – cut-up old clothes or sheets for wiping off paint, better if they have some absorbency such as cotton.
- Candle
- Turpentine or white spirit
- Alkaflow synthetic resin (if using oil paints)
- Linseed oil – refined
- Hardboard, size A3–A1, MDF (5mm) for larger-scale work
- Large palette
- Glass (5mm thick)
- Rollers for painting radiators or gloss oil-based paints from local DIY store
- Masking fluid

Preparing a Ground for Roller and Rag Painting

The idea is to have an opaque mid- to light-toned coloured ground on a board or canvas. When prepared in the manner described below the ground will feel almost as slippery as glass. In order to achieve this surface you will need to prepare a primed board, which will take minimum of twelve hours and up to four days depending on the drying conditions and the medium being used.

To experiment with this medium and method, it is best to begin by using fairly inexpensive materials. In this way you can find out exactly what surface you will be aiming for when using artists' materials and whether or not you like the results achieved.

Use a roller to prime the board with one or two coats of emulsion paint.

An acrylic gesso would be the more conventional but less cost-effective primer.

Once this is dry, you can apply a coat of coloured oil paint. The cheaper version to use would be household gloss paint of a mid-tonal value in the colour of your choice. A shade of either pink or blue would be a good way to start. Use a clean roller to apply the colour.

If using oil paints, mix any colour and add approximately three times the amount of liquid synthetic resin. You will need a large flat palette for this. Blend thoroughly with your palette knife. Don't worry if you see air bubbles, they will mostly disappear through application and drying.

This surface will probably take a couple of days to dry, especially if there is white in the hue. Do not proceed to the next step until thoroughly dry, there should be no tacky feel to it whatsoever.

Use two or three rollers for different tones keeping the hues within a family.

If you have already tried this exercise using household gloss paint, you will know what surface you are aiming for. To develop more of a sheen, apply successive layers of liquid resin diluted slightly with white spirit. Allow each layer to dry thoroughly in-between. Keep applications thin to avoid wrinkling of the resin as it forms a skin.

You can use this method to put grounds on pre-prepared board as well as canvas. If starting from scratch with unprepared canvas apply several coats of acrylic gesso primer, sanding each dried coat in-between. The idea is to reduce the texture of the weave to produce an even gloss surface. Five to six thin layers should be sufficient. Then proceed as explained above. It should also be noted that canvas does not provide a rigid surface but remains flexible and can crack if you press too hard when painting. Care must also be taken at all times when handling and during transportation. Avoid projecting objects poking the canvas.

EXERCISE: **PAINTING – ROLLER AND RAG**

— OBJECTIVE: To find the forms: dark to light, thin to thick, expressive mark-making and dynamic use of colour.

— MATERIALS: Oil paints, brushes, fur rollers, rags, white spirit, linseed oil and pre-primed board.

— POSE/SET-UP: Seated or standing against the light. Element of background become important. Reflections in mirror.

— TIME: 6–12 hours, depending on the size of board.

Your coloured board should be completely dry and if the ground is in household gloss paint then it should be as its name suggests – glossy. Whatever colours you now select to work in, modify them by applications of thicker or thinner density. Try to work within the same field or family of colours. For example, if your board is pink, then experiment with using a range of blues. The advantage of this is that if the colours mix with each other, as they undoubtedly will, they will not muddy or grey each other down.

Avoid using any white paint at this stage, as it will make the colours opaque. Keep the colours transparent, as they come out of the tube, so that you can experiment with tonal effects to produce values of dark and light by the thick or thin application of the paint upon the board. The ground underneath will only show through if the paint is applied thinly. This technique is very similar in method to an exercise from Chapter Two that entailed covering a sheet in charcoal and erasing back to find the form (*see* page 43). The process of working from dark to light applies here too.

If you are working on a blue board, try painting with alizarin red along with various hues of purple made by adding differing ratios of French ultramarine blue. If you use a pink ground instead, the result will be fairly monochromatic. As you become more adept at handling the paint on this surface using the roller and

Wiping off paint easily with a rag.

Mark-making with a brush.

rag technique, your colour choices can widen to as many as you can skilfully handle. This technique will take practice as you experiment with your tools. Losing and finding the image again is part of the process. It will make you less precious and enable you to make changes and alterations very, very quickly. Remember that wiping off the oil paint is very much part of the technique.

Initially, mix two hues of colour and keep a roller for each. Begin with the lighter hue, roller it on to the board and use a cloth to draw back into it to find the figure. You will simultaneously have to consider the space around the figure as it gives contrast or delineation of form and the figure itself. The flat coloured ground underneath seen coming through can simultaneously signify negative space and positive form; such as the space as seen through a window, to the outline of the figure or description of the light as it falls across the face, dress or any other object being depicted.

You can make a wide range of roller marks by adding a little linseed to the oil paint. This will make textures from the roller richer and more defined upon the board. You can also add a little white spirit or turpentine, which repels the linseed oil producing other reactionary elements of mark-making. Obviously the results are neither controllable nor predictable but you can allow areas like these to settle for ten minutes or so and when adding further layers of paint consciously leave some of the parts untouched.

This method of working is all about lightness and heaviness of touch. Try lightly dragging your roller diagonally in one direction and see the background coming through. In this way, you can see how a blue on a pink board will make a kind of lilac simply by the mixing of the two colours. If more pressure is used, the area will be read as dark which again can describe space as well as form.

Holding your roller at an angle and using the inside edge will help you to create quite effective straight lines as well as enabling you to be more precise. Experiment with different textures of cloth, lightly dragging the rag to see the mark you can obtain and using your fingernail beneath the cloth. Try other implements to get a wider range of mark – hog hair brushes or an old toothbrush to push the paint around to gain a more controlled rich texture. Test a palette knife or the handle end of the brush for more scratchy and linear marks.

The results of using this technique are quite striking. The method produces a very sculptural effect and, depending on the colours used, can make a work appear extremely contemporary as it can have the quality of a photograph and the photo negative. Sometimes, the way in which the colours directly affect one another is very evident. You know that you have applied an evenly toned ground to your board, yet you can see that some areas are more intense than others, depending on the colours overlaying and adjacent to them. Your choice of colours will produce exciting new possibilities, imbuing the painting with an atmospheric underglow to generate temperature, mood and feeling.

The advantage of working in this way is that you can make the transition from direct observation to the realms of the imagination whilst still being able to refer to the subject in front of you. The results, which are sure to surprise you, should help to open other doors to your imagination, making you aware of possibilities that might never have occurred to you before.

The Monoprint on Paper

The monoprint is a unique print transferred from the plate directly or indirectly on to your paper. The process, which falls somewhere between painting and printmaking, is a really spontaneous and direct way of working that can transform routine drawing into something that looks quite professional and sophisticated. The technique allows you to work from direct observation and provides a real stimulation for the imagination. It is also a good way to liven up old ideas or past drawings which can result in very good pieces in themselves or become new beginnings for future works. The monoprint method is also relatively cost-effective when compared to board or canvas, takes up little space and is not too time-consuming.

You can use proper printing inks but the idea here is to use materials that are already to hand. With the right paper and mixture of oil paint you can print to a satisfactory level without the

Building up the image.

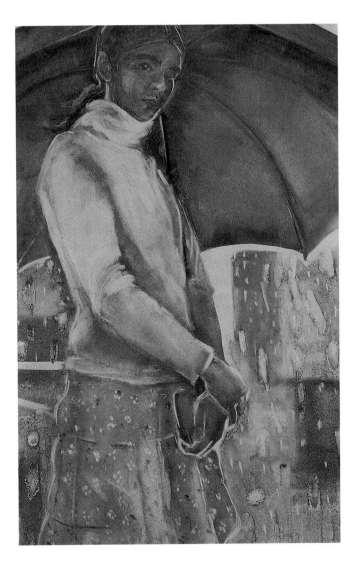

This painting was executed *alla prima*.

need for a press. You may try out various papers but without a press, the smoother and thinner the paper the more effective it will be in picking up the painted detail from the plate or glass.

To experiment, start with newsprint before moving on to the more expensive Japanese paper. Both come in A1 sheets and can be cut down to your desired size. Use scissors rather than the fold and tear method for the Japanese paper.

There are several ways of working the paint on to the plate to produce different qualities and effects. The most important consideration is to be open to elements of change, especially when following or working from an existing drawing. Do not expect highly detailed or meticulous work and remember that your images will come out in reverse, which is fantastic for seeing your work afresh! Because you cannot control everything that is going to be picked up by the paper, you will always have some surprises but usually they will be very pleasant ones.

EXERCISE: **MONOPRINT**

— OBJECTIVE: Freedom in artistic expression

— MATERIALS: Oil paints, brushes, print rollers, rags, white spirit, and extender for oil paints, cartridge, sugar and Japanese papers

— POSE/SET-UP: Any

— TIME: Up to 1 hour depending on the method

Place a white piece of paper underneath glass. Ink up the plate.

DIRECT DRAWING

First of all, on a fairly good-sized palette, mix up some black oil paint and block-printing medium for oils – the ratio should be approximately two-thirds paint to one-third medium. As you become accustomed to the monoprint technique, you will get to know the consistency that gives you the best results. Remember that the medium will make the hue of the oil paint more transparent. Use your palette knife to work the mixture and then spread a line near the top end of the glass or steel plate and roller it out.

Once it has been equally distributed on the plate, listen to the noise the roller makes. If there is quite a sticky, tacky noise, you may have too much oil paint and medium on the plate or too much medium in the mixture. If there is no sound, the mixture may be too dry and the paper will not pick up much of the drawing.

Once you have inked up the plate, place your paper on top – this can be either cartridge or sugar paper. It is good practice to fix the paper to the plate or the surface beneath with some masking tape. Although probably unnecessary for this particular approach, should you want to lift up the paper to see what is happening to the image, check consistencies, pressure of hand, add further drawings or build up in layers, you will be able to retain the same registration.

Now draw on the paper using a ballpoint pen or sharpened pencil. This method is good for simple flowing line. Remember that the paper will pick up some of the ink in quite a random way. This produces lovely gradations of textural marks that contrast well with the linear. However if you lean your hand heavily on the paper as you draw, the paper may pick up far more ink that you would like, so be careful. Once you have finished drawing, smoothly peel back the paper to see the lovely results!

THE SHADOW PRINT

Don't clean your plate just yet! You will often be able to get a second print but it will not be the same as the original impression because it will be much lighter. At this stage you have an opportunity to block out or add more detail to the plate. To get the idea, place a thin paper such as newsprint or Japanese paper on the top. The Japanese paper is so thin that you can get an indication of whether the image is being picked up, which is very useful. Rub the back of your hand gently over the paper. You may also wish to rub the back with a baren but when using thin paper such as this, slip another sheet of paper on top of your original, for thin paper will tear. The effect of a shadow print is that the dark lines on your first print will now be seen in the negative: in

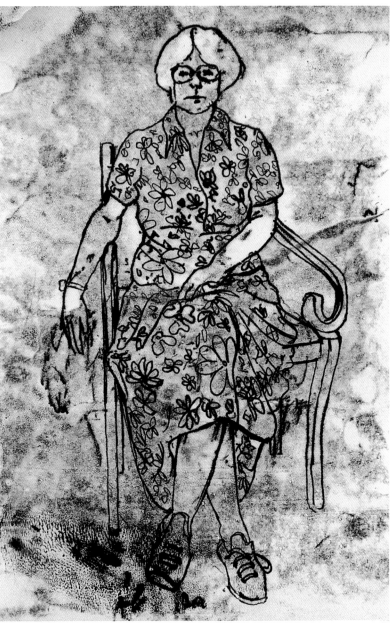

ABOVE LEFT: **Place paper on inked glass, draw your image, and peel back carefully.**

ABOVE: **The paper will pick up lovely unexpected texture.**

LEFT: **You can make up textural patterns like these squiggles in the background.**

Before cleaning a glass plate, put a fresh sheet of paper down. Use your hand or a baren to help put on more even pressure and swipe it over the entire surface.

The shadow print produces an interesting transparency negative quality.

other words they remain blank, the un-inked area of the plate that produces a photo negative like effect.

DRAWING ON AN INKED PLATE
Roller up the plate with ink and then use the back end of the brush to draw into it. You can see exactly what is going on so if you make a mistake simply roller over it. Keep the drawing linear. For stronger use of line try a palette knife, which is also very useful for making patterns.

DRAWING AND WIPING AWAY ON AN INKED PLATE
The master of this method was Degas. For inspiration and to see what it is possible to produce just look at some of his mono-prints. In this manner he achieved a rich range of tone and a wonderful array of mark-making suggesting individual proper-

ties of skin, drapery and the fall of light. Of course, he was using printing inks and a press but as seen above right, it is possible to achieve a good result without one (see also page 175).

Ink up the plate and use rags to take off paint using the dark to light drawing method. Remember that you can also re-apply paint with the roller or brush to correct or draw into. Don't forget different mark-making tools and remember to register the paper (use either Japanese paper or newsprint) to the plate! In this way you can make some small modifications, going back over or applying more paint on the plate where it has come out too pale. However, you can't do it the other way round, for once the image is on the paper there is nothing more you can do unless you start overlaying in an impasto-like way which will produce something else altogether.

ABOVE: **Scraping into the inked plate. Simple easy lines and pattern convey a decorative space.**

ABOVE RIGHT: **Note all the expressionist marks that create interest.**

RIGHT: **Wiping away ink with rags and brushes to create tones and drawing.**

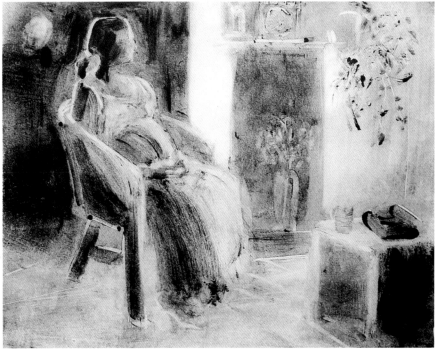

PAINTING STRAIGHT ON TO THE GLASS

You can rework an old drawing by tracing it directly by placing it under the glass. You might like to use some of the drawings that you made of figures in different positions.

Test out painting the mixture on to the plate with various brushes – hog hair will give gestural marks, synthetic brushes will be smoother. You will need to experiment with consistencies of paint and medium mixture as well as finding the correct thickness of application. You will notice that whilst more medium in the oil mixture will allow the paper to pick up greater detail, it makes it much more difficult to push the paint around on the plate because it is sticky. If you increase the ratio of oil paint to medium this will improve the pliability and it will be more effective if you keep your brush quite loaded with paint. You can try adding a little white spirit for a 'painterly' effect but remember that if you overdo it, especially if using thin paper, the image will come right through. Similarly, if you decide to add a little linseed oil be very careful – too much and it will make the thin paper transparent for good.

Using Stencils

This is a fun way to explore composition and also achieve striking effects. Trace a figure drawing on to some sugar paper or a paper of similar thickness. Make the stencil by cutting out the figure using a craft knife. Ink up the plate and position the stencil. Draw into the rest of the inked plate using your imagination to create space and setting, then take a print.

Note that silhouettes work best if they have negative spaces between arms and body and legs. If you have a solid shape, remember to take a shadow print but before placing the paper, either draw into the plate or apply paint to the plate to delineate the inner form. You can make further images by using the actual stencils themselves.

Create an interior space or allude to it with a simple floor and wall divide perhaps drawn at an angle for interest. Experiment with positioning as this will also give you ideas for spatial compositions. The results are even more interesting and helpful in sparking your imagination further if the stencils are of varying

**Take a print off an orange inked up
glass (registered). Clean glass and
paint your image. Reprint.**

**Paint on to the glass tracing the
drawing that you have placed beneath.**

ABOVE: **Using stencils.**

ABOVE RIGHT: **Extra negative drawing (taking ink off) has been added before taking a shadow print.**

RIGHT: **Combinations of taking prints from stencils, painting, negative drawing and increasing the extender for transparency of colour.**

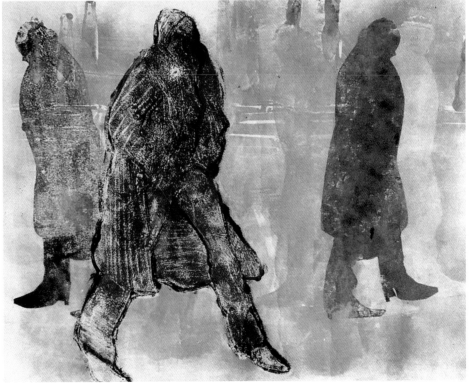

scales. These can create depth and recession as well as developing interesting scenarios.

Tips

Scrape back the plate or glass every so often to either throw away drying mixture or to refresh it.

Remember that you can work in any single colour, or try two elements of colour. Ink up a plate solidly and take a print, then clean the plate, paint another colour on and reprint.

Use a combination of all the above methods, overlapping and layering colour to build up more complex images.

Creating Different Moods

An experienced model will naturally settle into a variety of uninhibited and unselfconscious positions. It is likely that he or she will,

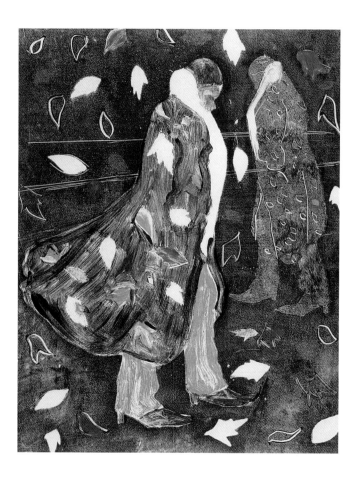

**A combination of methods.
Remember to keep glass plate and
paper registered in the same position.
Mark with masking tape.**

to some extent, pick up on certain idiosyncrasies that the artist finds appealing – the graceful or powerful twist of the torso, the tilt of the head and so on impart subtle suggestions which can inspire the forever watchful artist. Indeed, you can see that historically many artists became drawn to working with a particular model.

You may already have an idea for a piece of work and know exactly what you want of your model. But if not, whether embarking on a portrait commission or something much less formal, take a few moments to reflect. Apart from making sure he or she is as comfortable as possible and assuming a stance that feels natural, just allow the model to 'be'. It is quite usual that even a very informal set-up will make the model feel a little self-conscious but that will pass. Now try asking yourself some of these questions.

What does the pose suggest? Is it energetic, thoughtful, or reflective? What is the body language like? Whilst two or more people can sit in a similar or identical pose, one person may be quite tense in stature, another perhaps languid and another maybe slumped.

What ambience does the lighting give?

Are the clothes very decoratively pleasing or exciting in some other way? Are there any really strong shapes?

Does the personality of the model play any part? Are there any body language signs that suggest inner emotions or character? You may pick up upon individual mannerisms, expressions or gestures that encapsulate the person best. Consider what impact the personality of the model has on you; and what of your own perception? You can try to imagine what your model may be thinking or feeling or even make up your own scenario of what your model's life might be like.

What about the artist? Should the thoughts and feelings of the artist be considered? Not only can you convey the essence of the person you are drawing, you can also convey what it is like to look through your head and through your eyes. Lucien Freud is a good example of an artist who conveys himself to the world in this way.

All these reflections can influence the interpretation of a piece of work and can help you to see something more in what might otherwise be considered mundane.

Some of these next few methods and techniques are simple but effective as the process itself may suggest to you possible interpretations of the clothed figure before you. Artistic decisions as to how you go about it can also reflect your response to any one of the above sentiments and thoughts.

Colour Key

A picture that is light (high values) is referred to as 'high key' and a dark-toned picture or one with a muted palette is referred to as 'low key'. As already mentioned, colour not only describes

This would generally be considered as high key, although the overall impression of a blue dress is subtly coloured.

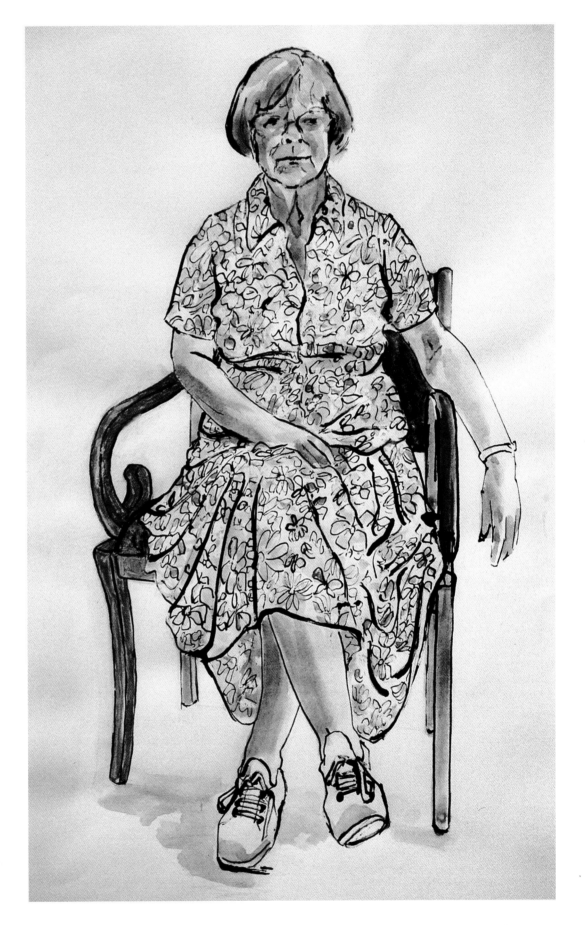

This is also a high key piece of work and the colours are more saturated. The overall bright range of greens produces a feeling of warm sunshine.
ARTIST: CARYL STOCKHAM

BELOW LEFT: This fairly monochromatic painting is subdued and in contrast to the piece above would be considered 'low key'.

BELOW: Wax has been used in quite an expressionistic way.

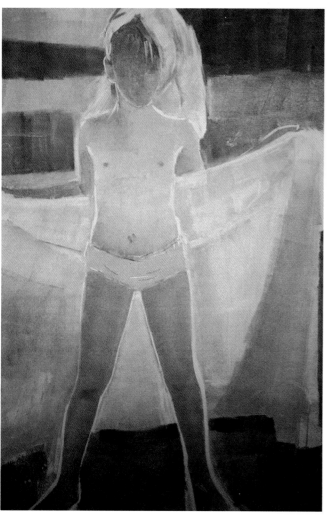

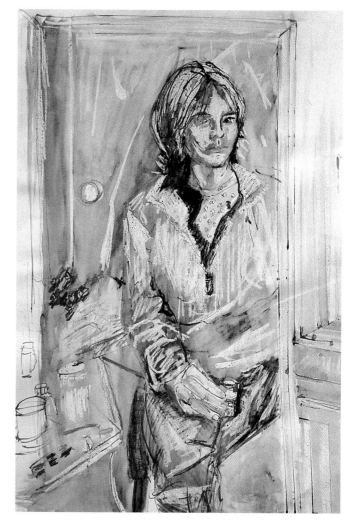

spatial relationships and temperatures, it also exudes a feeling or impression according to the colour key being used. It is interesting to note that colours appear even more luminous and intense when outlined by black.

When looking at different artists' work, compare their overall colour schemes. Some works have a dominant overall colour, which is not to say that it is necessarily monochromatic. For example, a picture may have quite a few colours in it but the overriding and unifying colour may be predominantly blue. This overall colour impression helps to tie in all the other colours used; unifying parts to the whole much in the same way as a coloured ground. A predominantly blue picture will be usually be sensed as cool, even icy cold. However, blues can also be perceived as clean and refreshing, or serene, calming and peaceful. Depending on the key of blue, they can also be experienced as reflective, sad or melancholy. Likewise, predominantly hot colours such as red can be bold, invigorating, stimulating and passionate but also jarring, screeching and demanding. Bright and hot colours do not necessarily convey warmth, joy or celebration either – just think of *The Scream* by Edvard Munch. As you work through the following methods try to be aware of your colour choices.

Watercolour and Wax Resist

This method is based on the same process as we looked at in one of the exercises in Chapter Two (*see* pages 52 and 53). As well as using wax resist to describe different planes of the body, you can use it for pattern too. Apart from the thickness of the candle wax tool, you won't be able to see quite what you are doing but don't worry, this does not have to be articulate, rather it is an opportunity to feel your way, to visualize your mark-making by way of your hand action. It could be a series of dots, feverish lines, squiggles and dashes or scribble-like figures of eight.

Experiment on a scrap piece of paper to test effects. Or faintly outline your design in pencil, and once sure, go over it with ink. When the ink is dry, wax in the pattern to produce an effective motif that stands out from the subsequent watercolour wash. Of course, you can also use the wax as a medium for modelling form. After you have made a light outline drawing, put in the highlights with wax. Wash over the area with your next lightest chosen colour. When the wash is dry, wax the areas to be left in this colour before overlaying with another wash or darkened colour. Proceed in this way until you arrive at the desired result. Compare the examples (*below*).

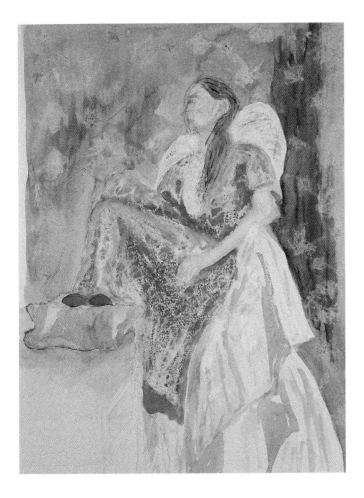

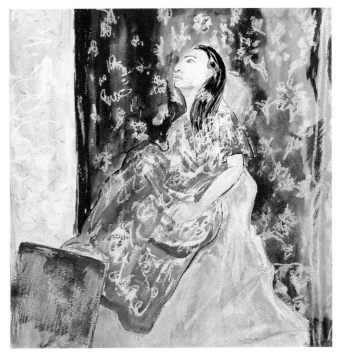

LEFT: **A build-up of pale washes creates subtle tones in this pretty design.**
ARTIST: LESLEY ORMROD

ABOVE: **A very bold design.**
ARTIST: DEB McCORMICK

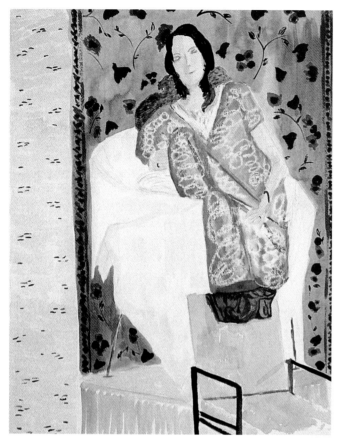

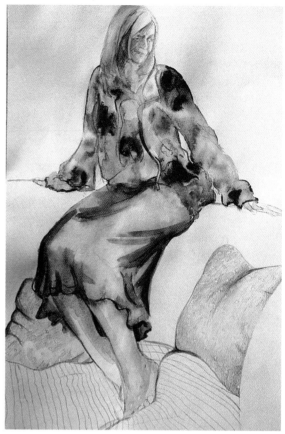

OPPOSITE PAGE:
TOP LEFT: **The wax resist has been used minimally in this very effective composition.**
ARTIST: PAM DICKSON

TOP RIGHT: **The shirt was done wet into wet and whilst the paper was still wet edges were drawn in with watercolour pencils.**

BOTTOM LEFT: **Ink was drawn on lightly first for this simple but effective figure.**
ARTIST: CARYL STOCKHAM

BOTTOM RIGHT: **The tender moment between mother and child are captured with such simplicity.**
ARTIST: CARYL STOCKHAM

THIS PAGE:
BELOW: **Areas are masked with masking fluid.**

BELOW RIGHT: **Yellow dress masked out while more layers are built up.**

Watercolour Wet into Wet and Ink

Using either a pencil or working straight away in black ink, draw your figure – the amount of detail is up to you. If you have used ink, allow it to dry first!

Dampen the area that is to have the wet into wet technique. Apply your colour, which can be either intense or more washed out. While the colour is still wet, apply another colour so that they can bleed into each other.

If a colour is spreading far too much or going too swiftly in an undesired direction, use some cotton wool to mop up.

Splattering

This method is simply as the name suggests – splattering or spraying by flicking paint off a stiff brush or something similar on to the paper. The dots then make up the texture, colour and tone. You can splatter with either masking fluid or watercolour or both and

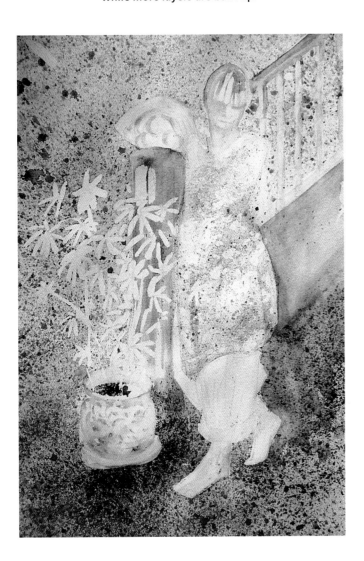

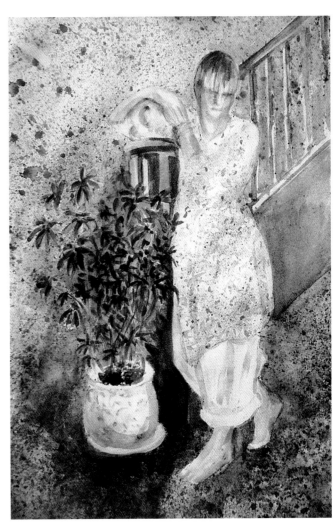

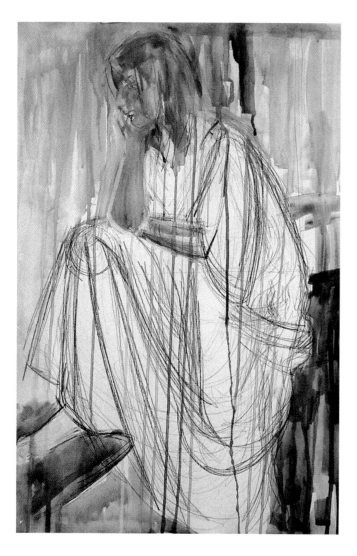

**The figure was drawn and then some of
the background colours were dripped in.**

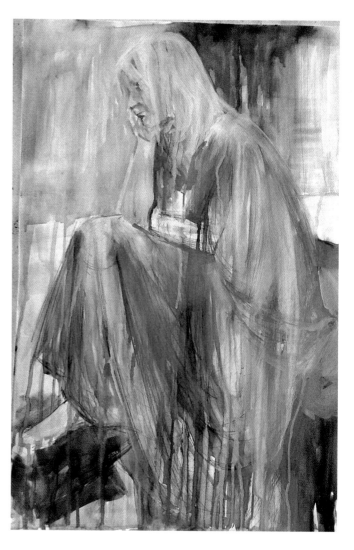

**The figure was built up; the opacity
of gouache is good for overpainting.**

build up in layers. Mask out areas not to be affected and allow layers of splattering to dry in-between.

Pointillism is in essence a controlled and of course more time-consuming method of this technique where the dots of broken colour mix in the viewer's eye producing the illusion of merged and blended colour. Printed reproduction also relies on this process, which you can observe with a magnifying glass.

Dripping

This takes splattering a step further by overloading the brush with a mostly liquid mixture and brushing or splattering on to the surface allowing the paint to drip. Again, you can mask out areas where you do not want the paint to go. You could also try tilting the paper at different angles to allow the paint to dribble in a chosen direction. You can use this technique to suggest different emotions, perhaps anxiety, depression or introspection.

Watercolour Masking Fluid Resist Method

Using an H3 pencil, make a drawing directly from life. Keep the initial outline very pale and light as the pencil lines should not

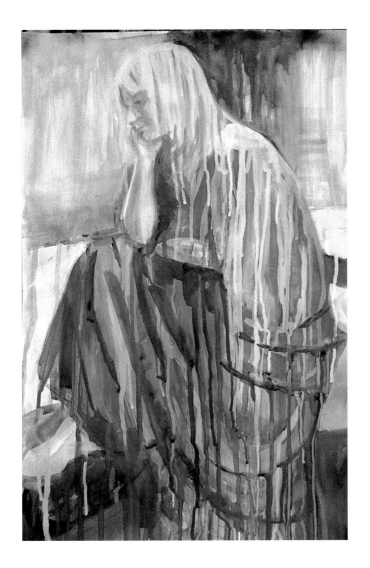

ABOVE: **The final surface drips are applied. Note how pose and method are sympathetic to each other.**

RIGHT: **Observe the different patterns of dress, hair and net curtains kept bare using masking fluid. Note the wet into wet technique as well.**
ARTIST: CARYL STOCKHAM

be visible in the finished painting. Use as little pressure as possible to draw otherwise you will indent the paper.

It is up to you whether you describe the figure only or extend it to the entire room. Use a small, stiff, round hog hair brush to paint on the masking fluid in a linear fashion following your outline and then leave it to dry. The nature of the masking fluid as it comes off the brush will make your design more simple and bold. Once the masking fluid has dried, which should not take longer than a couple of minutes, apply a colour wash of your choice. Remember you can build up density and intensity by painting a wash on top of the previous one (allowing each layer to dry in between) as well as developing subtle and beautiful hues. Once you are satisfied with all your washes and they have dried, peel back or rub off the masking fluid to reveal the white of the paper. This method is very effective when the wash is applied in a single colour.

Flat Painting

This means simply to paint in an evenly overall toned area of colour, applied in a smooth way so that everything results in looking flat. You can still have texture and colours coming through from another hued layer beneath but you are not really using the colours to describe any sense of three-dimensional space. Think of it as a purely decorative design where you do not have to create depth by modelling light. However, if you are using texture be aware of the need to maintain a unity throughout the entire surface of the picture. Remember too, that you will still be able to convey elements of space through the position and relative

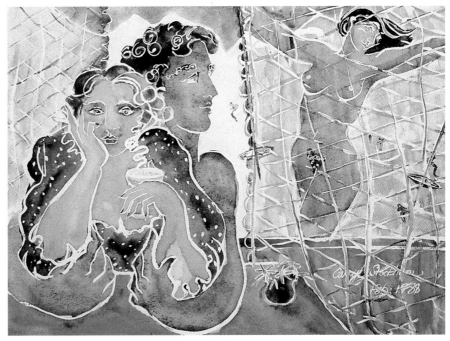

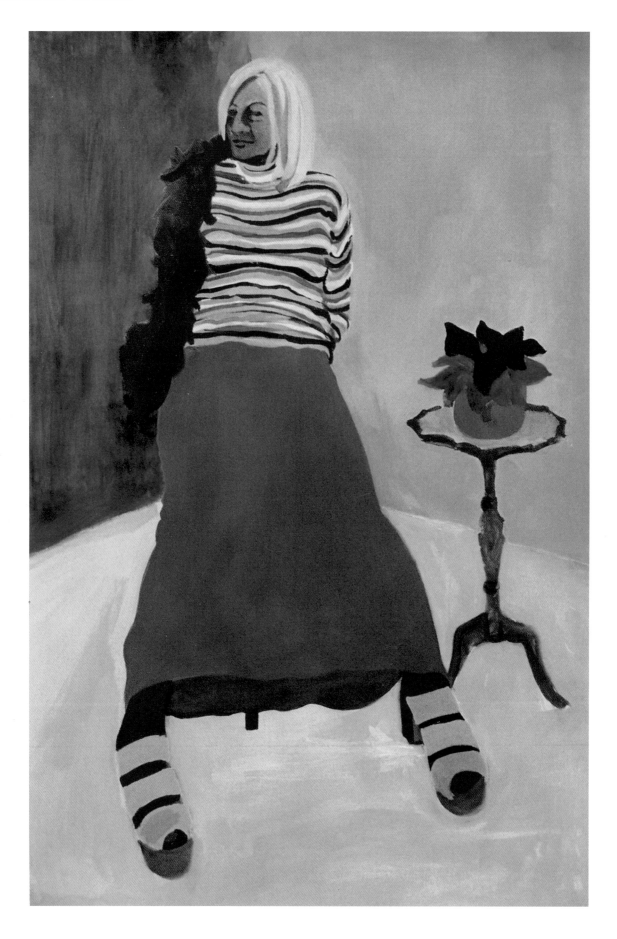

size of elements within the composition as well as through relationships of colour.

Pay attention to the designs and shapes you are creating. Again, patterned clothes are also great for defining the decorative contours of form. Either you can keep the pattern completely flat within the shape of the item of clothing, like a collage effect, or you can allude to a third dimension by allowing the patterns to follow the body contours. See in the example (*opposite page*) how the stripes convey roundness and how the skirt edges give clues to the nature of the fabric. The green wall has texture and underpainting but brush marks can be seen throughout. Observe how the entire picture has been painted in fairly intense, bright colour. Study the placement of colour – the green of the leaves to balance the green wall; the reds of the stockings, boa, stripes and poinsettia. The blue gives a little space and blends well with the lilacs of the jumper, table and platform sandals. The blonde hair echoes the much larger area of yellow floor.

Collage

As well as making a really nice piece of work, collage is a good way to test out ideas for other projects. First of all you will need to rummage around collecting all sorts of different types of paper – plain and patterned. Magazines are always a good source but do not forget wrapping papers, tissue papers, newspapers and even bits of wallpaper. Old scraps of material, buttons, trims or piping are also useful. It is interesting to see that you have the irony of being able to use real wallpaper to represent your respective wall/interior as well as to use the same motif for a cardigan or other item of clothing. Both Picasso and Matisse were skilled at doing this in collage and in painting, thus reminding the viewer of the flat two-dimensional surface.

First, draw and paint in the design, especially the areas of the face that will not be collaged. Trace the shapes and use these as templates to cut out shapes of patterned paper. If you are using material then use white chalk to draw around the shapes. Arrange your collage and remember to notate the order in which they are to be glued when building layers.

OPPOSITE PAGE:
This flat approach suits the fashion-like pose of the model.

THIS PAGE:
ABOVE: **Note the use of complementary relationships that has produced a more melancholic image. Placement and shapes of flat colour produce flattened pictorial planes of space.**
ARTIST: CARYL STOCKHAM

RIGHT: **The design is painted in first in flat colours. Some of these areas are collaged whilst others, such as the hat, are left.**
ARTIST: SONYA DEAN

THIS PAGE:

LEFT: **Once items are glued in place, the artist softens the hues to pastel shades by white-washing over the surface with ordinary emulsion.**
ARTIST: SONYA DEAN

BELOW LEFT: **Have fun with creating dress designs of your own.**
ARTIST: SONYA DEAN

BELOW: **A delightful collage.**
ARTIST: SONYA DEAN

OPPOSITE PAGE:
TOP LEFT: **The figure was sketched in over a toned ground.**

TOP RIGHT: **Brush marks follow form and note texture over the entire surface.**

BOTTOM: **The baby blues and soft lilac pinks suit the child-like pose.**

Impasto

This is where you build up so that the paint is in relief to some extent. If you are working in oils, you may have to scrape off quite a bit as this technique is not as easy at it appears. To retain freshness and spontaneity you have to be quite sure where you are going to paint or place your paint-loaded palette knife. Then you have to apply colour over that, scraping in texture but just in the right way so that you do not have to touch it again! For this reason, the best medium to use initially is probably acrylic as the paint dries relatively quickly. However, if you wait too long to scratch back you may find the layer already dry. In order to bulk out the acrylic paint you can add a gel thickening medium. Have fun creating textures with the hog hair brushes and note how these can also serve to describe the form of planes by making the direction of the brush mark follow the direction of the form.

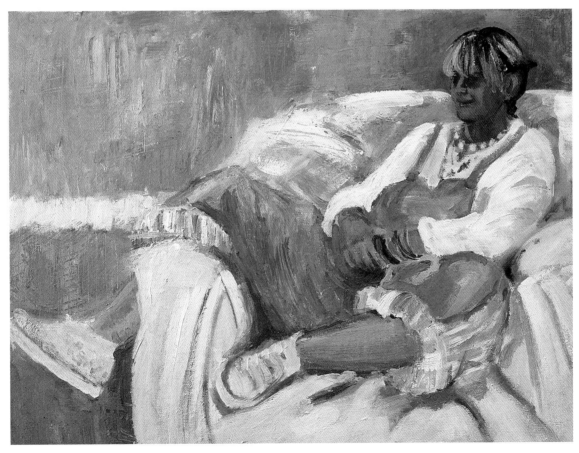

INDEX

acrylic 81–3, 94
aerial perspective 136
Alkaflow 168
alla prima 94, 171
artist position 10
atmospheric colour 66

balance 15–16
bamboo/quill pen 33
baren 168, 174
body:
 map contours 21
 rhythm 112–15
 shapers 108–11
 support 156
brushes 87

charcoal pencil 9–10
circular lines 124
collage 187–8
collars 85, 87
colour 61–7
 body 77
 combinations 64–5
 complementary 64
 mixing 64
 darkening 74
 greying down 74
 intensifying 74
 lightening 74
 primary 62
 properties of 62
 schemes 125

secondary 62
simultaneous 64
successive 64
supporting ground 79
tertiary 62
theory 62
colour key 178–81
colour pencils 66–9
colour wheel 63–4
composition 115–39
 group 136–8
conté crayons 70
creating moods 178
crosshatching 47–9

diagonal lines 122–3
different positions 103–13
drawing the clothed figure 85–90
drawing on inked plate 173
dripping 184–5

eye level 25–7

feet shapes and planes 142–4
fixative 33
flake white 81
flat painting 185–7
folds:
 analysis of 34–8
 diaper 34–5
 drop 35
 inert 37
 lock 36

pipe 35
spiral 36
zigzag 37
foreshortening 24–9
fur 165

glasses 162
glazing 76–82
golden section 118–20
gouache 184
grid 59

hair 161
hardboard 168
hatching 47
hats 146–9
horizon line 25–7
horizontal and vertical line direction 120–2
hot spots 118
hue 62

impasto 189
imprimatura 79, 94
ink 33
inside to out (ex) 19–21

Japanese paper 168
jewellery 163–5

leather jacket 61
line 33, 38
local colour 66

mark-making 57–9
masking fluid 183–5
measurement 10–13
model 10
monoprint 172–8
 tips 178
movement and action 150–3
muscles 17–18

oil paints 62–3
oil printing medium 168

overpainting 76–7

painting:
 clothes 73–83
 in layers 99–101
 onto glass print 176
 red material 79–80
 tips 91
 tones of fabric 74–6
painting the clothed figure 91–101
paper 33
pastels 70–3, 86
pen and ink 49–52
pencil and watercolour wash 54
pencils 9
personal props 158–64
perspective 24–9
 placement 134–6
placement 118–22
posture 15–16
print direct drawing 172–3
printing roller 172
proportion 10–11
 head 22–4
putty rubber 10

researching and using data 157
roller and rag painting 168–71
 preparing ground for 168

saturation 62
scaling up 139
scribble hatching 48
scumbling 82
sequin material 82–3
sgraffito 76–7, 79
shade 74
shadow print 172–4
shag jacket 68–9
shapes and strategic points 30
shiny material 79–81
shoes 141–6
skeleton 13–14
sketching 153–5

skin tones 91–3

space 117

splattering 183

spotted fabric 72–3

stencils 176–8

stress and tension points 107–8

stretching paper 52

striped fabric 68–71, 97

textures:

 in pen and ink 60–1

 in pencil 57–61

tint 74

titanium white 81

tone 33, 41–5, 125–8

toned ground 94

torchon 33

tubular approach 31

turpentine 57

underpainting 76,

value 62

viewfinder 59

viewpoints and perspectives 129–33

watercolour wash and pencil 54–5

wax resist 52–3, 180–2

wet into wet 183

white spirit 57

willow charcoal 9

zinc white 81